Judy,

Many thanks from the
Connecticut Library Association
Technical Services Section

11/4/2010

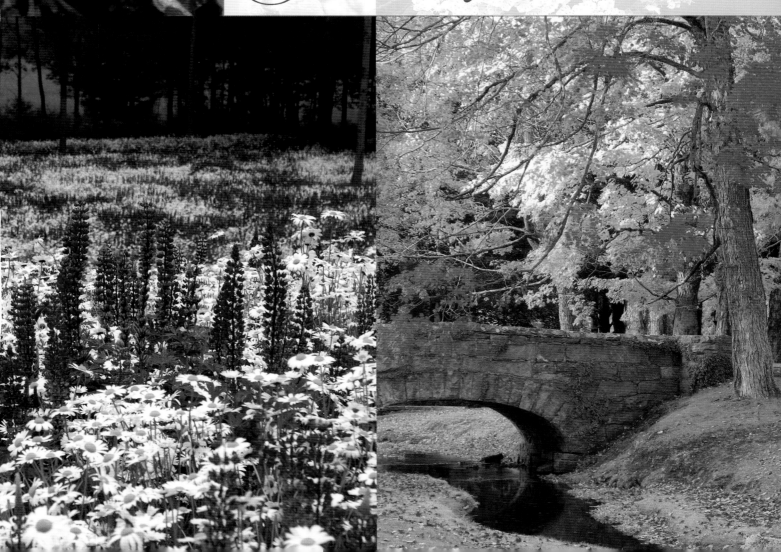

Seasons of Connecticut

Seasons of Connecticut

A Year-Round Celebration of the Nutmeg State

DIANE SMITH

Guilford, Connecticut

Positively Connecticut™ is a trademark of LIN-TV and licensed to Diane Smith.
Poetry excerpts on pages 80 and 81 are reprinted courtesy of:
Lita Hooper, from the poem "Ellipse," published in *Perspective* (www.litahooper.com).
Opal Palmer Adisa, from the poem "Language," published in *Eros Muse,* Africa World Press Inc., 2006.
Marilyn Nelson, from the poem "Moton Field," published in *Carver: A Life in Poems,* Front Street, 2001.

Text design: Sheryl P. Kober
Project editor: Julie Marsh
Layout artist: Melissa Evarts

Library of Congress Cataloging-in-Publication Data

Smith, Diane.
 Seasons of Connecticut : a year-round celebration of the Nutmeg State / Diane Smith.
 p. cm.
 ISBN 978-0-7627-5907-1
 1. Connecticut—Social life and customs—Anecdotes. 2. Seasons—Connecticut—Anecdotes. 3. Connecticut—Description and travel—Anecdotes. 4. Connecticut—Biography—Anecdotes. 5. Connecticut—History, Local—Anecdotes. I. Title.
 F94.6.S66 2010
 974.6—dc22

 2010002441

Printed in China

10 9 8 7 6 5 4 3 2 1

CONTENTS

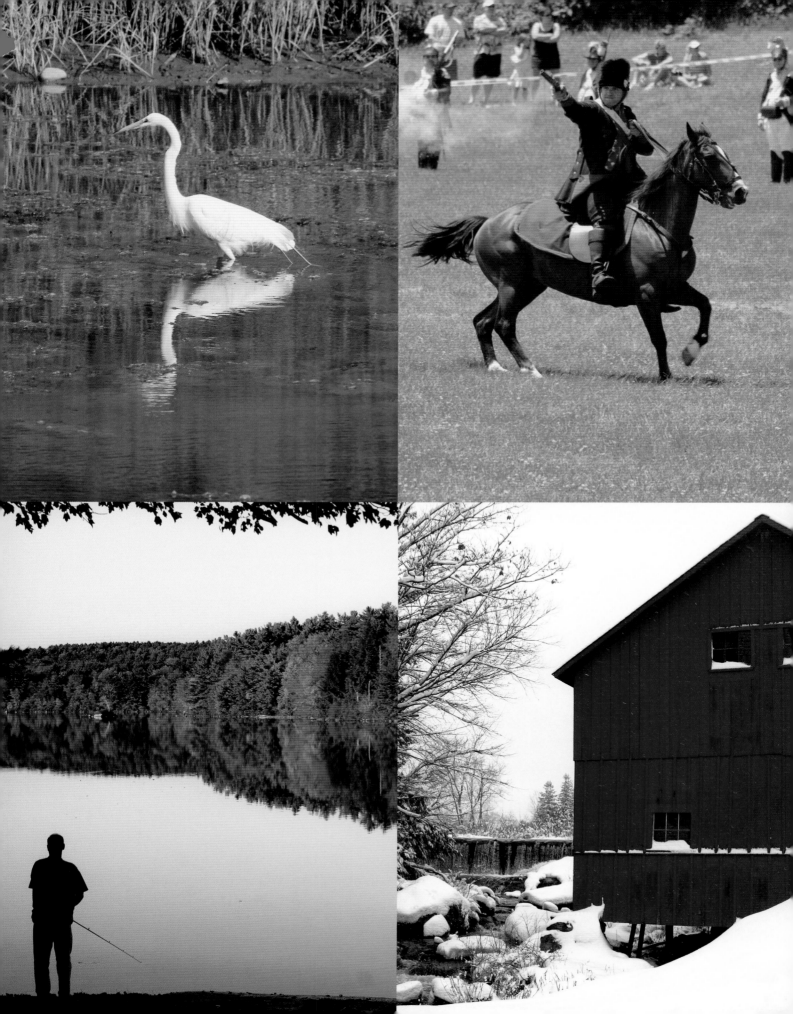

FALL 🌿

WINTER ❄

INTRODUCTION

A DEEP BLUE CROCUS PUSHES ITS WAY THROUGH THE earth, the first stroke of color to burst onto the winter palette of gray and white and evergreen. Suddenly it is spring in Connecticut. Gather up the rakes and trowels, it's time to start the seedlings, some for our own plots, and some for a community garden to spruce up the city and give kids green places to play. Daffodils sprout in a sea of yellow in Hubbard Park, while pink and red dominate the trellises in Elizabeth Park, the nation's oldest public rose garden. Alongside ponds and lakes and shoreline marshes, this spring's flock of ducklings and cygnets hatch. Kite flyers come out in April and May, eager to catch the freshening breeze.

The breeze in June and July lures summer sailors of every stripe to Long Island Sound, while the rivers come alive with rowing and tubing. Summertime is about sports in Connecticut, from boating to baseball to cricket, the colonial American game making a comeback all over the state.

Days spent outside are seasoned with the fresh flavors of summer.

Savor the sweetness of lobster, trapped hours earlier, accompanied by clams dredged from local beds and eaten at a picnic table on an island marked by a lighthouse. The abundant crops raised on local farms are hand selected by lucky shoppers at dozens of farmers' markets all over the state. Blue ribbon bakers turn berries into prize-winning pies at country fairs. Sitting on a wraparound porch, sipping an ice-cold soda made the old-fashioned way, is wonderful for whiling away the lazy days. Connecticut is the place for poetry in the summer, with verse hanging in the fragrant air of a sunken garden in evening. Night and day music is hot, whether it's jazz or classical or pop; in the city or the country or on the town green, there's a festival celebrating it.

The fall foliage takes our breath away. What gives the scenery its Connecticut character? A weathered tobacco barn in Windsor set off against the scarlet and gold of autumn. A great pumpkin enthroned in a roadside patch. Hiking the Sleeping Giant with leaves rustling underfoot or walking through a Wallingford winery, as the grapes are heavy and ripe for picking. September signals the new semester and schoolchildren set about unearthing the lost heroes of Connecticut history. Walktober is when thousands of visitors make a little noise in the quiet corner. Fall is when legendary theaters fill with fans eager for a new season. It's the time for a whimsical weekend in a getaway modeled after a child's tree house, but with all the comforts any adult might crave. Thanksgiving means volunteers wrangling huge helium balloons in one of the nation's biggest balloon parades staged in one of the state's biggest cities.

Winter is Husky season in Connecticut, not just for the fans who pack the men's and women's basketball games at Gampel Pavilion, but for the mushers who hitch their Huskies to handcrafted sleds and head out into the new fallen snow of Higganum. Dashing through the snow you might encounter John Allegra, bundled in a cape and bearskin cap, with a matched team of horses hitched to a Victorian sleigh. Winter is a time to be swept away by a sport like curling or to cuddle by the fire with a nice cuppa tea.

The four seasons are why we live here. In other parts of the country, it may be warm all year, or rainy all year, or snowy and cold for lengthy stretches. In Connecticut we take pleasure in four seasons that are distinctly different.

I hope you enjoy this collection of stories spanning the Seasons of Connecticut. ≈

Spring

Blight Spot to Bright Spot

The Knox Parks Foundation

Locally grown—that's a good way to describe the Knox Parks Foundation. Its mission is to build stronger, greener, and more beautiful communities in Greater Hartford while helping young people learn job skills.

A TREE GROWS IN HARTFORD ON SHERMAN STREET, on Lorraine Street, and on Barbour Street, where Robin Hussain is presiding over a tree planting at the Generations Housing Complex.

"This tree is dedicated to Chad. He was one of our grandchildren that was taken from us too early," says Robin as she pours a trickle from a garden hose onto the young cherry tree. It was planted outside the home where Chad Adgers lived, in a complex created for grandparents raising their grandkids. The tree planting was organized by the Knox Parks Foundation.

"Knox plants hundreds of trees all over the city every year, and it's a fitting tribute to Chad because a tree is a symbol of life," says Ron Pitz, the interim executive director of the foundation.

In all there were seven trees and more than a dozen rose bushes planted by the Knox "Green Team" workers and "Green Crew" volunteers on this beautiful Saturday. Lynn Johnson and her friends raised nearly $2,000 to buy them.

"It was my sixtieth birthday and I didn't want presents. You know you have too much stuff when you're sixty," Lynn explained, "and I thought, what would I really like . . . I would like to plant some trees."

Lynn calls herself a longtime admirer of Knox Parks. "I have MS so I can't do a lot of the stuff they do but I think that they are awesome. They do great work in the city."

Their work is to beautify city neighborhoods, with projects like turning eyesores into green space, and to connect people with the earth, as they do at their community gardens.

"Knox's mission is to improve the lives of the people of the city of Hartford using horticulture as a catalyst," explains Ron.

Betty Knox started the foundation with that in mind. She loved her city, its people, and its green spaces, which she yearned to save.

"Unfortunately many of the trees being removed in Hartford are not being replaced. The city just doesn't have the budget to replace the trees that they take down," says Catie Curran, president of the board of directors, who is rolling up her sleeves on this planting day.

So Knox plants trees, tends landscaping for nonprofit agencies, and creates planters for city streets, all while training young people from the inner city, like Giovanni Gonzalez, a Green Crew member.

"Not only is it good working for the environment, it's a good workout for your body," Giovanni smiles.

Green Crew members work for six months in the Knox greenhouse and outdoors, learning more than horticulture. They learn life skills, like how to write a resume and how to land and keep a job. They're paid by federal AmeriCorps dollars, and when they finish

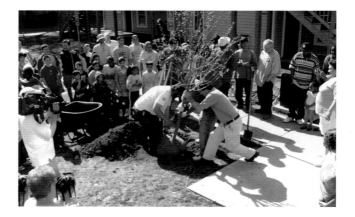

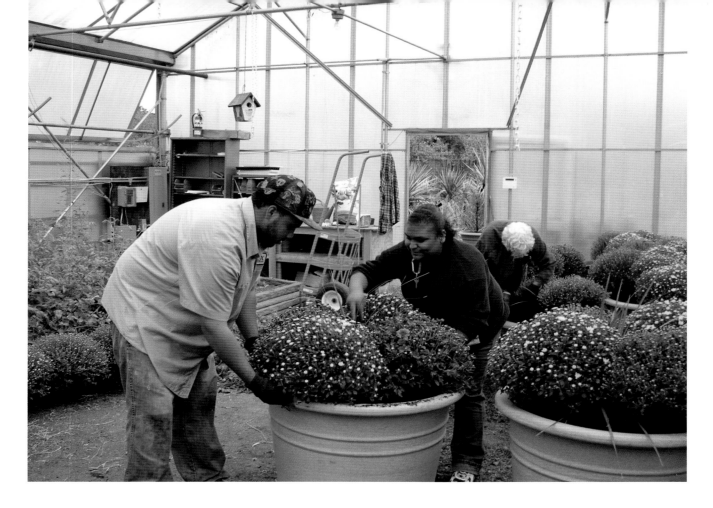

there's a bonus for workers like Giovanni.

"When he came to us his life was going nowhere. He was living with his parents and he wasn't in school anymore. He wanted to go back to school and one of the most important things in the Green Crew is the money that they get for college at the end of the program," Ron explains.

But besides beautifying the city, and training young people, Knox has another mission. On community work days like this one, dedicated volunteers like Val Bryan are building bridges.

"It provides an opportunity for people in the suburbs to come into Hartford in a protected way for them and to feel comfortable about what they're doing, and I would really hope that more suburbanites would come and be part of this," says Val. "It's also great for people who live in the city because we have our own little neighborhoods and walls that are invisible, so this helps to break down those walls."

They partner to break down those walls with shovels, and rakes, and wheelbarrows, working side by side. Three generations of the Gilhooly family turned out to plant trees at the Generations Housing Complex.

"This gives me more pride in my neighborhood and where I live," says Bridget as she shovels a trench for a tree with her daughter and her mom.

"Everybody's sharing, helping each other—it's like a family," according to Jenny Colon, who lives at Generations.

Ron Pitz says it's a win-win for everyone.

"It's a wonderful thing to have people of a diverse background working together. Our inner city Hartford youth that we work with and people from the suburbs that work with those young adults—it's an amazing learning experience for them both."

The Knox Parks Foundation—beautifying the city and building relationships that are positively Connecticut. ✿

Go Fly a Kite

ConnectiKITERS Festival

Next time someone tells you to "go fly a kite" don't take offense. Take them up on the invitation.

Soaring, diving, gliding, floating on the breeze . . . for nearly as long as man has dreamed of flying, kites have carried those dreams aloft.

Some say kites were known in China as early as two hundred years before the birth of Christ. Marco Polo told tales of them. Benjamin Franklin used them to study weather. The Wright Brothers experimented with kites while working on their airplane. Kites are still used for scientific studies, but on a spring day at the beach, it's purely about pleasure.

I asked Jim Burnett, "What are you thinking about while the kite's in the sky?" "What a nice day it is, life is good, it's a lot of fun. And you can do it almost anywhere," he says without ever taking his eye off his kite.

Jim should know. He's proud to say he has flown a kite in every state in the union. "The name of our club is the ConnectiKITERS and our motto is 'just for the fun of it.' I just fly for the fun of it. I don't try to impress anyone."

The club's one hundred members build and fly kites of every description.

"I don't care what their abilities are, physical or mental, there's something here for everyone, whether you are a couch potato like me or an athlete," says

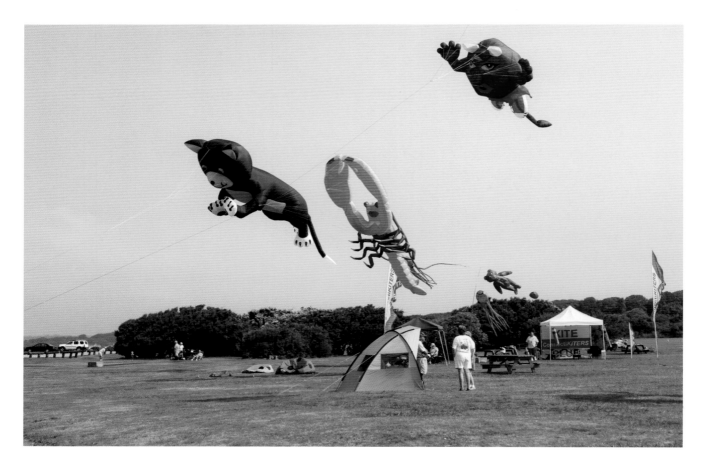

Gary Engvall. "There's something for every pocket-book; you could make a perfectly good kite out of a grocery bag, or you could spend thousands of dollars on a kite."

Gary is a professional kite flyer—teaching workshops, building and selling kites, and flying them with his wife, Maggie, at festivals all over the country.

Gary started out small. "I knew what everybody else knew. Kites are made out of plastic and you buy them in the drugstore in March and April because that's kite season, but now I know there's no such thing as kite season."

Thanks to materials such as rip-stop nylon and frames made from fiberglass or carbon fibers, kite flying is a year-round pastime.

Fledgling fliers can make kites from a small sheet of Tyvek, a skein of string, and two sticks, as the club members demonstrated.

Ready for something a little more exciting? Veterans like Larry Zaleski take workshops on line to learn how to make magical kites that look like a strand of DNA unfurling.

"I love it," he says. "You get to talk to or chat with people from all over the world who are making the same kite at the same time you are."

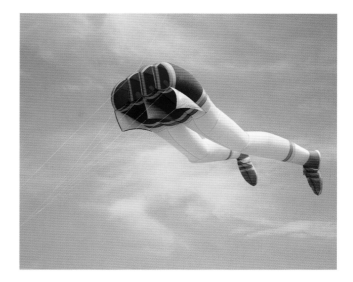

If you've ever had trouble getting your kite into the sky, you might wonder how Gary manages to get kites as long as three hundred feet airborne. He explains: "If you're running with your kite—*don't*. Chances are you aren't looking at the kite and it's probably bouncing on the ground breaking every bone in its body. If I do turn around and look at the kite, then I am not looking where I am going and I am going to run into you. If you watch people out here, they stand and hold the kite and they take it for a walk downwind, and then they release it."

Joe Perron is well known for flying three kites simultaneously in an aerial ballet.

"I will fly one kite controlled completely by my hips that will be the middle kite and that is the center of the universe. Everything revolves around it. It's like the sun; the others are like the planets."

Joe is one of the stars of the ConnectiKITERS festival held every May at Hammonasset Beach State Park in Madison. The weekend features an array of kites of every size and shape and attracts kite flyers from beginners to experts and hundreds of spectators.

Club member David Olsen thinks flying kites is the best way to appreciate nature. "It makes you look up, and all the good stuff is up, clouds, stars, and kites!"

So go fly a kite . . . it's positively Connecticut.

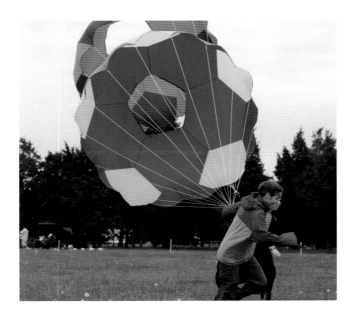

COWPIES TO COWPOTS

A Freund Farm Innovation
Connecticut farmers are turning a problem into profit.

THERE ARE MORE THAN 250 COWS ON THE FREUND Farm in East Canaan, and that means more manure than Matt Freund and other dairy farmers can possibly use to fertilize their fields.

Matt says it really is a problem. "Some guys are making compost; some are selling the manure to other farms that need the nutrients. In our case we're making Cowpots, which takes the manure and turns it into a biodegradable container that our city cousins find acceptable," he says with a laugh.

The Freunds extract the methane gas from the manure, which they burn, and use the remaining dry odorless fiber to create pots for plants that look like cardboard. Matt experimented by drying out the manure fibers in his wife's toaster oven, a process that didn't endear him to her, but got the idea off the ground.

Sal Gilbertie, one of the nation's largest wholesale herb growers, says these pots really do grow better plants, and there are other advantages.

"It does away with plastic; that's the biggest thing," Sal says. "It adds its own fertilization, too. When you plant the seedling, you bury the pot too. So it's all green. It's exactly what everybody has been looking for."

The pots can last months in the greenhouse but after four weeks in the ground, the pots decompose and continue to feed the plants. At Gilbertie's Herb Gardens in Easton, the "Connecticut made" Cowpots are planted with Hart Seeds from Wethersfield. Finding a way to deal with a manure overload, and creating a new product, is another way for local farmers to stay on their land.

"My grandfather started this company in 1922. The Harts started their seed company in the 1800s and Freunds have been around since the early '40s, so it's three old agricultural companies banding together to come out with this program," says Sal.

Still the creators of Cowpots need a sense of humor. Matt Freund has heard all the manure jokes.

"The original name was gonna be COWS pot, which stood for Connecticut Organic Waste Solutions, but someone might think that was cow spot. We enjoy that part of it. That's what makes it a fun product; because it is so whimsical you can't take it too seriously. On the other hand we want to take it seriously enough to build the sales up to where we can make it a viable business," he says.

Orders for Cowpots are coming in from as far away as Israel and South Africa. The Freunds are counting on new technology to make them the industry leader in turning cowpies into Cowpots that are positively Connecticut.

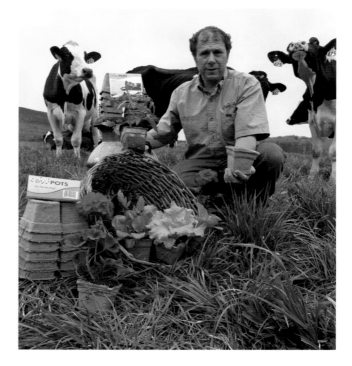

CONNECTICUT'S CAVALRY

First Company Governor's Horse Guards

When the word went out that the First Company Governor's Horse Guards were looking for a few good men and women, I decided to see if I had the right stuff.

CRISP COMMANDS AND THUNDERING HOOVES— the sounds of the First Company Governor's Horse Guards drilling at their base in Avon. They are Connecticut's own cavalry. Though they are mainly seen marching in parades and escorting the governor, this is a well-trained military platoon.

In the spring when the call went out for new recruits, I wondered what it would be like to join their ranks—so I dropped in on their class several times during their four months of training.

Donna Manning, a Berlin police officer, was one of the new recruits.

"You get to be part of history continuing. They practice drills that they've done in the cavalry for over one hundred years now," she says.

No riding or military experience is required, but these volunteers do need dedication and discipline. That comes naturally to Ryan Pelky, a former Marine.

Turns out Ryan has another advantage: "Being from northern Minnesota originally, I grew up on a farm and was around horses a lot. I like the military aspect of it too."

Recruits drill twice weekly and according to the officers, they need it.

"The first couple of weeks they are kind of rough around the edges and the other troopers like to size them up," admits Staff Sergeant Bree Berner.

On Sunday morning we recruits fall into formation at 08:30 for inspection wearing riding uniforms

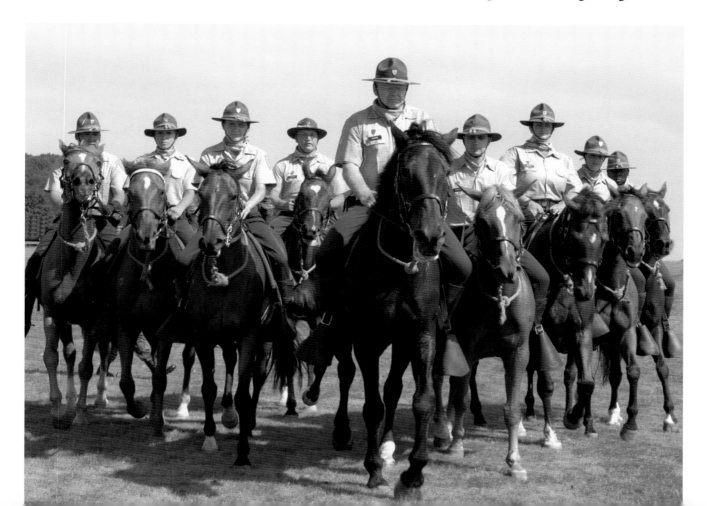

that include a hat known as a "campaign cover." Horses are assigned and we report to the tack room to collect bridle, halter, ditty bag, blanket and a U.S. Army cavalry saddle stamped 1917. My mount for the day, Fire, is a nearly black Standardbred, the horses you see in harness racing. Most of these donated horses had previous careers.

Staff Sergeant Berner explains: "Nobody else does things the way we do in the cavalry tradition. Everything is very team oriented and very squad oriented. You live under the chain of command."

Grooming and tacking up are all done in precise cavalry fashion, and then we head to the riding ring where the training session begins with basic maneuvers.

Bree shouts commands, "Circle right, and circle left, column right, column left."

I try to hold my position in the column first while walking, then trotting, then at a canter.

Bree continues, "Good, all together . . . excellent . . . this is what we're after . . . hooooooo."

On Thursday nights the recruits learn about caring for the company's twenty-eight horses. And yes, that includes getting your hands dirty, shoveling out stalls and spreading fresh bedding.

When the stable is tidy, the recruits report to class, preparing for written exams on everything from troop history to equine anatomy.

Learning to do things the military way to the minutest detail is part of a tradition more than two hundred years old. In 1788 veterans of the Revolutionary War organized the first company as an honor guard.

"After the Civil War they grew in numbers and became a pretty prominent part of the Hartford social scene," according to Sergeant Howard Miller, the troop historian. "They would hold field days where they would parade through the streets of Hartford."

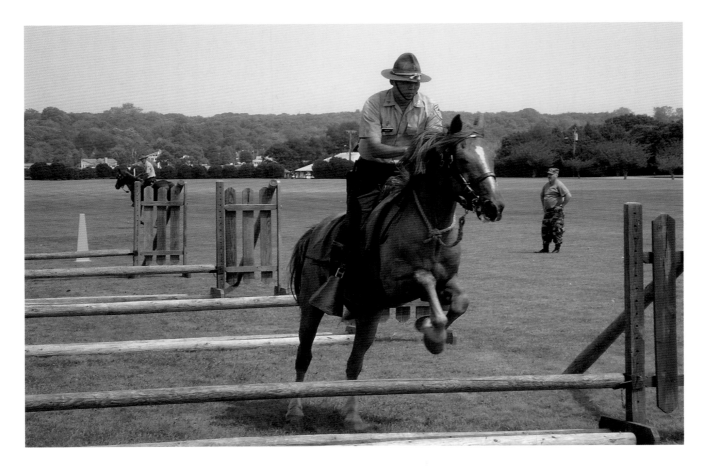

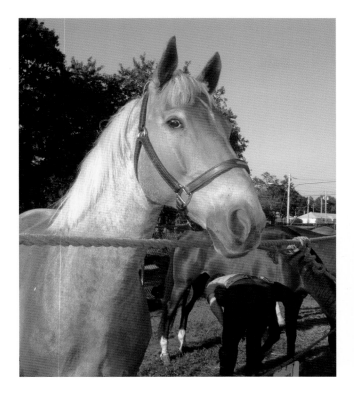

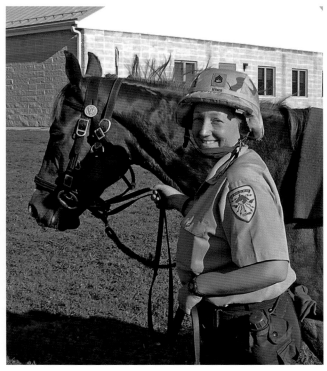

But it wasn't all pomp and ceremony. In 1911 the unit was sworn into federal service as Troop B Cavalry and that continued into World War I and World War II, both in battle and on the home front. Today these volunteers are part of the state militia, and they train through the year, ready to be called up by the governor to handle crowd control or search and rescue missions.

By midsummer the recruits are halfway through their training period and starting to feel as though it is paying off.

Donna tells me, "When you're on the horse, you have these small moments that feel right and they just take you somewhere else where you forget about everything."

Major Commandant Andrew Arsenault is in his thirtieth year with the company.

"I see people who have really made a transition into military life and their equestrian ability to control a large animal. Where they were very timid in the beginning and some of them were even afraid of these horses, they have learned a lot of skills. It's really amazing to watch them blossom," he says.

"You know when you nail something finally that you've been having a real hard time with, and when you do something together as a group or a squad or as a recruit class, it's 'ah what a rush!'" Donna says enthusiastically.

The final transformation happens at Camp Rell, the National Guard training camp in Niantic where the drills and work details give way to a little fun too, as the troopers and recruits take the horses swimming in the river.

After months of training and a week at Camp Rell, the recruits collect their spurs, becoming full-fledged troopers.

The First Company Governor's Horse Guards—a dedicated militia that is positively Connecticut. ❧

BY ANY OTHER NAME

Elizabeth Park Rose Garden

Geraldine Gunnels came to Elizabeth Park to get ideas for a climbing rose for her garden. Geraldine had a lot to look at. There are 15,000 bushes blooming in the two-acre rose garden, with more than eight hundred varieties of roses. Fences of climbing roses provide a fragrant backdrop to the shrub roses.

"IT'S JUST ABSOLUTELY ENCHANTING. IT MAKES ME wish that I had something like this at home," Geraldine says.

Three hundred thousand people a year visit Elizabeth Park, which straddles the Hartford/West Hartford city line. The rose garden has been here since 1904, and as the first American rose garden built with public funds, it is on the National Register of Historic Places.

The main garden shows off modern roses, while older varieties are planted in the Heritage Garden. Since 1937 Elizabeth Park has been a test garden for the American Rose Society, which tries out new varieties here, before they are sold to the public. But for a time in the 1970s the park was dropped from the list of test gardens, when city budget cuts meant less care for the roses and the weeds grew nearly as tall as the bushes. That's when local garden clubs pitched in,

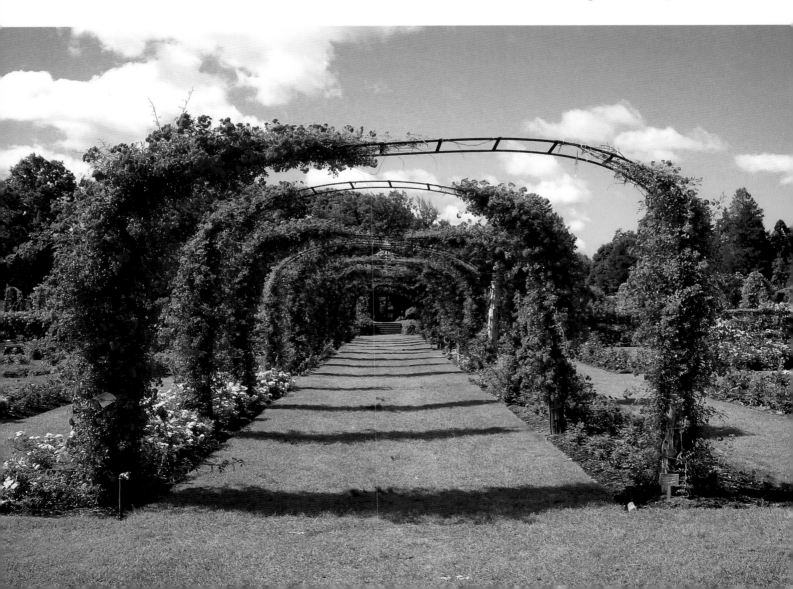

donating time, labor, and thousands of dollars to bring the park back to its prime. Friends of Elizabeth Park was formed, and Donna Fuss was named Rosarian for the park. She helped restore the gardens to their former splendor.

Although Donna visited the park regularly for more than fifty years, she told me once that each time she rounded the corner and caught sight of the rose-covered arches in bloom, "It's always very exciting. Even if you are not a rose person, it just takes your breath away."

When Donna Fuss passed away in 2008, her friend Marci Martin took over as Rosarian, continuing Donna's work. Marci is leading the renovation of the Heritage Garden and overseeing the gradual replacement of the seventy-four arches that are the garden's hallmark.

Marci is well qualified to supervise these gardens and conduct workshops here. She has been growing roses for more than thirty years and cultivates 150 varieties of roses in her own garden.

Wedding parties often gather for pictures beneath the arches when they are at their peak in late June, swarming with rambling roses like 'Excelsa' and 'White Dorothy'.

"I love the rose garden," says retired park foreman John Cosman, "and I attribute most of the way it looks to the tremendous dedication of the gardeners." A crew of professionals and volunteers tenderly care for their charges. Pruning correctly is important, John explained: "You cut back to your first five-leaf cluster and a new rose will develop right at that point."

John's favorite is a German variety that blooms in bouquets of crimson. Some visitors search for the fuchsia and white rose called 'Love' or the palest yellow petals tinged in pink of 'Peace', the lipstick red of 'Showbiz', the lemon yellow of 'Midas Touch', the palest mauve of 'Blueberry Hill', or the showy coral number called 'Cary Grant'.

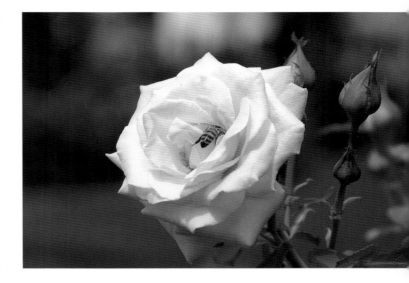

In 2004 to celebrate the one hundredth anniversary of the rose garden, John Mattia of Orange, a member of the Friends group, created a special rose to mark the occasion, the 'Elizabeth Park Centennial'. The hybrid tea is a delicate pale pink, with a raspberry-colored edge. John is one of the top three rose exhibitors in the United States and one of the founding members of the Connecticut Rose Society. Because it seems to bloom all season, the 'Elizabeth Park Centennial' is rapidly becoming a favorite among regular visitors to the garden.

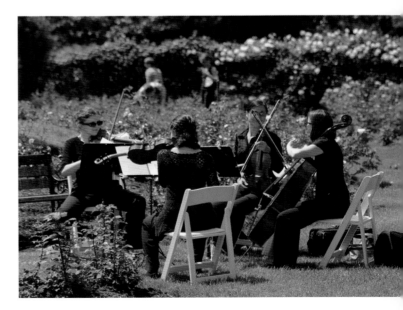

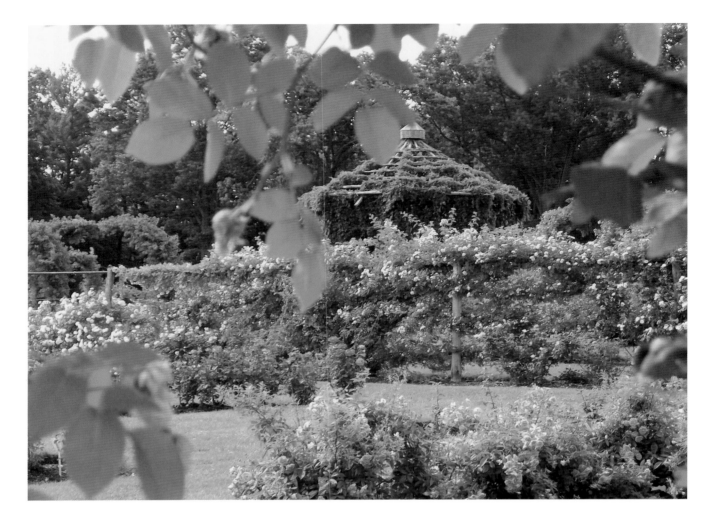

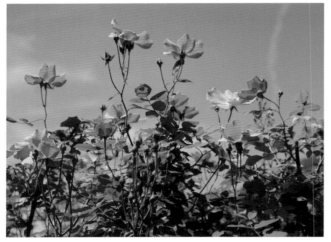

It is just one of many flowers that inspire watercolor artists who set up easels beside the row of flower-covered arches.

"I just love the roses and they're all here. There are so many clusters of roses and the colors are magnificent," says one woman while continuing to paint.

The Friends of Elizabeth Park organize activities throughout the season including flower shows, tours of the garden, and workshops for gardeners.

The Elizabeth Park Rose Garden—a stunning work of nature and, thanks to loving gardeners, a city treasure that is positively Connecticut. 🌿

Lourdes in Litchfield

When you think of a religious pilgrimage, you may think of Mecca or Jerusalem. But a shrine in Connecticut attracts the faithful too.

IN THE LITCHFIELD HILLS THERE IS A CHURCH WITHout walls and without a roof, unless you count the canopy of trees that overhangs the simple wooden benches at Lourdes in Litchfield. Some 30,000 people flock here each year to pray at a stone grotto reminiscent of the one in Lourdes, France, where the Virgin Mary is said to have appeared to a girl named Bernadette.

Father Eugene Lynch was a seminarian here before the Montfort Missionaries built the shrine. "This was just a little rock ledge where we students used to come with our books and sit on the rocks and study. There was a little stream babbling on the other side," he reminisces. "That's one of the memories I carried for forty years before I came back here as a priest to live at Montfort House."

The shrine was constructed in 1958 from stones gathered on the property.

"Two religious brothers from our community in Italy came here and operated a farm to feed the hungry seminarians," says Father Lynch. "In their spare time they built the shrine."

The woods are deep and green surrounding the shrine. Chipmunks often scamper across the grotto as the three resident priests celebrate mass or anoint the sick.

"They bring their cares and concerns," says Father Lynch. "They pray with Mary, and they ask the Lord to hear their prayers and help them in their difficulties as they carry their own personal crosses."

Colette Boyd lives nearby in Litchfield. "When you're here you feel like you're with God and you're in His creation. There is a beautiful service that goes on here in praise of our Creator. It's just a very awesome experience."

Some come for religious retreats or to wander through the 160 acres. Others walk the quarter mile that commemorates the Stations of the Cross—bronze figures are placed along the wooded trail, representing the last hours of the suffering and death of Christ.

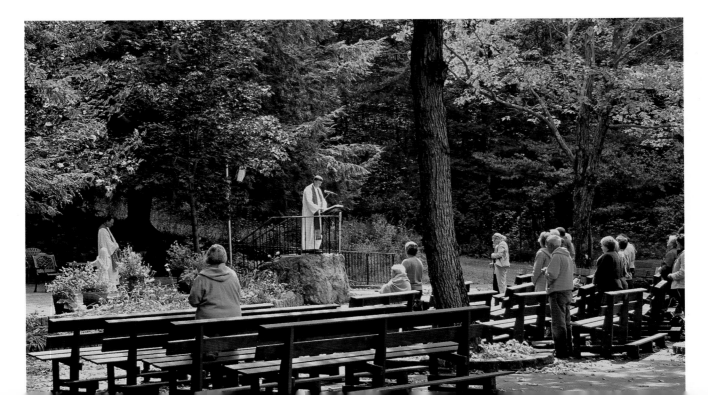

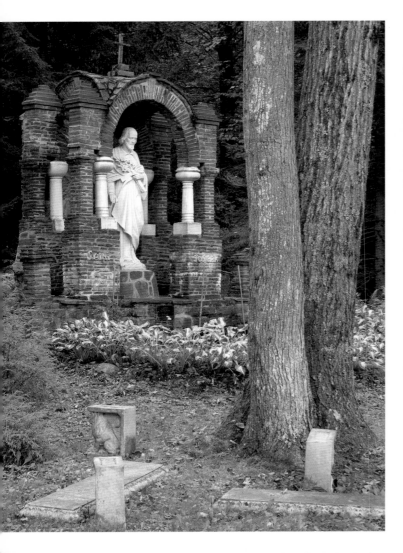

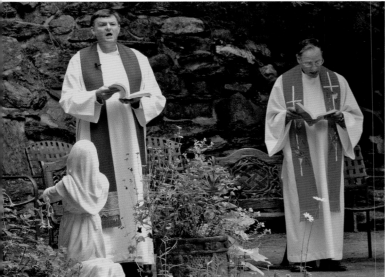

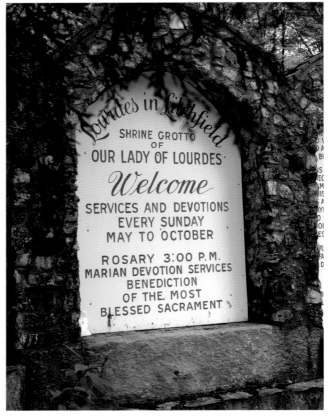

"One of the favorite songs sung here is 'This is Holy Ground.' All ground is holy, but there are places where God is more evident," says Father Lynch. "This is one of those places."

Ralph Rubino treasures his time here and drives up frequently from his home on the shoreline.

"When I am here, all the aesthetics of the world are right here," he says, taking in the scenery with a sweep of his arm. "And it hits me right here," he says, thumping his chest over his heart.

By 1998 the shrine was beginning to show its age due to wear and tear from the weather. Volunteers mounted a campaign to raise more than $100,000 for its restoration.

Donna Valente explains why. "This place has always been very special. There's a feeling of peace and almost overwhelming beauty here."

Lourdes in Litchfield—a place of peace that's positively Connecticut. ✑

GREEN THUMB GRADUATES

Master Gardeners

When Harry Reynolds putters around the conservatory at the Mark Twain House, it's hard to imagine him anywhere but here. After all, he is a bit of a Twain-o-phile, looks a tad like Samuel Clemens, and even played him in college.

HARRY REYNOLDS STILL DOES A FAIR MARK TWAIN impersonation. "We had something much stranger in our midst than a lawyer that kept his hands in his own pockets," he intones. "We had a lawyer that told the truth."

But Harry spent thirty-three years with Prudential before retiring and volunteering at the Twain House, where he pursues his passion—gardening. Under Harry's care the conservatory is being restored to the way it was in Twain's time.

"Over the years the Twain House has taken plants that people kind of didn't want—for instance, the Schefflera," he says. "I'm replacing those. Most of the species of ferns that you see now, the asparagus fern, the maidenhair fern, all were pretty much used by the Clemenses in here."

For Harry, job one was salvaging the wisteria that greeted the Clemens family when their carriage drove up to their front door. Harry had seen it in historic photos of the home, but when he went looking for it, all he found was a tangle of brown stick-like vines.

"I just thought wow, what a piece of history! The last wisteria that we think was original to when they lived here, you know, we just can't let that die. I was determined to save it and it worked. I thought I could do it. If a master gardener can't save this, then take me out and shoot me," he says, laughing heartily. By spring the wisteria was heavy again with purple flowers.

Harry is a master gardener, educated and certified through the UConn Cooperative Extension System. Thousands have been certified since the horticultural program's inception in 1978.

Invasive plants are just one topic Julie Lehmann is learning about during a fourteen-week course that spans a broad curriculum. She inherited her green thumb from Dad.

"We'd hear his stories about the bugs and the weeds and what grew and what didn't and we'd politely listen and say 'yes dad that's great,' and toward the end of his life we figured maybe we'd better start listening," says Julie.

Now, without her dad to turn to, Julie figured she'd have to become the family expert in gardening, and enrolled in the master gardener program.

A classmate, Sally Carbone, is a real estate agent.

"Homeowners don't know how to manage their turf and their shrubs and trees, and so the more I know the more that I can advise and look out for problems in advance," says Sally.

Besides their class work master gardener candidates are required to volunteer in a community gardening project. We caught up with Sally and Julie at the 4H educational center farm in Bloomfield where they and other master gardeners are hoping to raise three thousand pounds of produce for Foodshare, which supplies more than 350 food pantries for the needy in the Greater Hartford area.

"A lot of food banks don't bother with fresh fruits and vegetables, but we find this is something the people are really looking for," says Stephen Slipchinsky, who is Foodshare's fresh foods specialist.

The Foodshare plot is sprouting kale, collard, turnip and mustard greens, spinach, chard, bush beans, melons, herbs, and fresh peas and peppers.

Other master gardeners intern at the cooperative extension offices around the state, like the one at UConn's West Hartford campus. Home gardeners get the benefit of the master gardeners' training every time they pick up the phone.

"In the last year we have had six hundred to one thousand inquiries and that doesn't include soil tests. That's people inquiring about pests, diseases, proper location for certain plants, and garden ideas," says Sarah Bailey, who coordinates the services of master gardeners.

For the master gardeners, investigating the problem is part of the fun. That's why Harry is going on to a full-time job as a researcher with the cooperative extension. And he's typical of the recent graduating classes, according to the state coordinator Cindy Wyskiewicz.

"We're actually starting to see a different mix of students, people who either retired younger or are doing a career change. So they're anywhere from ages eighteen to our oldest one, who was about ninety!" she notes.

With their community projects, Cindy's master gardeners are planting seeds that will be nurtured and maintained by others.

"We're hoping the community can pick up these projects and make them their own," she says.

Visitors are already enjoying the restoration work Harry Reynolds has done to Mark Twain's house.

"This is my kingdom," Harry declares. "Especially in the winter, it's just a beautiful oasis, to listen to the waterfall and do some planting. It's just spectacular."

Spectacular once more, thanks to a master gardener who is positively Connecticut. ❧

MAGNIFICENT MAESTRO

Conductor Gustav Meier

Nearly forty years on the job—now that deserves a round of applause—and that's just what music lovers are giving a Connecticut maestro.

SINCE 1972 BRIDGEPORT'S KLEIN MEMORIAL AUDItorium has been a home away from home for conductor Gustav Meier.

"There was just a chemistry between the orchestra first, then the board and I think with the audience too, so I think it's always homecoming when I come here," says Gustav.

He was born in Switzerland, lives in Ann Arbor, Michigan, and teaches at Johns Hopkins in Baltimore, but Meier has been the maestro of the Greater Bridgeport Symphony for more than thirty-five years.

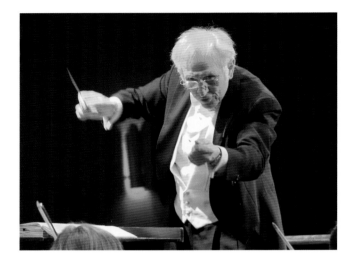

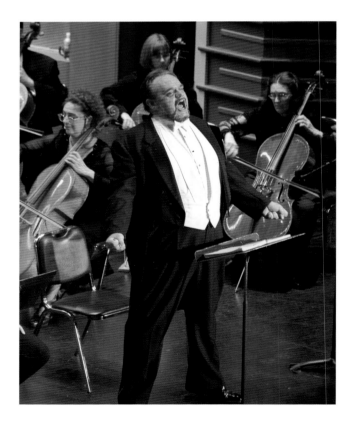

"There are a number of names that are associated with Bridgeport automatically; P. T. Barnum obviously is one of them," says Paul Timpanelli, president of the Regional Business Council. "To certain audiences Gustav Meier is probably the second one."

The lengthy partnership began when Meier was teaching at the Yale School of Music and has flourished through a career that has made him the world's most renowned teacher of conducting and a name known throughout the classical music scene. He is also the glue that holds together a core group of the symphony's musicians who hail from all over Connecticut, New York, and New Jersey.

"There is a large pool of musicians who like to play in Bridgeport because it feels like home. It's a great family to come back to," says the conductor.

Violinist Kate O'Brien played in country-western, rock, and swing bands before taking what she calls a "sit down" job with the symphony that has lasted nearly twenty years.

"This conductor has such a joyful enthusiasm and it permeates the entire orchestra," Kate says. "We all feel elated after the concerts."

Bob Tellalian is chairman of the symphony's board of directors.

"This orchestra loves this man and they play their hearts out for him. When Gustav came here he had to build up this organization and he did. He made it into a first rate orchestra," Bob says. Bob not only attends every performance, on concert night he greets every patron with a handshake, setting a tone for the evening.

Trumpet player James Ranti has played on Broadway and with Zubin Mehta in the Montreal Symphony, but he cherishes the camaraderie fostered by Gustav Meier in the Bridgeport Symphony.

"He doesn't put himself on a pedestal—I'm up here and you're down there, the peasants so to speak. He puts himself at the same level as the musicians," says James.

Kate O'Brien calls the conductor the rock of Gibraltar. "When things get hairy as they always do at some part of every concert, Gustav is there to bring us back in and to make it clear exactly what we need to do," she says. "We count on him and we've always been able to count on him."

Ever wondered exactly how a conductor communicates with his orchestra?

"As a conductor we can do all sorts of things. We can conduct with one arm. We can just conduct with the head. We can do it with the whole body or just the eyes. The physical aspect of how to communicate is really very, very important," says Gustav. "As a conductor you take it all in and go from one musician to the other. Hopefully you don't forget anyone and that's the beauty of it, you're sort of involved with everything."

"Everything" includes making decisions about what programs will bring in the audiences. While other symphonies are struggling, the Greater Bridgeport Symphony frequently sells out its concerts, held in the 1,500-seat Klein Auditorium. One of those was the concert version of the opera *Tosca*.

Gustav Meier knows why it packs the house. "It's one of the most gorgeous operas ever written, and

there's everything you can want in an opera from death to lust to love to horror—it's all in there."

The success of the performance is based on the maestro bringing the musicians and the singers together.

"The thing is for the musicians to feel 'yes, now I know how I fit in, I see what I have to do. Here I have to pull out, I can't always dominate.' It's a give and take in the music making," he says.

It's a give and take with the audience too.

"The most important thing for the audience is to feel there is something coming from the podium, an understanding of the music, a vision for what it's all about," Gustav says.

And it's clear the audience appreciates what Meier brings to the music.

"I'm involved in the music but you cannot take your eyes off Gustav. He's very interactive with the music. You'll see him up there moving and dancing along with the rhythms of the symphony," says Lisa Brown, who is attending the performance of *Tosca*. "He's very entertaining in his own right and I think that's why he's been there for over thirty years."

Gustav Meier, a man making music that is positively Connecticut.

LIVING IN A GLASS HOUSE

Philip Johnson's New Canaan Masterpiece

Philip Johnson was one of the most important figures in twentieth-century architecture. When his renowned home became a museum, tickets were an immediate sellout.

PHILIP JOHNSON CALLED HIS FORTY-SEVEN-ACRE estate in New Canaan his fifty-year diary. With his iconic Glass House as the centerpiece, he played out his thoughts about modernism and architecture on this canvas until his death in 2005.

As Johnson told CPTV in 1978, "I could do what I wanted and I didn't have any clients. It's very important to do away with clients."

In his will he left his country home to the National Historic Trust. Dorothy Dunn is the director of visitor experience at the house.

"It's been photographed many times and in every architecture or art history class there is a slide or two of the Glass House from the outside looking in, almost as if it's an object on display on a shelf," Dorothy explains. "It's only in visiting the property that you realize it's about Johnson's investigation of the relationship between architecture and landscape. It's not about outside looking in; it's about inside looking out at nature. As he said, 'I built a pavilion for viewing nature.'"

To understand how revolutionary the Glass House was, executive director Christy MacLear compares it with a popular film of the day that takes place in a similar Connecticut suburb.

"In 1949 *Mr. Blandings Builds His Dream House* is happening at the same time," says Christy. "So there's Cary Grant and Myrna Loy and they're building a shingled house with scalloped window treatments. Conversely you've got Philip Johnson who's designing a house which uses innovative materials and where you are practically living outdoors in this unique modern platform."

Johnson called the view his very "expensive wallpaper."

"When he bought the property in 1946, he began a fifty-year process of reduction, taking away some of the trees, taking away all the elements that weren't essential to his creative vision," Christy says.

Inside his house there was little to interfere with the view, its 1700 square feet of expanse uninterrupted by clutter. Each object is deliberately chosen and carefully placed . . . including the ashtray and malachite box on the coffee table. There are no interior walls and the bathroom inside a rounded column is the only area with privacy.

As Johnson joked when he lived here, "If people want to look from [the road] five hundred feet away, well, God bless them. They won't see much and I don't care anyhow."

Just across a grassy courtyard that Johnson referred to as his "center hall," he built the rectangular Brick House as a guest room and reading room. The circular pool balances the scene.

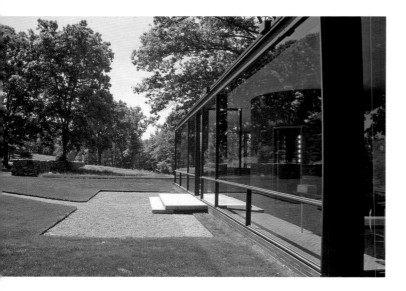

Tours are limited to ten people. Most expect to see just the Glass House—but there is much more, fourteen structures in all including Johnson's underground art gallery.

"The painting gallery hosted over two thousand works of art over fifty years that have subsequently been donated to MoMA [New York's Museum of Modern Art] and created the foundation of some of their most incredible works," says Dorothy as we walk into the gallery built into a hilly section of turf. There are still paintings here by Frank Stella, Andy Warhol, and others, hung on racks that allowed Johnson to easily display different works together.

The complement to the painting gallery, his glass-roofed sculpture gallery, which he called an "inside out building," is inspired by a Greek village, with stairways leading to courtyards and plazas, allowing visitors to walk around the sculpture and see it from above.

Johnson's vast art collection was curated by his life partner David Whitney.

"David had a keen eye. He was a central catalyst to emerging artists and great artists of the second half of the twentieth century," Dorothy asserts. Many of those artists spent time here in a vibrant social scene that art historian Vincent Scully called the "longest running salon in America."

Johnson worked as an architect up until his death at the age of ninety-eight, surrounded by books in his studio/library in the meadow.

Its one window looks out on the chain link Ghost House—inspired by architect Frank Gehry. Nearby stands Da Monsta, a black and red painted gatehouse constructed by spraying a cementlike substance over a previously shaped sculptural form. *New York Times* architecture critic Herbert Muschamp called it Johnson's "monster in the meadow." Johnson liked that, but adopted the hip-hop version of the moniker, calling it Da Monsta. Johnson envisioned Da Monsta as the entry point when the Glass House eventually opened to the public.

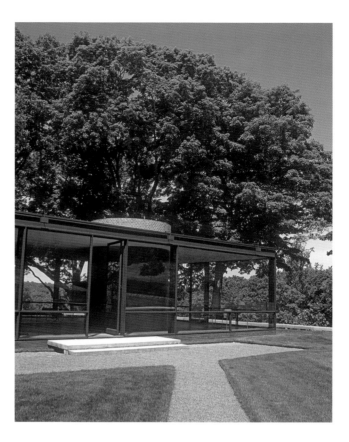

The notion of strangers visiting intrigued him.

"I'm very surprised as this house was hated when it was built," Johnson once said. "As a letter in a local paper said, 'when Mr. Johnson has to make a fool of himself why doesn't he do it in someone else's town?' because they were so outraged by it. Now it's on postcards as a traditional historic house!" he laughed in delight.

Visitors gather in downtown New Canaan to begin their ninety-minute tour, to see a place some have longed to see for fifty years.

Dorothy has observed some of those tours. "As soon as they enter that space tears well up in eyes, and people become very quiet. We share Johnson's belief in the power of architecture to wrap itself around you and bring you to a very personal and emotional response to the place."

The Philip Johnson Glass House is a storied place that is positively Connecticut. ❦

LIVING MODERN IN NEW CANAAN

WHEN WE HEAR THE WORDS HISTORIC PRESERVATION, most of us probably think of that rambling Victorian house with the sagging porch, in need of repair, or the newly restored colonial saltbox at the edge of the village green. But these days historic preservationists are focused on modernist houses, built in the middle of the twentieth century. Many are in danger of falling to the wrecking ball.

At the time, modernist architecture was being derided by some. But the architects who became known as the Harvard Five (Philip Johnson, Marcel Breuer, Eliot Noyes, Landis Gores, and John Johansen) flocked to New Canaan because of its proximity to New York, its cheap land, and its beautiful wooded landscapes. The town became a kind of laboratory for modernist architects.

Alie Pyne's parents wanted a Philip Johnson house.

"They interviewed Mr. Johnson and he was quite frank about what it would cost per square foot and they couldn't afford him," she says, "so they said 'what do we do now, Mr. Johnson' and he said 'you go to John Johansen. I work with him and he's a fine architect.'"

Johansen built them the Bridge House, named that because its four wings are connected by a barrel-roofed living room, acting as a bridge straddling the Rippowam River.

The Bridge House or Villa Ponte has been widely photographed for decades, and featured in everything from the New York Times to House and Garden magazine.

The designers of mid-century moderns (as they're called) became known for rejecting previous architectural conventions, and using new materials and new construction techniques to create open floor plans.

Heather McGrath is a historic preservationist who surveyed the homes known as "the New Canaan moderns."

"Here in New Canaan it was about reuse of traditional materials in a modern way. So you stripped away the ornament, you opened up the spaces, you connected the interior to the exterior," she explains.

The "hemicycle house" by John Howe is a good example. Howe was a protégé of Frank Lloyd Wright, whose influence is apparent in everything from the stained glass ceilings and built-in furniture, to the way the curved house hugs the landscape and invites the outside inside.

When Susan Belmont and her husband bought the house, they went to Howe's archives at the University of Minnesota to get his original renderings and drawings before they built an addition.

"The woman in charge was so thankful, she said 'oh my gosh somebody is going to keep and preserve this house,'" Susan says.

The original galley kitchen was too small for Susan, but she was so intent on keeping to the original design of the house she spent two years researching and planning before building a new one, even locating the same Delaware river stone used by the original architect.

Not everyone can lavish that care and attention to detail on renovating the mid-century moderns, which is

why some of them have been demolished. Their relatively modest size makes them a target.

"They were also built on large lots of land, so you had a lot of land and a tiny, difficult house," says Heather. "The threat is demolishing them and building houses that were double and triple their size."

The 1700-square-foot house Philip Johnson designed for Alice Ball is reminiscent of his own Glass House and was threatened with demolition so a new owner could take advantage of its two-acre plot of land. It took another architect to save and restore it.

"It's a house that's not about when it was built," says Christina Ross. "It's a house that's timeless and about how we are probably going to live in the future."

Rita Kirby is a real estate agent experienced at marketing and selling the mid-century moderns. Rita says there is a perception among some homebuyers that moderns are not warm and inviting for family life. Until—she says—they step inside.

"There is a relationship that you have with the outside, with the air, with the sun and that shouldn't be left at the door, that should be incorporated into the space."

Recently five national, state, and local organizations commissioned a study to identify and document nearly one hundred of the New Canaan moderns, concerned that these significant homes might disappear.

"It underscores that each one of these are specially built one of a kind examples and once they are gone there are no others to turn to," says architect Jared Edwards. He is a leading voice in the movement to preserve these and other modern structures in Connecticut, like the landmark Phoenix building in Hartford, and the Pirelli building in New Haven.

"If you take all those things away, how are you going to be able to understand that Connecticut's prominence rose in the Second World War? Its importance during the end of the twentieth century is recorded in its architecture. If we don't have the architecture, there's no way to tell the story."

As a result of the survey some of the New Canaan homes may join the Philip Johnson Glass House on the register of historic places.

"We tend to walk away or discard our grandfather's architecture," says Heather McGrath, "and then the next generation comes around and realizes it's something to be saved."

Modernist architecture is something worth saving, and that's *positively Connecticut*. 🌿

DOORKNOCKERS

Cindy Erickson's Connecticut Doors

Think about your front door. It's not just the entryway to your home; in a sense it is the entryway into your life. Or at least that's how one Connecticut woman sees it. Her dream is to photograph front doors in every town in the state.

EMMY LOU DEBARI'S GIFT SHOP IN GLASTONBURY has moved three times, but her bright yellow door has always been her trademark. It caught the attention of photographer Cindy Erickson.

"When I start photographing a town, I am looking for color and personality. That's what draws my eye to the door," explains Cindy.

Emmy Lou's door is one of twenty-five featured on Cindy's poster "The Doors of Glastonbury," and Emmy Lou can hardly keep them in stock.

"Everyone in Glastonbury wants to have one," she declares. "Many people send them to relatives or friends that used to live here, so it travels."

Cindy's photographs make people feel like part of a community even after they've moved away. Bringing a community together is the reason Cindy started photographing doors in the first place.

Mikayla Nuhn is a happy second grader today, but her mom, Michele, has filled a scrapbook with photos of earlier times, when Mikayla was diagnosed with a rare condition.

"When she was about a year old, she started getting sick a lot, all different symptoms—her neck hurt, her speech was impaired," Michele recalls, with a sigh.

Mikayla needed expensive brain surgery, and a spinal fusion, so her hometown of Killingworth pitched in to help one of its own with bake sales and other fund-raisers. Cindy created a poster, featuring some of her Killingworth neighbors' front doors, and helped raise $5,000. The posters were so popular, Cindy started producing ones of other towns too.

"I wake up and if I want to drive to Litchfield on a fall afternoon that's how I did that area, or if I felt like being near the ocean I went towards Stonington. It's just random," Cindy says about her choice of towns to photograph.

She has already produced posters of nearly fifty towns but plans to photograph all 169 in Connecticut.

"When I see a door I take the picture, then I leave a little article that was written on me and another piece of paper asking for permission," Cindy explains. "If they decline then that's fine, too."

But most people are flattered, like Sonya Gill of Chester, who hangs a giant ice cream cone on her door. Cindy says some towns have a definite flavor—Stonington is nautical, Guilford is historic.

Sometimes homeowners are so excited about being featured in Cindy's posters they order copies right on the spot. Cindy tries to deliver those personally. Occasionally that doesn't work out. "I drove back there a couple of weeks later, and I am driving around and around and I can't see the house. It turned out they had demolished it not long after I took the picture!" she laughs.

Sometime even when the houses are gone . . . the community lives on through Cindy Erickson's prints of doors that are positively Connecticut.

ART REFUGE

FOR CINDY ERICKSON'S LATEST PROJECT, A CHILDREN'S book about the green parrots of West Haven, she needed studio space, and some guidance in painting her illustrations. She found both in a breathtaking spot in Killingworth, a private nature preserve that's home to painter Joan Levy.

"It's a very rejuvenating place that has a wonderful energy, and no matter what the weather it is beautiful and peaceful here," says Joan.

Levy has lived and worked at Murray Pond for twenty-five years. When she bought the property, Joan says it was overgrown and looked like "a bomb had hit it."

So Joan got to work. "I basically took what was naturally here and cleaned up the debris and revealed the pure forms. It's like Michelangelo's sculpture of slaves emerging out of the stone."

Joan planted 750 trees that underscore the site's undulating topography. Their foliage casts shadows on the

carpet of green moss. With the heavy undergrowth gone, Joan now observes wildlife attracted to her pond including bobcats, bears, and deer. Joan's love of nature colors her paintings.

"I met Willem de Kooning when I was fifteen years old, and he took me under his wing and became a second father and reared me up as a painter. When you have a strong mentor like that, you really have to work hard to overcome that kind of influence to find your own voice," she says, "so coming to Killingworth allowed me to do that because I plugged into the landscape, physically working on the landscape, and then painting it."

Today Joan opens her home and her waterfront studio to other artists like Cindy who are looking for lessons, studio space, or a getaway.

"I decided a couple of years ago that I wanted to teach drawing and painting and color theory, and make the place available to other people who want to come and draw and paint here and take classes or just come on retreat and work on their own projects, or write or play music or compose music. It's a wonderful open space, both inside and outside, for that to happen."

You might call Joan a modern-day Florence Griswold, the woman who opened her home to the American impressionist painters in the early 1900s, in order to nurture their painting careers.

"What I teach here is about using direct observational drawing and painting as a starting point—and then following the path of discovery through the process of painting," Joan explains.

Joan Levy has cultivated a refuge for art in a corner of Killingworth. Serving artists like Cindy Erickson and many others, it's a welcome sanctuary that is positively Connecticut. ✑

RAILROAD REVIVAL

Restored Rail Lines, Historic Depots, and Steam Engines

Railroads helped make this state an industrial powerhouse, but then their glory faded. Now they're enjoying a revival thanks to the passion of local locomotive lovers.

REVIVING THE NAUGATUCK RAILROAD

Bob Miller loves trains—but he generally plays with the kind that fit on a tabletop. For one hour the model railroader had the chance to drive a real diesel electric engine, under the watchful eye of Howard Pincus, a volunteer with the Railroad Museum of New England.

The engine runs on a rail line that goes back to 1849 and used to run all the way from Bridgeport to Winsted. It was once the right of way of the Naugatuck Railroad Company.

As Bob climbs down from the cab, he is smiling ear to ear. "That was great! Thank you very much, Howard."

"A lot of people say it's a dream come true, that they've wanted to do it ever since they were a kid waving at locomotive engineers going by on a train," says Howard.

I was one of those kids and couldn't resist slipping into the driver's seat.

As I take the throttle in hand Howard explains, "The engine weighs 125 tons so it takes a certain amount of power to get it started, but once it starts it rolls very easily."

The engine known as "529" nearly ended up on the scrap heap—but now she's the pride of the Railroad Museum of New England, part of a collection of about eighty pieces of rolling stock.

"When we got this locomotive it was a used up old mess. There were holes punched in the Masonite in the cab. These windows had been plated over years ago. It had about fourteen different colors of paint, all peeling off," he remembers.

The 529 is an old workhorse that pulled freight and passenger trains on the Naugatuck railroad line, at one time a vital part of the valley's economy.

"The railroad was necessary to bring all the raw materials in; to take the finished products out; it even brought new immigrants into part of Connecticut where they were going to live."

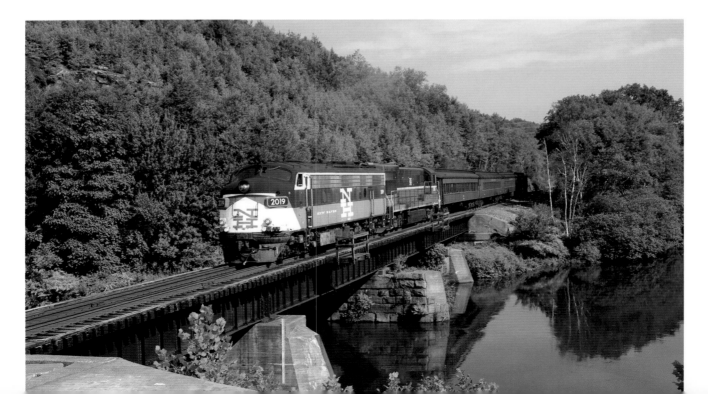

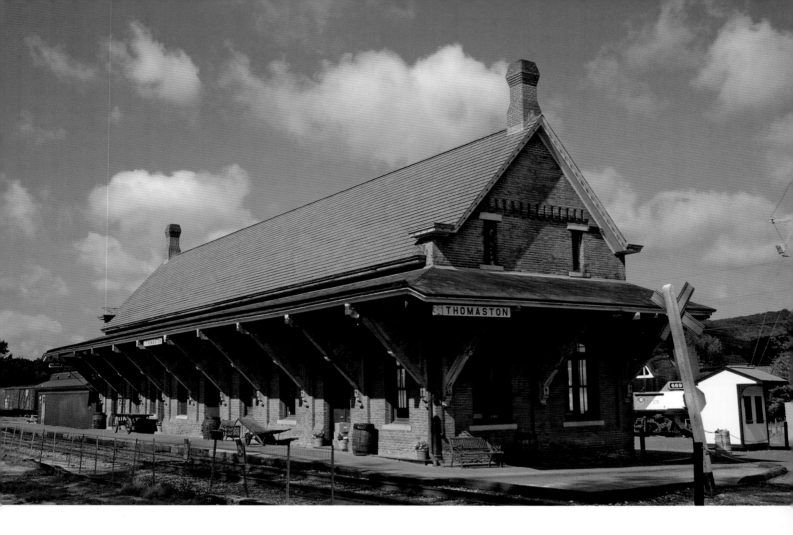

But over the years, this rail service was phased out—until hobbyists and history lovers formed the Railroad Museum of New England and brought the Naugatuck Railroad back to life for the fun of it— repairing tracks, and restoring old trains. They're working on restoring the old Thomaston railroad station that dates back to 1881. When they're finished, it will be more than their home base—it will be a cherished reminder.

"Our culture is a shared past, and these are parts of our past, and so they're parts of who we are," says the museum's president Ralph Harris. "I personally don't think we can maintain our present identity without these mileposts of where we've come from."

The museum runs a variety of scenic train rides through the year, in addition to giving would-be engineers a shot at taking the throttle. The trains run from Thomaston to the Waterville section of Waterbury.

DANBURY RAILWAY MUSEUM

In Danbury there's a train station that was a bustling place when it was built in 1903. If it looks familiar, it may be because it was featured in the Alfred Hitchcock movie *Strangers on a Train*. Today it's the Danbury Railway Museum. Its president Ira Pollack says at one time this was a busy transportation hub.

"They would have been servicing locomotives here. There were as many as 150 employees at some point," he says.

These days all the workers are volunteers, lovingly restoring relics of the great northeastern train lines.

"There's that old saying about the only difference between men and boys is the size of their toys . . . that's very true," Ira says.

This museum showcases everything from model trains up to the real thing. Train rides in the yard are available on weekends April through November.

ESSEX STEAM TRAIN AND RIVERBOAT

Rolling alongside the Connecticut River onboard the Essex Steam Train, you get a feeling for what it was like in the days when railroad travel was leisurely and elegant.

As scenic Deep River passes by the window, an evening repast is served aboard Connecticut's only dinner train. Built for the U.S. Army, this kitchen car once served hot meals to soldiers. Now the chef dishes up baked salmon, stuffed chicken, and prime rib to passengers enjoying a convivial Friday night excursion.

Jane Earnest is enjoying the view. "I like the fact that at every stop you make everybody waves, everyone says hello."

"We strive for atmosphere as well as fun," says general manager Staci Roy. "It can be intimate in the back of the car, or in the middle you can meet some new people or just dine alone and not be bothered."

The dining cars, known as the Wallingford and the Meriden, date back to the 1920s. They've been authentically restored and are elegantly turned out, with velvet draperies and period lighting. Dining at a table set with china and linens is a far cry from what most travelers have grown accustomed to.

"It certainly beats airline food. This is like the Orient Express of Connecticut. Everyone should try it," says passenger Roger Hancock.

For a really special occasion, the dining cars are available for private charters, and a child's birthday party can take place in a caboose. If you want to learn to drive a steam engine, the Essex Steam Train can make that dream come true too. Or combine your train trip with a riverboat cruise on the Connecticut River.

Across the state, it's "all aboard" for a railroad revival that's positively Connecticut.

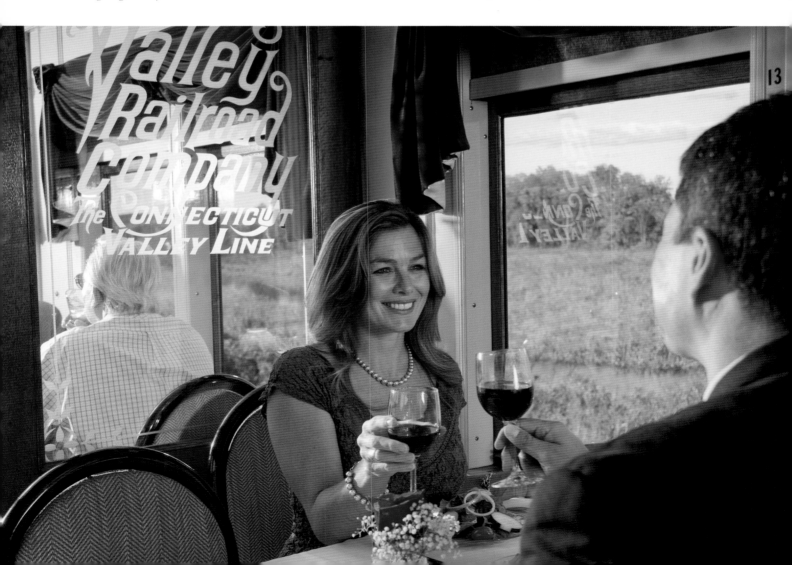

Livingston Ripley Waterfowl Conservancy

Ducks wearing tiny GPS units? That's what I found in Litchfield, along with many other kinds of ducks and waterfowl most of us have never seen.

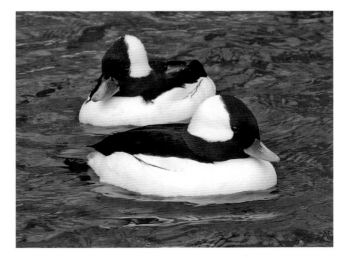

YOU'VE HEARD THE SAYING, WHEN YOU SEE A BIRD that walks like a duck and swims like a duck and quacks like duck, it probably is a duck. But what kind? At the Livingston Ripley Waterfowl Conservancy in Litchfield there are dabbling ducks, diving ducks, perching ducks, sea ducks, and even ducks outfitted with GPS units.

Susan Sheaffer, the director of the conservancy, demonstrates the GPS unit on a female mallard. "It's mounted between the wings with a very soft Teflon ribbon harness. You can see the solar panel here on the back. That is what charges the battery that sends the signal to the satellite."

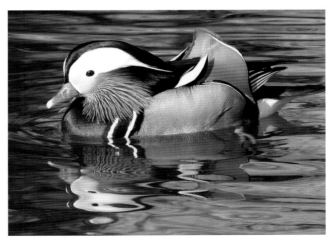

The satellite then sends that data to Susan, who can pinpoint the mallard's location, within fifteen meters, anywhere in the world. That information will become part of a continental study aimed at better habitat management. Dillon Ripley, the founder of this place, would have liked that. The former head of the Smithsonian spent summers here with his wife, Mary Livingston.

Susan notes, "He's very well known as the first person to successfully breed in captivity a whole list of threatened and endangered species."

That was Ripley's hobby and his passion, according to Susan. "He really saw the value in the fact that by keeping some of these birds in captivity they could be used as a tool to educate the public about how important these birds are and why we need to conserve their habitat."

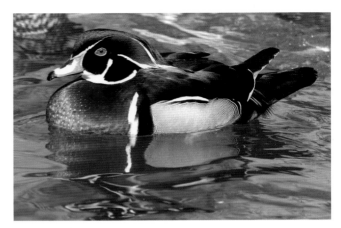

Ian Gereg cares for the 350 birds that live on these sixteen acres. "The only continent we don't have birds from is Antarctica because there aren't any birds there."

There are more than sixty-five species. Many of them are rare, and some like the emperor goose and the falcated duck are endangered. Ian runs the breeding program, which provides birds to other educational facilities and zoos.

I asked him, "Without being indelicate, can you explain what bird family planning is all about?" "Well we eat a lot of egg sandwiches," he says. "So there are some eggs that we don't allow to hatch. One of the beauties of birds is that it's very simple to keep your populations in check. One of the things that we do with these surplus eggs is feed them to the young ducklings."

"Isn't that a little like eating your own young?" I asked him. "I hear that a lot and I don't know, they seem to like it," Ian says.

Ian has been raising waterfowl since he was a child. "My father was a fanatic for exhibition poultry. I went to many different shows as a kid and started to see waterfowl and ducks and geese and said 'forget the chickens—I want waterfowl' and it's just gone crazy from there."

Ian says the biggest challenge is trying replicate habitat from all over the world, in the countryside of Connecticut. The smallest birds are housed in aviaries with overhead netting to protect them from predators like owls, hawks, and even eagles. An eight-foot fence,

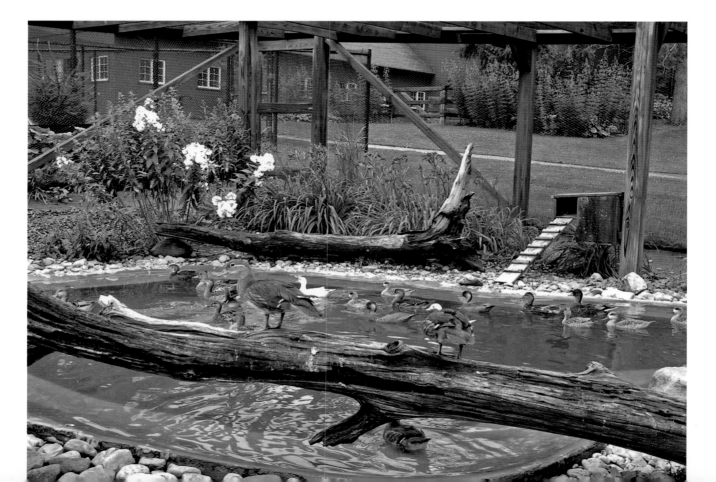

dug two feet into the ground, that's electrified at night, keeps out other predators like coyotes and raccoons. One of Ian's jobs is to keep the peace among these species from all over the globe.

"That's not always easy," he notes. "It depends on the time of the year and there's a very delicate balance of who will go with who. There are some species that are notorious for hybridization—they'll jump anything in feathers so we avoid that at all costs."

Swans like the Asian Whoopers are highly territorial and not too happy when we approach in a canoe.

They begin an elaborate display raising and flapping their broad wings aimed at scaring us off.

Other birds use their voices, including the odd-looking ones called "screamers," who have definitely earned their name. They're the evolutionary link between waterfowl and gallinaceous birds like turkeys.

Some of the waterfowl like Woody, a wood duck native to the area, go out to classrooms to help educate kids. And sometimes the kids come to them, like art students from Wamogo High School, armed with sketch pads, pencils, and watercolor paints.

Their art teacher Wendy Costa calls the conservancy "inspiring." She adds, "Many of these birds you don't see taking a walk down the road, so it really provides a creative spark for us."

If you'd like to enjoy these plumed beauties, there are guided tours on Sunday from May through October. The Livingston Ripley Waterfowl Conservancy, one man's legacy that is positively Connecticut. 🌿

RAILROAD GARDENING

Connecticut G Scalers Club

If you think of model trains running around the base of the Christmas tree, or in your uncle's den, you haven't met the Connecticut G Scalers. Their trains run through some of the most interesting bits of the state's landscape.

IN THE LATE 1800s, OUTSIDE DENVER, COLORADO, the towns of Silverton and Durango are thriving, now that the railroad connects them. The era of wood-burning locomotives is ending, and coal-fired steam engines are coming in.

Although in real life nearly fifty miles separated the towns, they exist on a quarter acre of Charlie Hall's backyard in Salem.

"Silverton to Durango was forty-five miles of some of the most beautiful terrain that a railroad could go through. It actually runs alongside of a mountain with a real heavy dropoff, so that's what I have here," says Charlie.

Maybe it was his career spent underwater as a submariner that gave Charlie a yen to move heaven and earth . . . at least on his own plot of it.

"This was all woods," he says, pointing to his grassy lawn with a railroad running through it. "I pictured it as if it was done and the trains were ready to run. I knew where the freight yard was going to be, I knew how many sidings there were going to be, I knew where the bridge was going to be and it just has all come together."

Since he had never drawn a plan of the layout he envisioned so clearly, his wife, Jean, was a little surprised when she came home one day and found that Charlie had removed thirty-six trees to make room for the railroad.

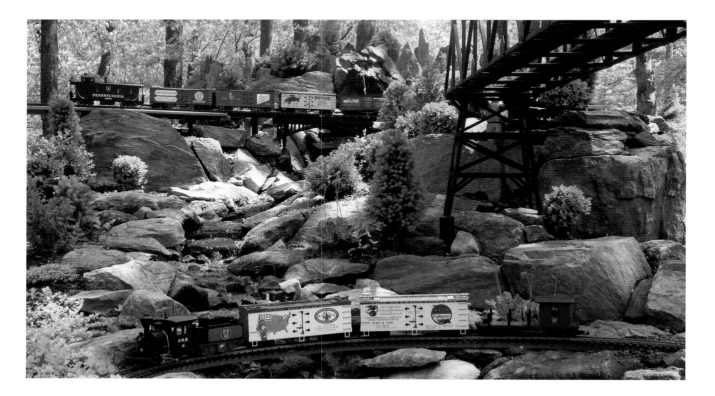

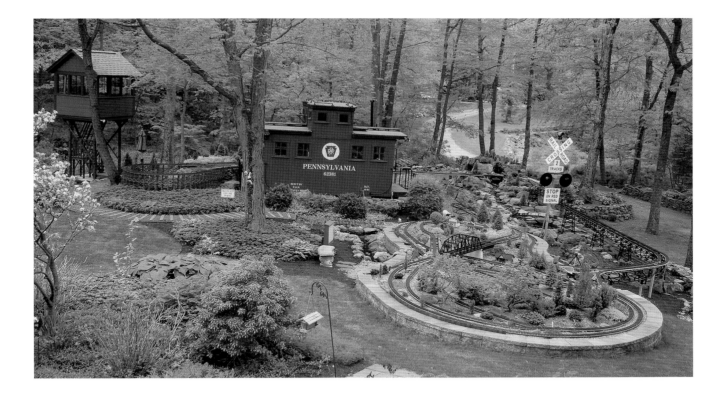

Charlie is one of several dozen railroad gardeners in Connecticut, whose layouts wind their way through their landscapes, in part because the Halls' spare room couldn't hold all that Charlie could imagine.

"When I first started out I was a model railroader, but I got more enjoyment out of the planning and the gardening and the actual landscaping than I have with actually playing with the trains," he muses.

In this mini-town there's not only a rail yard and prosperous general store, but vignettes of life in town in the 1890s: a young couple getting married at the little white church, and desperadoes trying to rob the stagecoach, thwarted by the arrival of the cavalry.

Besides the bank and the windmill, there's a saloon populated by the women Charlie's dubbed "the floozies." Honky-tonk music blares from its little windows.

Outside of town is an Indian encampment complete with animals and Indian braves. Not far from the encampment prospectors are mining gold. As a visitor passes each portion of the layout, appropriate sound effects accompany the scene, ranging from the drumming at the Indian campsite, to the shootout outside the bank.

But Charlie's not through. In the next phase of development he hopes to upgrade his technology so he can run as many as a dozen trains at a time.

His wife, Jean, seems resigned to losing more of her yard to the railroad. "I guess he was deprived as a child," she laughs.

Stepping beneath a picturesque trellis, Bill Dressler enters one of the most elaborate and inviting gardens in Fairfield County in his own backyard.

"I have a fatal attraction for pretty flowers, and I see them at the nursery and bring home flats and flats of flowers and then look for places to plant them," he says with a broad smile.

At his Shelton home, Bill planted a woodland garden and a formal garden with a fountain and gazebo.

"As I was reading through garden magazines, I happened to come upon garden railroading and I hadn't appreciated that trains were available to run outdoors, so I immediately latched on that," he says.

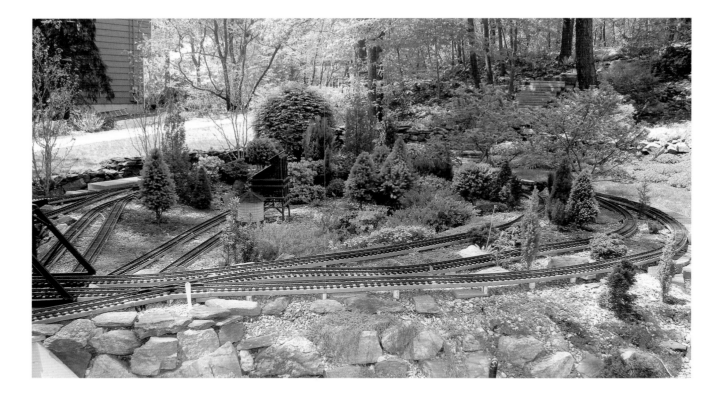

The retired biologist spends at least a couple of hours a day gardening and sometimes the rest of the day working on his train layout. And what a workshop he built, modeled after an old wooden caboose. The model trains pass right through the workshop. A complex control system inside allows Bill to operate up to eight trains at a time and generally keep them from colliding. The charm of the railroad garden attracts everyone from the FedEx deliveryman to the neighbors.

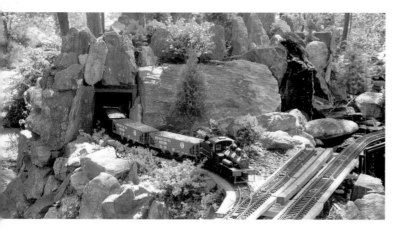

Bill's neighbor Diane Dobosz says the kids in the neighborhood are always welcome to drop by, and sometimes they bring their parents along. "I think everybody is a kid at heart when it comes to trains. It's nice to see he keeps working on it and it's getting bigger and better."

Unlike Charlie Hall, who envisioned his entire layout in his head well before he put it in, Bill's yard is a work in progress, with rolling stock from different eras of railroading and new plantings going in all the time, including a wide variety of dwarf trees.

"Whether the person is into plants, if someone is into storytelling in detail, if someone is interested in the electronic aspect of it, or building trains from models, railroading has been called the world's greatest hobby because it has different facets that attract people depending on their interests and skill levels," Bill says.

Bill has met a lot of them at the Connecticut G Scalers meetings. He calls railroad gardening a "pastime with personality" that is positively Connecticut. 🌿

Summer

TWO IF BY SEA

The *Mystic Whaler*

Love to get out on Long Island Sound but don't have a boat? Slather on some sunscreen and hop aboard.

FOG ROLLING IN CREATES AN AIR OF ADVENTURE as passengers settle in for a cruise aboard the *Mystic Whaler* in New London. While some relax on deck, others join the crew in setting the sails.

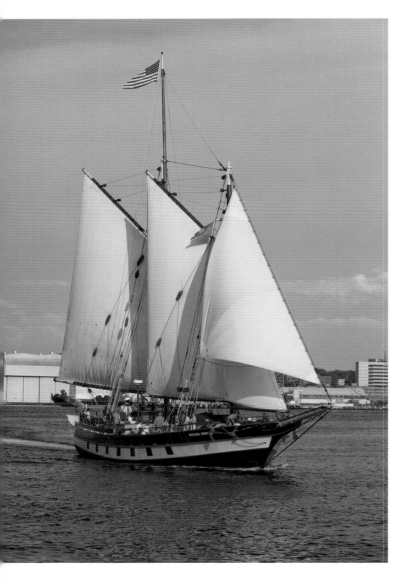

As the tall ship heads into Long Island Sound, Geoff Kaufman sings a sea chantey. "It's a rhythmic song developed by sailors to help them get the job done, like hoisting the sails."

A nuclear-powered Seawolf-class submarine surfaces in the mist, passing the 110-foot gaff-rigged schooner. The contrast is striking between the present and the past, even to Captain John Eginton, who has been plying these waters on ships like the *Whaler* for thirty years.

"The *Mystic Whaler* is modeled after the late-nineteenth-century cargo boats. They were basically the tractor-trailers of commerce in New England. Before we had good roads, most goods were carried by the coastal schooners," the captain tells his passengers.

The *Mystic Whaler* is reminiscent of the fleet that serviced this coastline up until the Great Depression, but this replica is built for comfort, from the overnight cabins below to the charcoal grill on deck. Lunch is served as the fog lifts and Fisher's Island and New London Ledge lighthouse take shape.

Tricia Rowland lives nearby in Noank. "I never see this area from the water because I don't have a boat, but it's like it's another place. It's a totally different experience than driving around or walking around."

The *Whaler* offers day sails and dinner cruises. Longer sails of three or five days make port calls at Block Island, Long Island, and Newport. The captain's course depends on which way the wind blows.

"From the time you step on board there are no decisions to be made except whether or not you want seconds on the clam chowder," says John. He adds: "There is something therapeutic with the motion of the boat gently rocking on the water and the sounds of the vessel under sail with no engine running, so people come back to shore refreshed."

For a more scientific look at Long Island Sound, chart your course for Norwalk's Maritime Aquarium. The Research Vessel *Oceanic* cruises out of Norwalk Harbor more than three hundred times a year in every season. There are trips for families and for school kids.

"The floating classroom of the *Oceanic* is just such a wonderful way to capitalize on the kids' curiosity about our natural environment," says Cathy Hagadorn, the boat manager. "They're the future decision makers and this is gonna be their backyard, so it's really rewarding to teach them and to inspire them to get involved."

On this "critter cruise" Cathy is teaching fourth graders from Norwalk's Jefferson Science Magnet School about life in Long Island Sound. The kids toss a net overboard and bring up some plankton. Then they take a closer look by observing their catch under a special microscope on board.

The fourth graders are part of a collaboration between the Maritime Aquarium and their elementary school. There are programs for students at all grade levels. On weekends the public is welcome to climb aboard for marine life study cruises in the spring, summer, and early fall.

"We essentially do the same kind of samplings, but it's a bit more informal. It's kind of like going on a whale watch," she says.

The students love studying aboard this forty-foot modified fishing trawler. After trolling the bottom of Long Island Sound, their dredging has paid off.

They've netted a sea star, a lobster, a crab, and three different varieties of flounder.

"I like that we got to touch some of the animals, and I really like touching the flounder because it was slimy," says Aleksandra Madejeck. As ten-year-old Elizabeth Guillen strokes the flounder, she lets out a small shriek and observes, "That was awesome" before releasing the fish into the water.

All observations made on study cruises are recorded and included in an ongoing research project. Twenty million people live within an hour's drive of Long Island Sound, and the cruises aim to educate passengers about the importance of this natural resource and people's impact on it.

"We like to have people come out here and have a good time but also come away with the feeling that maybe we can make a difference to take care of the environment a little more," says Cathy.

As the RV *Oceanic* pulls into its docks, Cathy reminds the kids onboard: "Not everyone eats seafood, not everyone has a boat or likes to go swimming, but what we learned on the boat today is that we all need Long Island Sound. We're all connected to it in one way or another, right?"

"Right," the students shout back.

Whether stroking a slimy flounder or sipping a cup of chowder, aboard the *Mystic Whaler* or the RV *Oceanic*, you're connecting with the coast, in a way that's positively Connecticut. ❧

SEAS THE DAY

Sail Connecticut Access Program

"Twenty years from now you will be more disappointed by the things that you didn't do than by the ones you did do. So throw off the bowlines. Sail away from the safe harbor. Catch the trade winds in your sails. Explore. Dream. Discover." So wrote Mark Twain, and hundreds of people with disabilities have taken his advice.

"Let's go sailing!" whoops Donna DeMarest, as she casts off from the dock and heads into Long Island Sound.

There was a time Donna DeMarest thought she'd never say that again. At seventeen Donna fell in love

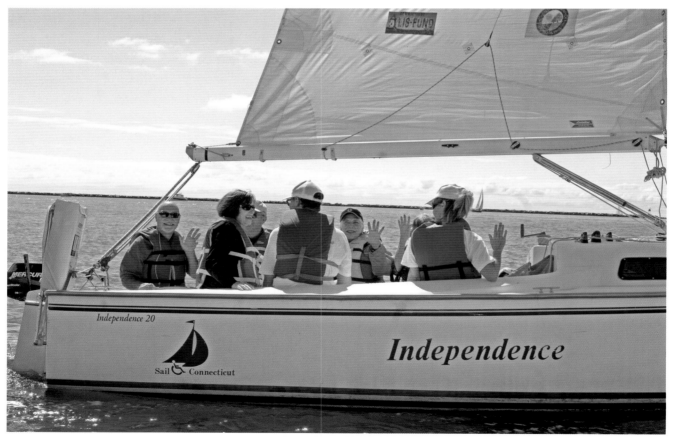

with sailing, but at nineteen a car crash left her a paraplegic, and she thought that part of her life was over.

"The boat I had was a Sunfish, which of course you have to be very agile to use," she recalls, "so I ended up having to sell the boat because it was just sitting in my yard getting no use at all."

Then Donna heard about Sail Connecticut Access. "It kind of opened up my sailing doors again and you know actually broadened them, because I resumed sailing and started racing and competing."

Based at Brewer Pilots Point Marina in Westbrook, Sail Connecticut Access has all the adaptive equipment to get a person with disabilities out on the water, beginning with a pulley system so wheelchairs can negotiate steep boat ramps, and a Hoyer lift to get people into the cockpit.

"You get an incredible sense of freedom and independence," says Richard Fucci, a founder of Sail Connecticut Access. "Anyone who goes out on a sail on a beautiful day really enjoys the experience."

For Dick life is about experiencing freedom and breaking the bonds that tie us to Earth. Years ago he was piloting a small plane when its engine quit, and the plane went down. The accident left him seriously injured, but he rediscovered the feeling of soaring again when he took up sailing.

"When you leave the wheelchair behind on the dock and you get aboard our adaptive boats, these Independence 20s, you can sail the boat competently because of the way the boat is rigged and specially adapted. You're a sailor like any other sailor," he says with some satisfaction.

The sailboats are designed with extra heavy keels and will right themselves in the unlikely event they turn over. The cockpits are self-draining so they can flood and the boat will still float. The skipper and crew sit in specially designed swivel seats that can pivot to either side of the boat. Sails can be raised and lowered with a minimum of effort, and their lines lead all the way into the cockpit, so the skipper can

single-handedly control the sailboat without ever having to scramble onto the deck.

"When you start out there are certainly qualified people who are taking you out, and they understand the trepidation of the novices," says Donna. "It's a good sport to start in because you can participate at whatever level you are comfortable with."

Sail Connecticut Access invites people with all kinds of disabilities to sail, whether they ride the wind as a passenger or become a captain. Elizabeth Ethier

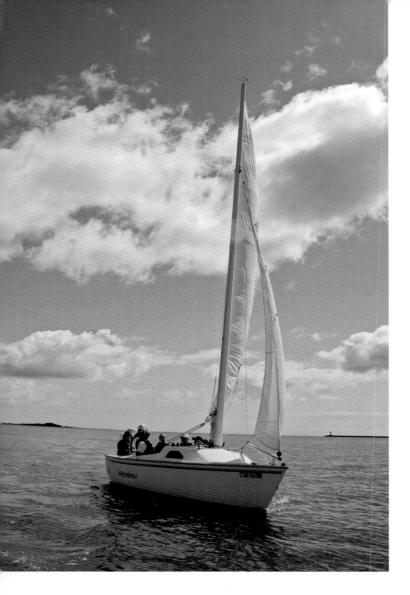

Liz works full time and loves to sail, fish, and even skydive. As a volunteer counselor to patients who have recently suffered spinal cord injuries, she brings a message from the heart. "That life is worth living, that they shouldn't let any barriers keep them from aspiring to do what they'd love to do. There are lots of challenges but nothing that can't be overcome," she says, "and I'm proof."

Since Sail Connecticut Access started more than a decade ago, Dick has seen people embrace sailing as more than a sport or a hobby.

"When a young person sustains a spinal cord injury, they feel that they've lost so much. All they see is what they've lost," he says. "But when they've had the opportunity to go sailing, when they've mastered that art, they have a lot of confidence that might enable them to go back and finish their education, to seek employment, and to live independently."

With a membership of about three hundred, Sail Connecticut Access is always looking for new sponsors, would-be sailors, skippers, and volunteers.

Donna puts in a pitch. "Yes, it's a program for people with disabilities, but there's a lot of physical work that it takes and without our very committed group of individuals and their able bodies, we would not be able to have the program."

Sail Connecticut Access . . . a program that dissolves barriers and offers an experience that is positively Connecticut. 🍃

is training for her first races. She was injured in a car accident in 1984 and says, "I'm a quadriplegic, meaning I'm paralyzed from mid-chest on down; my upper extremities were affected to some degree."

KEEPERS OF THE FLAME

Connecticut's Lighthouses

Among the most popular travel destinations in the state are the many lighthouses that mark our shoreline. Although more sophisticated navigational aids have decreased the need for these structures, the passion for them continues. For some people a peek or a quick visit isn't enough; they want to be part of preserving the maritime past.

CAPTAIN JOHN WADSWORTH GREW UP ON LONG Island Sound, taking over his father's sport fishing business in Waterford. His boat the *Sunbeam Express* once carried roughnecks to and from oil rigs. These days the destinations are often the dozen lighthouses at the eastern end of the sound.

"There are people that keep a logbook and they log every lighthouse they've seen and take pictures of them. They get together and swap stories. It's quite a little lighthouse society," says the captain of his passengers.

Local historian Ben Rathbun is often onboard as tour guide. At New London Harbor he points out Pequot, the oldest lighthouse, built in 1760.

"The first lighthouse was built by the proceeds of the lottery that they'd held. Apparently they gave the contract to the lowest bidder, because shortly after they built it, a huge crack developed," Ben says.

Farther out, and not usually included in the tour, is Lattimer's Reef lighthouse, a cast iron column seated on a stony base. "The first lighthouse keeper spent twenty-four years in that little bit of a twenty-four-foot-diameter lighthouse," Ben says. "It was a job no one would take today. But in those days people went away on three-year whaling voyages too. It was a different way of thinking."

The owner of the lighthouse on North Dumpling Island certainly isn't living a deprived life. The decommissioned lighthouse is now part of an island estate complete with a windmill.

"As I understand it he was told to take the windmill down because he didn't have a permit," Captain John tells passengers. "He said 'I'm Lord Dumpling, this is my island and my domain and if you want it, you come and take it,' and it's still there."

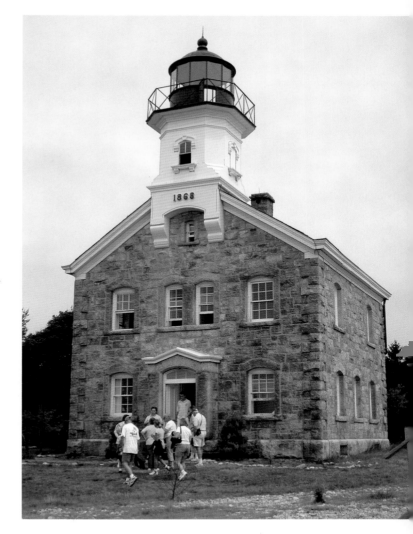

There has never been another lighthouse like the one built in 1909 on New London Ledge. The Coast Guard maintains the automated signal light, but the New London Ledge Lighthouse Foundation has a long-term lease on the lighthouse and plans to restore the French Empire–style mansion. When foundation member Jerry Olsen took me on a tour, he mentioned the infamous ghost said to live there.

"Ernie the lighthouse keeper was despondent after his wife was supposed to have run off with a ferry captain. They say he went up to the top of the lighthouse and jumped off," Jerry says in a stage whisper.

While boats are the only traffic around New London Ledge, the Stonington Lighthouse sits right at the end of the main road through the village. The lighthouse was moved to this spot after it was threatened by erosion. When the Coast Guard replaced it, the lighthouse became a museum of Stonington history. It's quite a story. For the last half of the nineteenth century, Stonington was a railroad hub between Boston and New York, and the harbor was clogged with passenger steamboats, seal hunters, whalers, coastal traders, and the commercial fishing fleet.

The Stonington Lighthouse was decommissioned in 1889, but there are still twenty-two working lights in Long Island Sound and Chief Warrant Officer John Strauser is the Coast Guard officer in charge of them all. The only manned lighthouse left on the East Coast

is in Boston, but the Stratford Point lighthouse comes pretty close. Strauser and his family live there. After new automated signals were installed the lighthouse cupola was removed and for twenty years it was displayed in Booth Memorial Park, but in 1990 it was reattached to the lighthouse. Although Stratford Point is not open to the public, John has been known to give tours to people who stopped by.

"Lighthouses have always been a symbol of faith, of safe haven. I think people find it comforting to see a lighthouse," John says.

In Norwalk the Sheffield Island lighthouse looks a bit like an old stone church. The island has served as a dairy farm, a resort (in the 1930s), a rumrunner's paradise (during Prohibition), a family summer home, and most recently as the Stewart McKinney Wildlife Refuge. It's populated mostly by deer and birds, but in the summertime there is a lighthouse keeper hired to live on the island and give tours to visitors who come out by ferry from the seaport. The Seaport Association organizes weekly clambakes, adventure programs for kids, and kayaking trips.

Since the nonprofit Seaport Association bought the lighthouse in 1987, it has gotten a new roof, the tower has been restored, a nature trail added, and the grounds improved. Volunteers have done much of that work.

Devoted lighthouse supporters Pauline and Mark Shlegel pitched in because "we want this lighthouse here for our grandkids. This is history that we can't get back. Too many lighthouses have fallen to ruin because no one cared."

In Noank Jason Pilalas salutes passing boats with a shot from a cannon mounted outside his lighthouse home at Morgan Point. If it seems he is having an awful lot of fun, that's because he is living out a boyhood fantasy.

"When I was ten years old and living in Greenwich I used to row out to Great Captain's Island, where the exact twin of this lighthouse sits," says Jason, "and I'd talk to the Coast Guardsmen and dream of owning it. Of course that would never be, but boys do dream."

Forty years later, Jason, who had long since moved to California, saw an ad in the *Wall Street Journal*. The Morgan Point lighthouse, just like the one from his childhood, was for sale. It took a million dollars to turn it into a special family home including building a replica of the missing light room.

"Opinion is divided over whether it was the hurricane of 1938 or Coast Guard frugality that removed it when the lighthouse was decommissioned," Jason says. "But we felt you can't have a lighthouse without a light room, and it's a spectacular place to sit and enjoy sunrise or sunset or fireworks or thunderstorms."

Morgan Point is also the perfect setting for Jason's collection of nautical antiques collected by this navy vet who saw two tours of duty in Vietnam aboard the USS *Sutherland*.

Although Morgan Point is now a private home, Jason recognizes that the lighthouse is a local landmark and that he is the caretaker of history.

"I had to own it. I wanted to own it when I was ten, and I wanted to own it when I was fifty," he says. "Sometimes dreams do come true."

You might call Jason and the others modern day lighthouse keepers. Even in lighthouses that are automated or no longer needed, there are still people who care for them, making sure these beacons from the past do not go out. They are keepers of the flame who are positively Connecticut. 🍃

SEE SHELLS ON THE RIVER

Crewing on the Connecticut

While you're sitting in traffic, dozens of Connecticut rowers are recapturing the riverfront that runs alongside the highway in Hartford. Climb into a rowing shell and see how one of the state's oldest sports isn't just for Ivy Leaguers anymore.

IT IS THE HARTFORD FEW OF US SEE, THE VIEW OF the city from the middle of the Connecticut River, from a seat in a crew shell.

"You're out there thinking how cool am I? I am out here on the river, and they're up there in bumper-to-bumper traffic. What's wrong with them?" chuckles Joe Marfuggi, the director of Riverfront Recapture, the organization that organizes the city's rowing program.

There are hundreds of people out on the river, spring, summer, and fall, swarming around the Jaycees Community boathouse in Riverside Park.

Mary Hobart took up rowing at the age of sixty-two.

"Last summer I decided I wanted to meet more people. I started rowing in the early morning in what we call a sweep boat—eight people—each with one oar. I met a fabulous group of people from all walks of life."

Allyson Zoppa teaches rowers at all levels, from those who have never been in a boat before to some

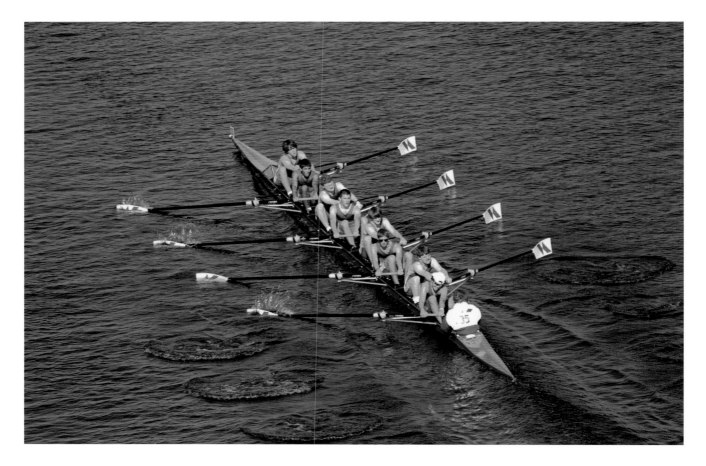

who competed in college. The youngest are barely out of middle school; the oldest are in their eighties. Allyson started rowing in the Riverfront program when she was in eighth grade.

"It's one of those things that takes a while to learn, and it takes a lifetime to master," she says. Besides teaching here, she coaches at UConn.

Collegiate crew in Connecticut has a long history. The Yale-Harvard regatta is America's oldest intercollegiate athletic event. As many as 100,000 fans have lined the banks of the Thames River to see it.

Long popular in prep schools, rowing is now becoming popular with Connecticut suburban and city kids, too. For nineteen-year-old Jesus Bermudez of Hartford, rowing was a way to discover a part of the city he'd never known and to develop a part of himself.

"One of my mentors rows here, and he told me that it's really good in terms of teamwork and leadership. I tried it, and I kind of took a liking to it," Jesus says.

For Joe Marfuggi, the head of Riverfront Recapture, that's what it's all about: getting city kids out on the water.

"It shows them they can do something they never thought they could do," says Joe. "It also introduces them to kids from prep schools and private schools,

and upscale suburbs. They row together and they hold their own. They start to see there is a bigger world out there, and it really starts to help open doors in their mind about what I can do, and what I can be."

High school teams dominate the river in the afternoons, but adult men and women show up as soon as they can kick off their business clothes and line up to crew the four- and eight-person shells.

Even in the cool of the morning, or in the late afternoon, rowing is a full tilt full body workout and an exercise in teamwork.

"Imagine eight people in the boat, and imagine you chain us together at the ankles and wrists, and now we've got to race eight other people. So the arms have to move together, the ankles have to move together. That's what we're trying to do. So it is tricky, it does take time, but with practice and perseverance, it works," says Brian Wendry, the director of the rowing program. He describes many of the rowers as Type A personalities, but he says they pull together, literally, under the command of the coxswain, who directs the rowers and steers the boat.

"The rewarding thing is when you put the people together and the boat moves, it's a shared experience, and it's like 'whoa we did it.' That's one of the things that brings a lot of people down here."

Dave Newberg spent a lot of time fishing and boating before the motorcycle accident that paralyzed his legs. "I was born under a water sign," Dave says, "I dove and swam and all that before the accident."

Now Dave can abandon his wheelchair for the freedom of an adapted shell. "It's amazing how fast you feel like you're going," he says. "You feel like you're in a powerboat or something, but really you're just pulling it with the oars."

Bob Turcotte has been rowing for seventy years and likes the camaraderie of the bigger shells. "If the crew is in a flow situation, everybody is doing things pretty darn close to right. There's a quiet excitement about it."

"When you get your oars out of the water after you 'drive through,' the boat will run underneath you and you can feel it fly," says Mary Hobart. "The first time that happened to me on the river it was magical. It was magical."

So many people are eager to try crew that Riverfront Recapture runs rowing sessions almost all day.

"This is now the centerpiece of the riverfront. It's just full of people in the morning and after work it's really humming," says Joe.

Still Dave Newberg says the bank of the river is where he finds serenity, and he is thankful for all those who cleaned it up and built the park and the boathouse. "To see what they've done with the river is just outstanding. I can't say enough about it. I just love this place. People should be proud."

That's why Riverfront Recapture's rowing program is positively Connecticut. ❧

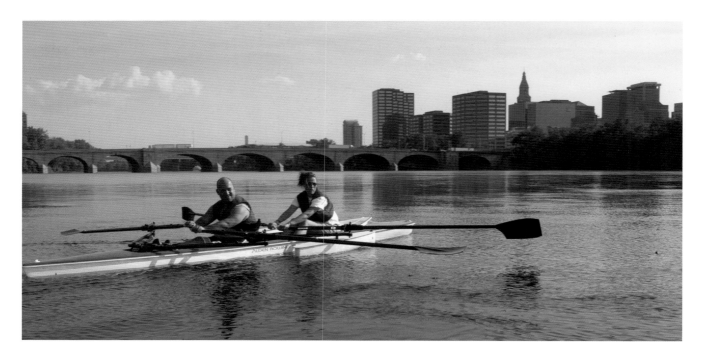

HIGH SCHOOL HOVERCRAFT

WHILE ROWING A SHELL ON THE CONNECTICUT RIVER is a nearly silent sport, there's nothing quiet about a new high school activity held there. High school kids are hovercrafting, riding on a cushion of air over land or water, in one-man vehicles they've built themselves, powered by go-kart and lawnmower engines.

As I found out in a recent test flight, skimming over the water can be a little wet and a little wild, when you're flying at speeds of twenty-five or thirty miles an hour.

One student, Peter Jakowski, described steering the hovercraft as "like driving a car on a frozen lake. You have so much flexibility you can spin on a dime and do different turns and 180's."

Jim Benini's technology classes at Parish Hill High School in Chaplin started building hovercraft in 2001. Students spend the first half of the year studying thermal, electrical, fluid, and mechanical systems, and then the fun begins!

"They learn how to work with lumber and fiberglass and Styrofoam and glue and internal combustion engines," says Jim. "The icing on the cake is it ties all the stuff they've learned earlier in the year into one neat little package."

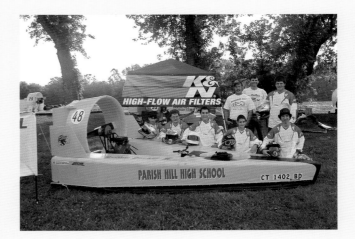

"It's probably the most satisfying thing I have done in school," says Alex Stick, who is also a musician. "It's sort of like recording an album and hearing it finished for the first time, or winning a five-mile road race. It feels awesome."

The class has worked on several different designs, including one they discovered on line that was first developed in 1970.

"It was re-engineered by us and built using lighter materials. It strongly resembles the original, and it performs the way the original was supposed to but never did!" Jim reports.

Each class sells the hovercraft it built at the end of the school term to raise money to build the next one. But before that happens they have a lot of fun with it. Classes have competed at a "hover rally" in Ohio, and students have found a few other classes in Connecticut that are building and racing hovercraft too. The Parish Hill High School technology class has even been written up in the national magazine Popular Mechanics, which asked the question, "Could hovercrafting be the next varsity sport?" If Jim Benini and his enthusiastic classes are the proof, it very well may become a varsity sport that is positively Connecticut. 🍃

Mystic Marine Trainers

Teaching Old Sea Lions New Tricks

Music comes on, lights come up as the announcer says, "Ladies and gentlemen, boys and girls, welcome to Mystic Aquarium and Institute for Exploration! Please put your hands together for your sea lion trainer for today's show, Deborah Pazzaglia!"

SIX TIMES A DAY IT'S SHOW TIME!

"Well hello everyone, today we're going to learn all about California sea lions," Deb says as she steps out onto a stage in the Marine Theater attached to a huge tank of water. "You're going to learn how these animals are perfectly adapted for their life out in the ocean."

They are known as the lions of the sea—but Surfer, Rider, Tabor, and Coco seem more like pussycats when performing with Deb Pazzaglia. A lifelong animal lover, Deb studied zoology in college. Her first job was training chimps and gorillas.

"You had an enclosed area and you were able to touch parts of their body that they needed to present

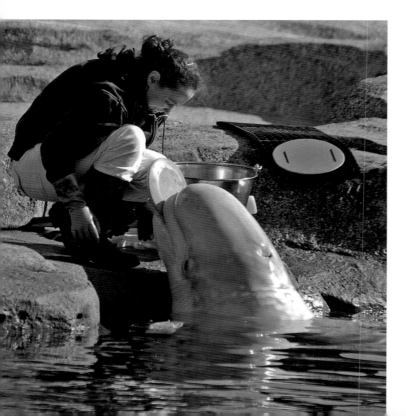

for medical reasons, but you were never in the exhibit with them. Although I worked with huge gorillas, there's nothing that compares to standing next to a 980-pound sea lion and being able to touch him. It's amazing," she says.

How do you get a 900-pound sea lion to leap out of the water, retrieve rings, and slide onto the stage to perform? The key is in the kitchen backstage. Before every show volunteers fill buckets with treats, following menus for each sea lion, thawing and chopping capelin, mackerel, herring, and squid.

The sea lions perform for the fish and, Deb thinks, for the fun.

"I think they feed off of the trainer's energy. And what happens is when you have a big crowd and they're clapping for you and you know they're loving the show, it makes you turn up your level even more," she says. "We all love educating people on all the behaviors that our animals know."

Damon and Nia Long drove in from Pennsylvania with their kids.

"I love the aquarium," says Damon. "We've actually been to a few and so far this has been the most interactive that we've ever visited."

Debbie Rubinstein called the show "awesome" and said, "They taught so much and it didn't feel like you were being taught, it was just really entertaining. I loved how the sea lions interacted with the trainers, and there was so much love for the animals, it was beautiful."

Rider came right out in the audience, and I had a chance to meet him close-up, while Deb demonstrated some of the sea lions' behaviors that are more than crowd pleasers; they can be lifesaving, whether it's having their teeth brushed, their eyes examined, or their flippers probed for injuries.

And, who says you can't teach an old sea lion new tricks? Before joining the show, Tabor retired from the navy, where he located and retrieved undersea equipment.

"It's the most exciting feeling in the entire world that we were just able to communicate with this animal and they had that lightbulb go off and they figured out what you were asking for," says Deb. "When they accomplish that behavior, you can just see it. They're so excited to earn their fish, it's the best feeling," she says with a grin.

What's it like to really get in there and mix it up with the animals? I had my chance and you can too, thanks to Mystic's Beluga Contact Program. Outfitted in waders, trainer Lynn Marcoux and I stepped into the 50-degree waters of the Beluga whale pool to meet Naku, an eleven-foot-long 1,300-pound female. Stroking her skin, I notice it feels like a hardboiled egg with the shell peeled off. You might say Naku's earned a college degree at Mystic. Lynn shows how the whale understands hand signals and can respond on request with up to ninety behaviors. Some of them are pretty fancy.

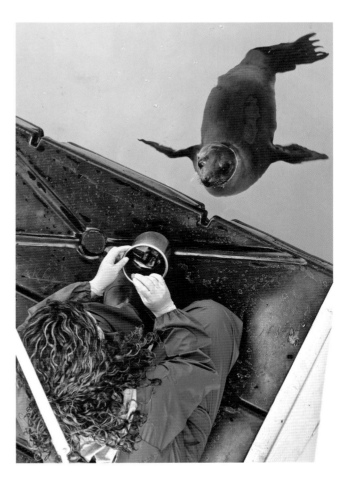

"We call this a spin jump," Lynn says. Naku leaps out of the water and spins, then splashes down.

Naku allows me to examine her blowhole, which is not only for breathing, but also the way she speaks (or vocalizes) since whales don't have vocal chords. She can go from the high-pitched squeak that gives belugas their nickname—"canaries of the sea"—to the foghorn.

Lynn studied zoology, marine biology, and psychology, all of which come in handy when working with Naku, Kela, and Inuk about ten hours a day.

"They rely on you," Lynn says. "You are their voice and if they're not feeling well, you communicate that to the vet. You feed them, you teach them, and you make them comfortable in their environment. At night when I leave them I think about them. I miss them when I'm away on vacations. They've just become a part of my family and I have a passion for being with them."

It's clear Naku and Lynn share an affectionate relationship. While you might scratch behind your dog's ears, with a whale, you show love by slapping her tongue. Lynn still has a long-term goal for the whale population at the aquarium. She would love to see a calf born.

"All of the facilities in North America together are working on efforts for artificial insemination so that way we can sustain the population and keep beluga whales in zoos and aquariums to educate the younger children growing up. If we could have a calf come out of it, that's my dream," she says.

The marine animals and the trainers—and fans—who love them at Mystic Aquarium are positively Connecticut. 🍃

BEING BELUGA

FOR DR. TRACY ROMANO, TAKING BLOOD FROM A *beluga whale is all in a day's work. Tracy is the head of research and zoological operations at Mystic Aquarium.*

"Today we are taking blood for health as well as research purposes," she explains. "Back in the lab, what we'll be doing is isolating cells of the immune system and looking at how well are they functioning. It's an important component to actually evaluating the animal's health," she says.

If the whales seem especially compliant, that's because they're trained to offer a fluke vein for a blood draw, or their bellies for an ultrasound. Their reward is a bucket full of mackerel.

Although visitors may not notice it, the aquarium is intensely focused on research, with a laboratory on site and research projects underway all over the globe.

Dr. Romano pioneered the study of stress and environment on marine mammal's immune systems. She is comparing the three belugas that live permanently at the Mystic Aquarium with seven temporary residents of the aquarium and with beluga whales in the wild.

"We know what the animals here are eating, we know what the water chemistry is in the pool, we know how cold the water temperature is, and we know their medical history. When we sample animals in the wild, we know none of those factors, so this is important information."

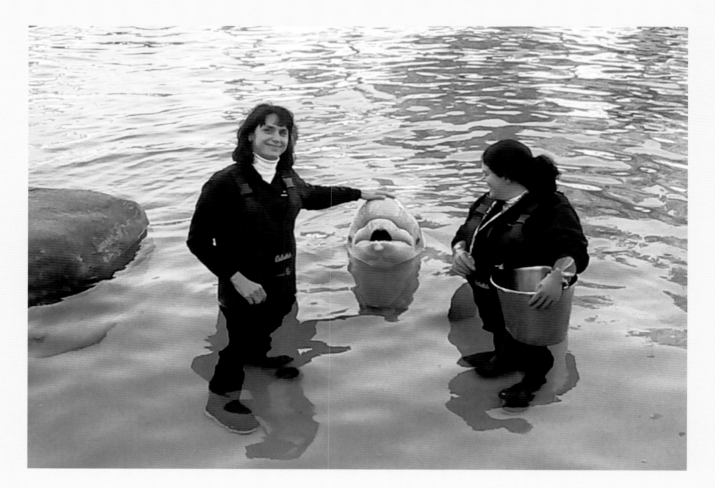

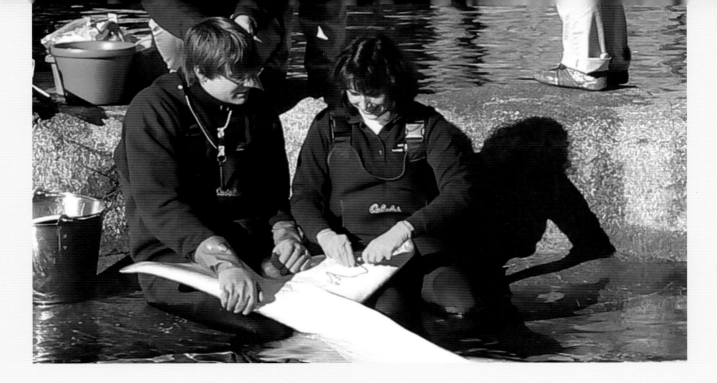

Mystic's Kela, Naku, and Inuk provide a baseline for the study. Their vocalizations and behavior are observed and recorded. Then they're evaluated against those of the whales who were flown over one thousand miles to Mystic where they lived while their home at Shedd Aquarium in Chicago was renovated.

In the lab, the blood samples give more clues about the belugas' health.

"What I'm going to be doing is taking the white blood cells off so we can do experiments with the white blood cells. That's where the cells of the immune system are and we're going to be looking at their function," says Dr. Romano.

Researchers are looking into how the immune system fights off infections like brucella, which causes reproductive failure in whales. The hope is that what these scientists learn here in a controlled environment will give them answers about what belugas face in the wild. That takes Tracy to Alaska for the third leg of her research.

"Belugas in Cook Inlet were listed as endangered recently, so the idea is that before any more beluga populations go on the endangered species list, let's get a general baseline health assessment before these outside factors such as oil and gas exploration and climate change start to impinge on the health of the animals," Tracy says while preparing a slide for the microscope.

Some of the whales in Alaska have been fitted with satellite transmitters so researchers can follow their migratory patterns.

"We can follow where they go. We can see how deep they dive, what the water temperature is, and also look at their vocalizations, record their vocalizations and then see what happens after oil and gas exploration," Tracy explains.

Students from Point Lay on Alaska's Northern Slope will be studying the data with Tracy in her lab in Mystic. They'll partner with students from the Mashantucket Pequot Tribal Nation, located just down the road from the aquarium.

Since joining the staff in 2004, Dr. Romano has not only doubled the size of the research department and established the on site lab, she's recruiting the next generation of scientists.

"The key here is to allow the young students to see the animals and then relate what we're doing in the laboratory to the animals and how it helps us learn about the animals and assess their health. And that's one of our goals here, too, to get kids at an early age excited about science and really inspire them to be future scientists," she says.

Dr. Tracy Romano . . . talking to the animals in a way that is positively Connecticut. 🌿

WISH UPON A SUNFLOWER

Farm-Fresh Ice Cream

There's nothing like ice cream to put a smile on a kid's face, and there's nothing like Duane Button's farm-fresh ice cream.

"WE ARE FORMER DAIRY FARMERS," SAYS DUANE. "I spent about twenty-five years milking cows with my father."

But now selling ice cream is the principle business at Buttonwood Farm in Griswold almost year-round. However, getting people out there to taste the ice cream was step one.

"I figured we needed an attraction," says Duane, "since we're a long way from a population center. So someone suggested we plant some sunflowers that would be good to look at."

So for a few magical days in mid-July folks come from far and wide to see 400,000 sunflowers blooming on fourteen acres.

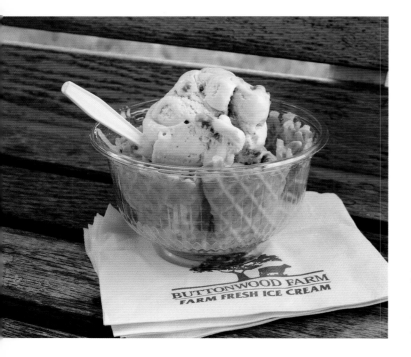

"Folks have drastically different feelings about sunflowers. Some people come, and they feel joyous, jubilation, I guess the word would be. And others, they have somber reflections," Duane noted.

Five bucks buys a bouquet or a hayride. There are sunflower note cards and sunflower t-shirts for sale. Try the sunflower-flavored ice cream and make more kids smile. The Buttons donate their sunflower money to the Make A Wish Foundation.

"It's a lot, and a lot of planning, but I would have to say that it feels good to own a business that can contribute, that's able to raise and contribute the amount of money that we can," Duane says.

The sunflowers are only in bloom for about ten days, and there are only about four days when they can be picked for a bouquet. That means Duane has to plant several times for a full crop, and he relies in part on volunteers who show up to help with the picking. But Duane says it's all worth it when he thinks about the kids helped by Make A Wish.

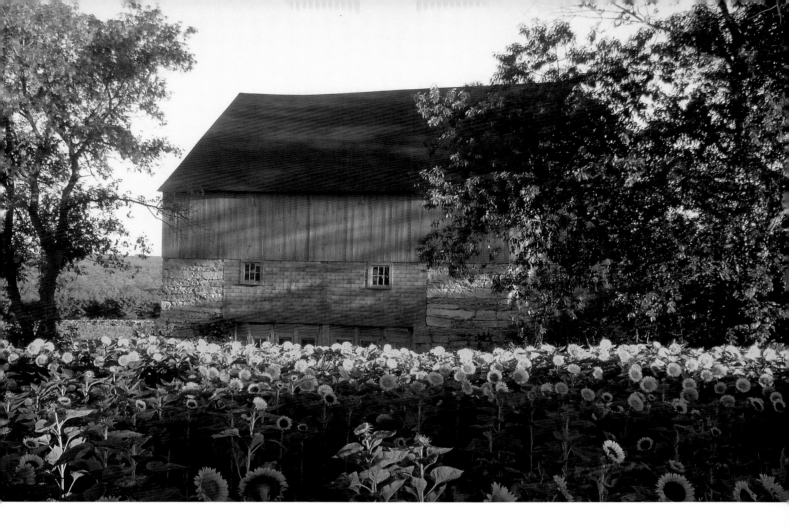

"Make A Wish grants wishes to children with life-threatening illnesses, but the family gets the wish. If a child wishes to go to Disney World or whatever they wish, the whole family goes. It's the whole family that is suffering, and it's the family that gets the break, I guess."

When the sunflowers are blooming, carloads of people drive up, pose the kids and grandma in front of the stone walls and the bright yellow flowers, and snap photos.

"Getting ice cream is a real family thing. Grandmothers and grandfathers and mothers and fathers and little kids all come at once. There's not a lot of things families do together like that," says Duane.

In its first five years Buttonwood Farm raised $235,000 to make wishes come true for thirty seriously ill kids.

"There's a lot of other good causes, but for us, and our values and the ice cream business, it's just a really,

really, really good match," smiles Duane, watching a little boy lick an ice cream cone. A good match that's positively Connecticut.

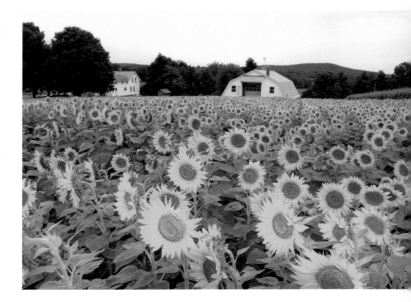

To Market to Market

Grown in Connecticut

A sure sign of summer are the farmers' markets blossoming across the state. These days "grown in Connecticut" is more than a motto—it's a sign of business success.

In cities and suburbs the flavors of the country come straight from the farms of Connecticut. The farmers' market at the old Billings Forge in Hartford is one of the latest success stories in local agriculture.

"It's on fire," says Rick Macsuga of the Department of Agriculture.

"In the last two years we've added thirty markets. It took me ten years to bring the first thirty markets on line. Now everybody wants one." There are about 125 markets tucked into every nook and cranny of Connecticut from the shoreline in Mystic to a church parking lot in Westport.

Eager shoppers cluster around an old-fashioned dairy truck at the first farmers' market of the season in Hartford.

"That's so good it tastes like a milk shake," says a woman wiping a milk moustache from her upper lip. She buys a quart and then a dozen free-range eggs,

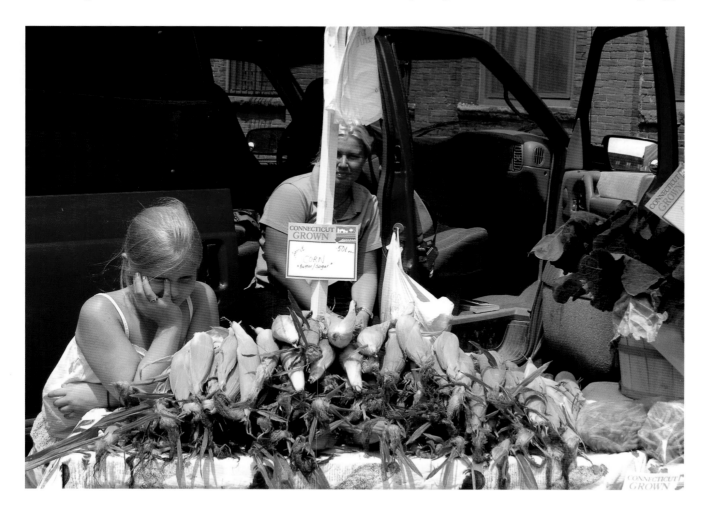

before wandering to a pastry cart to taste a chocolate croissant, baked an hour earlier.

Markets that once flourished in mid-July now open as early as May and a few operate year round, thanks to more greenhouses and hydroponics.

Sandi Rose owns Rose's Berry Farm in South Glastonbury, where she operates her own produce stand, as well as one of Connecticut's biggest "pick your own" berry fields. Still she says, "This year we're doing sixteen markets around the state. It has just mushroomed and it is one more way of retailing our product. This has been good for us, great exposure and good advertising." Sandy's berries and pies are among the first items to sell out at Billings Forge.

Early in the season the Mystic market looks like a farmer's pantry—with pickles and pies and homemade breads. Cold weather crops draw local shoppers, along with fresh-caught fish.

Sally Mogle is a regular shopper there. "It means a lot that the food is local, rather than being shipped from Timbuktu or whatever. We know where it comes from."

Elisha Riley says that's why customers count on the hormone-free beef she and her husband raise on their farm in Stonington. "It's very nice to know people want something that we've grown, we've fed, and we know how it's lived. Consumers appreciated that even more after all the beef recalls that have happened."

The popularity of locally raised food has driven the sharp increase in the number of farmers' markets. Chefs like Jason Collin at the Firebox in Hartford and Michel Nischan at the Dressing Room in Westport have helped stimulate the local food movement.

"I call people as much as I can to see what's growing and what's out there, and that really dictates the menu," says Jason. "For me it's a personal belief in thinking that the freshest stuff is closest to where you are getting it."

Michel Nischan started a market in Westport with the help of his restaurant partner Paul Newman. He has worked on organizing markets in urban areas too. Some markets accept food stamps and WIC coupons, making fresh local food more available to everyone.

In Hartford the market is about more than the food; it's about creating community, according to market master Hannah Gant.

"You've got the people who live here. Many are Latino. Many are lower income. Then you have the people that work in the area at the state capitol and the big companies, who don't really have cause to interact. But they all come to the market and shop together. I find food to be very democratic—everyone eats, and everyone shops for food."

And although Connecticut is still losing farmland to other types of development, markets like this are keeping many farmers in business. Paul Trubey makes delicious goat cheese at Beltane Farm in Lebanon.

"Without these farmers' markets I wouldn't be in business. We're small enough that we cannot survive on wholesale. We would not be able to survive if it were not for the direct sales to the public," he says while smearing some creamy cheese on a cracker and handing it to a customer.

These markets have encouraged farmers like Sandi Rose to diversify, so if one crop fails there's another to rely on. Once known only for berries, Rose's farm now grows more exotic produce like tomatillos, habaneros, and patty pan squash.

"Farming is a real satisfying way of making a living," she says. "It's challenging but in the end it's very satisfying."

Among those challenges are finding labor, and hanging on to land that fetches higher prices for residential and commercial development than for farming. Those are issues the Connecticut Department of Agriculture is working on—in addition to promoting Connecticut grown. Rick Macsuga says the challenge he faces is recruiting even more farmers to fill the demand for fresh local food. But he admits that's a great problem to have.

"I think people are finally starting to understand the value of their local food system," he says "and it helps that they get to meet the farmers too."

Helping farmers stay in business, bringing fresh foods to the table, and connecting Connecticut communities to the state's farms. Selling the local bounty of the season—a growing trend that's positively Connecticut. 🌿

DINNERS AT THE FARM

WITH FARMERS' MARKETS BLOSSOMING ACROSS THE state and more consumers demanding locally grown food, professional chefs are looking for ways to give it to them. Jonathan Rapp, the chef/owner of River Tavern in Chester, is known for menus featuring locally sourced meats, fish, and produce.

A couple of years ago he had a bright idea: "Why not just cook right on the farm?" Rapp teamed up with Drew McLachlan, the owner/chef of Feast Gourmet Market in Deep River, and Dinners at the Farm were born. Drew and Jonathan outfitted a cherry red 1955 Ford fire truck with a basic kitchen.

The extravagant summertime dinners take place at different farms in the state and include a farm tour and a chance to meet the people who raised your food. The menu at each dinner depends on what's come in from the farm that day but generally includes about seven courses, all cooked right in the middle of a farmer's field. Guests dine at candlelit tables set under a tent with a backdrop of views of some of the state's most scenic farms. One dinner was held at the oldest farm in Connecticut, the Stanton-Davis farm in Stonington, which has been worked by eleven generations of one family, dating back to 1654.

Best of all, the dinners benefit local organizations like City Seed, bringing farmers' markets to urban neighborhoods, and the Connecticut Farmland Trust, which works to conserve agricultural land in the state. Eating local—that's positively Connecticut! 🍃

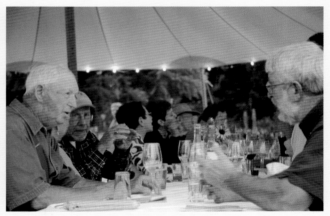

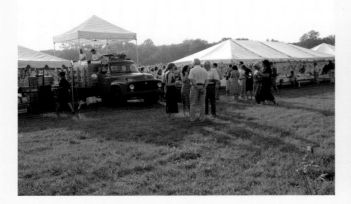

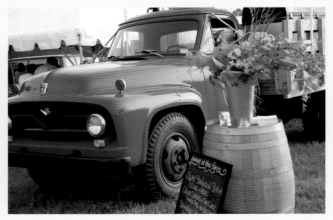

Trailer Flash

Airstreamers

Summertime is for exploring. And here in Connecticut, there are so many places to visit. How you travel, however, all depends on your style.

RICHARD AND KATHY KUSHMAN LOVE THE OUT-doors. They love it so much that they have hiked a thousand miles on the Appalachian Trail, backpacking and camping. That is, until one dark and stormy night.

"It was really a stormy, stormy night in a two-man tent and it was 95 degrees and just horrible, horrible humid," says Kathy with a shudder. "We couldn't open the windows, and there were bugs coming in. We said this is it, we're not gonna do this anymore so we went and got a trailer."

But not just any trailer. The Kushmans got an Airstream, which has been called the Cadillac of all custom travel trailers.

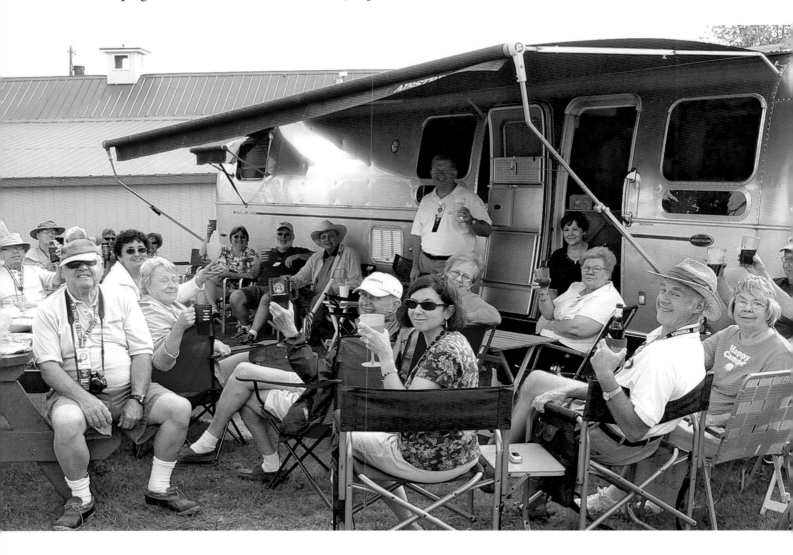

The Airstream. For Richard there was no other choice but this shiny aluminum American icon.

"They're beautiful as far as looks and an Airstream will last you the rest of your life—it won't fall apart," he says.

Richard and Kathy are so enthusiastic they are now the president and first lady of the Charter Oak chapter of the Wally Byam Caravan Club.

Wally Byam invented the Airstream in 1934. Byam's idea was to build a trailer so aerodynamic it could be towed by a standard car. He came up with the name because he said, "That's the way they travel, like a stream of air."

Richard and Kathy were eager to show theirs off.

"This is it. This is the living area, TV room, family room all rolled into one," Richard says as we walk into the main compartment.

The Kushmans are now on their third Airstream, moving up from a twenty-one-foot trailer to a thirty-four-footer that sleeps six. With all the comforts including a queen-size bedroom, full kitchen, and his and her computers, they've toured the nation in this trailer, including Alaska.

The 14,000 members of the international Wally Byam club like to caravan, often traveling together and gathering at rallies like the one they hold annually in North Stonington, where they spend weekends socializing with other Airstreamers. They like to share trivia with visitors, including the fact that there is an Airstream in the Smithsonian, and that the Apollo astronauts who first landed on the moon spent three weeks in quarantine in a specially built Airstream when they returned. Airstreamers will tell you that they feel at home wherever they go, because they take their homes with them.

Ron Chateauneuf briefly owned another camper, but on his maiden voyage with it, a close encounter with an Airstream changed his mind. "We met some folks with an Airstream and they parked it next to us, and we got their tour. Within a month of coming home from that weekend, we bought this Airstream," he laughs.

Many of the Charter Oak chapter members rarely leave New England in their trailers, but for more than seventy-five years Airstreams have caravanned across this continent and around the globe, venturing from Pisa to the pyramids. In the 1950s Byam led many of those caravans himself. Airstreamers buy into Byam's vision for traveling and his outlook on life.

"The club has more than his name," says Richard. "It's the whole concept of travel and friends and fellowship that he's created and we keep it alive. Traveling in an Airstream becomes a social event. You meet new people all over the country. You make new friends all the time and you just have fun on the road." For these trailer travelers Airstreaming is a way to see the world that is positively Connecticut. 🍂

BLUE RIBBON BAKERS

Country Fair Cook-Offs

When it's country fair season in Connecticut, many of us look forward to the midway, or the livestock competitions, or just indulging in the fair's foods. But for one competitive group, the fairs are all about blue ribbons, for the best cookies, cakes, and pies.

NORTH STONINGTON'S FAIR HAS ALL THE RIGHT ingredients—a country setting, kids and their calves, friendly folks, a Ferris wheel, and lots of food—from curly fries to fried chicken. But at the heart of the fair is the crafts shed—where the best quilts, cakes, and cookies are entered for a shot at a blue ribbon. North Stonington is the first of more than forty agricultural fairs each summer in Connecticut, and most offer a chance for the best bakers to strut their stuff.

Although Julie Armstrong won a blue ribbon the first time she entered the baking contest seven years ago, she still works hard at it. This year she is entering the two-crusted apple pie contest being held statewide. She has tested and tweaked her recipe.

Making a good piecrust can unnerve even experienced bakers, but Julie is confident. The key she says is chilling the crust before rolling it, keeping the counter cool, and not overworking the dough.

"That way the shortening is still in pieces, and what happens is when it goes into the oven the heat causes the shortening to expand, and that causes layers of air bubbles and makes for a flaky crust." Her butter and shortening are carefully measured—too much and the crust is too stiff or too soft.

In some contest categories the bakers are required to all use the same recipe, but this one is Julie's own. She precooks the apples, a combination of Granny Smith for tartness and Fuji and Braeburn for sweetness.

"In earlier times I thought that more was better as far as cinnamon and nutmeg went, but as time went on I learned that the judges tend to look for a pure apple taste so I cut back on my spices," she says.

She adds a half-cup of rum-soaked raisins to give the "mouth feel of the pie and added dimension."

When the pie comes out of the oven, it has just a few minutes to cool; then it's time to pack it up and drop it off for judging. The steamy weather the week before the fair cuts back on entries—there are three in each division.

Retired chef Frank James is dropping off his raspberry cheese coffee cake, and one made by his wife Marci, who also enters an apple pie. Baking must run in the family—his granddaughters Jessica and Dawn are competing in the junior division with pecan pie cookies.

"It's really part of Americana," says Frank. "It's like the rodeo of the small people, regular people showing what they're able to do."

Marty Booker and Michelle Butler have more than forty years of judging experience between them.

"Not everything tastes wonderful; looks can be deceiving. People say 'oh wow it must be so much fun' and even if everything tasted delicious you have to taste all of these pies and cookies—it all starts to run together," admits Marty.

The pecan pie cookies are first. The juniors all baked the same published recipe, which Marty has tried. "They tasted like mine," she laughs, "and that's a good thing."

The cookies are given points for appearance, flavor, texture, and how closely the bakers followed the directions. The winner is Frank's granddaughter Jessica James.

Next is the glazed raspberry cheese coffee cake. All three look good but one is undersized and

underglazed. Another seems a little short on raspberry jam. Marty and Michelle award the blue ribbon to the one that is the closest to the recipe. Turns out that's Frank's wife's cake. He placed second.

Then it's on to the apple pies. The winner will go on to compete statewide.

"You eat with your eyes," says Michelle, a professional caterer, "so I always look at it like 'what do I want to take home?'"

One pie is too brown, Julie's top crust is cracked, and the third is marked down for a crust that's heavy on top and underdone on the bottom.

"That one I can see all the crust would be left behind on the plate," says Marty. "You eat the wonderful filling and leave the crust behind."

The judges are enthusiastic about Julie's filling.

"I liked the raisins. It had a more complex flavor; they definitely put something different and really nice in there," says Michelle.

Finally they choose another pie over Julie's as the blue ribbon winner.

When Julie turns up to see whose pie won, the judges explain they'd marked hers down for the crack in the crust, and the extra liquid in the filling, both the result of a pie that was too hot to move. So Julie is already looking ahead to next year's contest.

"I thoroughly like cooking and baking. I like working with my hands and I like to see other people enjoy what I have done," she says with a smile.

Baking for the local fair—a summertime hobby that's positively Connecticut. ❧

Dogged Determination

Sheepdog Trials

Remember the film Babe, *about the piglet who dreams of herding sheep? An Andover woman could probably make Babe's dream come true. She's a top competitor in sheepdog trials.*

THE SIGHT OF A BLACK AND WHITE BORDER COLLIE herding fluffy white sheep might conjure up the rolling hills of Scotland or the wide-open plains of the western United States. Actually, I met Beverly Lambert and her dogs herding sheep just ten miles from downtown Hartford. Now more than a rural activity from days gone by, sheepdog trialing is a growing sport in this country. For four years Beverly organized a competition at a Bloomfield park, considered the largest and toughest in the Northeast, with dogs and their handlers coming from across the United States and Canada.

"A sheepdog trial is meant to be a test of all the phases of work that a good dog needs to be able to do," she explains. Beverly has bred and trained several of the top herding dogs in the nation. "That's Bill, Pippa, Huck, and Maid," she says pointing to each of her champs.

It's no surprise that Beverly learned to herd sheep by reading a book. After all, most people in town knew her as the director of Bloomfield's Prosser Public Library. But Beverly's come a long way from that handbook. She's now one of the top competitors in the sport, and she trains and raises dogs full time.

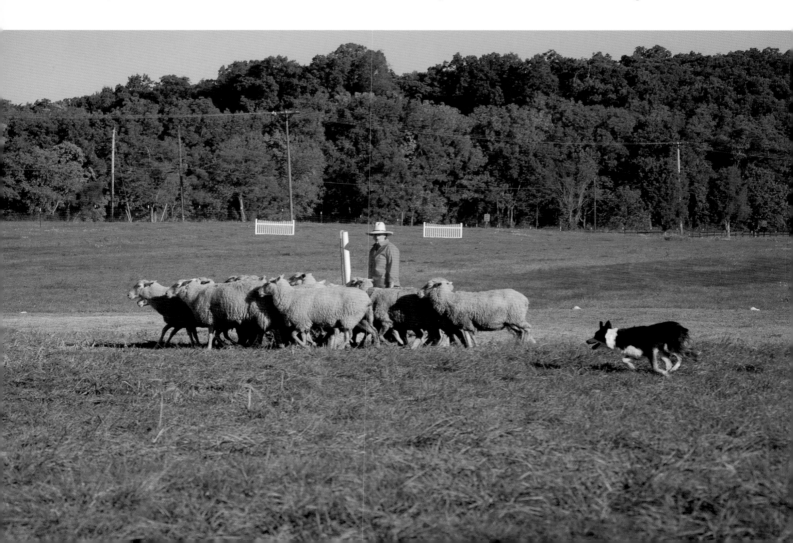

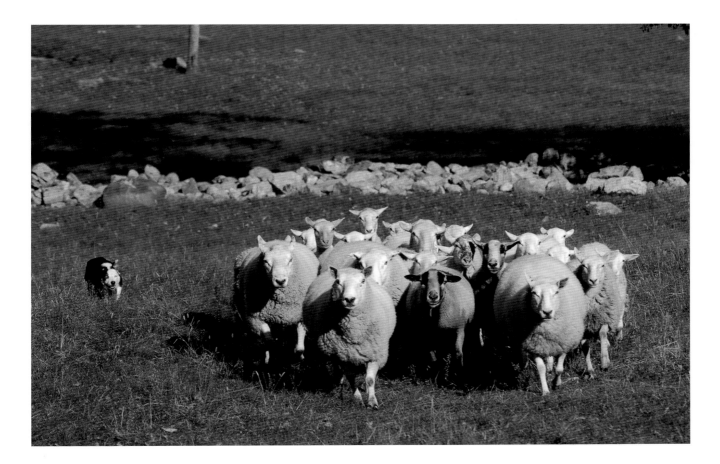

In the field, the human handler might look like the one in charge, but as Beverly showed us at her Sheepswood Farm in Andover, competitive sheepdog herding requires a complex partnership between handler and dog.

"All right Pip, you all set? Want to go do some sheep?" she says as we walk to a pasture where about twenty sheep are grazing.

"It's not a command thing, it's a discussion. For example they're supposed to bring the sheep to you in a straight line and as they're bringing the sheep I'll say to her, 'I think you need to move them over a little to the left to keep that line straight.' And she can communicate back to me, 'no, I think I'm in the right place.' We actually carry on a conversation as she brings those sheep in over that distance."

In what Beverly thinks of as "a conversation between two species," the language is complicated.

Besides spoken orders, there are whistled directions. Each whistle means something different, and each of Beverly's nine dogs has its own set of whistles.

At the Bloomfield sheepdog trial, it's clear that the dog is working on more than formal training. The ability to herd sheep and to communicate with their partners is built into border collies, bred into their genes.

"They have to have the attitude that allows them to accept the training from the handler. When they get into a situation and they're chasing a sheep as fast as they can, and they're hot and they're tired and they're angry because the sheep has been really bad, they still work with you," says Beverly.

To earn points, the dog must gather a small flock of sheep as quickly and neatly as possible.

"After that you drive the sheep. There's a couple of panels we set out to replicate taking them through a gate and a fence," Beverly explains.

The dog then herds the flock into a pen.

"Frequently the sheep are not interested in cooperating and that's when skill and smarts really come though," says Alasdair Macrae, a professional sheepdog handler from Scotland, and one of the winners of the Bloomfield trial. "It's got to be able to boss that sheep when it needs to be bossed, and court them when it needs courting, to say please when please is wanted, and say now you'd better go when you'd better go is wanted."

The trial's judge Herbert Holmes is a livestock breeder from Texas who uses dogs to manage his six thousand sheep and goats. "When you move them from one pasture to another, you use dogs and you get by with less people that way."

That takes a dog that's not only smart, speedy, and agile; it takes a dog that loves its job. "They'll forego a meal or almost anything else rather than miss out on working with livestock. They just love it," says Sally Lacy, a border collie breeder from New Hampshire.

None of this comes cheap. Bring home a border collie puppy and soon you need sheep, which need land, and if you compete, you'll likely need a camper that accommodates dogs and their people.

But as Canadian champion Amanda Milliken discovered, there's an appeal in a pastime that contrasts with much of the rest of modern life.

"The sheep-dogging is the only really lyrical part of my life. That's important. It brings moments of such extreme tension and beauty mixed up in them," she says. "It's a primitive thing you make very sophisticated by cranking it up a notch and taking it to a high level of communication."

The kind of communication shared by Beverly Lambert and her canine companions. A "conversation" that's positively Connecticut. 🌿

PLAYING WITH FRISBEES HAS COME A LONG WAY SINCE some Connecticut college students started tossing around pie plates made by the Frisbie Pie Company in Bridgeport in the 1960s. Now it's an international team sport—for people and dogs!

It's a great way to get your couch potato canine outside and have fun: Just ask Corinne Brewer and Kangaroo Jack.

"One of the biggest problems dogs have is people don't spend enough quality time with them, and when you're playing Frisbee with your dog you're concentrating on the dog," says Corinne.

Corinne is president of the Yankee Flyers, one of the oldest dog disc clubs in the country.

Ian Duncan spends long hours at work, but when he's off the clock his border collie Tartan springs into action.

"When I come home he is bouncing off the walls, so he immediately has to go out and burn off some energy," says Ian.

Shannon O'Brien stumbled on the sport while throwing out the garbage.

"I had gone and chucked a paint can cover into the trash and Clyde snatched it," she laughed.

Most dogs begin by learning the basic "toss fetch." Then it gets a little more complicated.

"You have a field set up and it's lined and you get several points depending on how far your catch is within the grid of lines. You get an extra half point if it's in midair when the dog catches it," explains Ian about the game.

Barry Griffin coached his lab Maggie all the way to a championship in the Disc Dog International Toss and Fetch contest. His winning secret?

"A lot of practice throwing," he says. "The handler needs more practice than the dogs, that's for sure!"

In the freestyle category a choreographed routine combines music and multiple discs.

Corrine loves this part of the competition. "I am a music teacher, and so half the fun for me is what's going to be the right tempo or what kind of music will showcase the dog."

The players all say that disc dogging has tightened the bond between them and their pooches.

"Instead of them just being home and being a pet they need that drive to go and do something," says Shannon. "Get out there and throw a Frisbee and play with your dogs. Spend some time with them—they love it."

Disc dogging . . . letting the fur fly in a sport that is positively Connecticut. 🌿

CONNECTICUT'S UNSOLVED MYSTERIES

Digging Up the Past

In Connecticut much of the past is buried . . . literally. And that's where the state archaeologist comes in. Nick Bellantoni is unearthing our history one piece at a time. While doing that he has uncovered everything from Native American civilizations thousands of years old . . . to Connecticut's own vampires.

SOMEWHERE WITHIN THE BOUNDARIES OF CONnecticut's biggest airport is the answer to a mystery—the exact location of the fatal crash sixty-five years ago of the man who gave Bradley International Airport his name.

Airport historian Tom Palshaw tells the story. "The 57th Fighter Group had just formed up on Mitchell Field, and on the 18th of August, 1941, they moved to Bradley Field, which was called Windsor Locks Airbase at the time."

First Lieutenant Frank Mears and Second Lieutenant Eugene Bradley were practicing dogfighting.

"Frank Mears had finally gotten behind Bradley and decided to call off the combat and to try it again. They both made a left-hand turn and pulled a lot of G's. Perhaps Bradley passed out."

Bradley was killed when his P-40 fighter plane slammed into the ground so straight and so hard that a portion of the fuselage is still buried there. But there is no record of the exact location. That's where the state archaeologist Nick Bellantoni comes in.

"When the crash occurred, they went out there immediately, and by the afternoon they had picked up the wreckage, bulldozed the area and straightened it out and walked away. It's not like today with GPS readings we would document all of that," says Nick.

Palshaw, a curator at the New England Air Museum, and a team of volunteers have asked Nick to help pinpoint that site. The team is using eyewitness accounts, military reports, topographic and construction maps, old photos, soil samples, and fieldwork to solve the mystery. They're hoping to fill in a gap in the story of the airport. Eventually ground-penetrating radar may provide the answer.

"Archaeology always completes history because between the written records and what's in the ground is all we'll ever know about the past," says Nick.

From his office at the University of Connecticut, Nick reviews plans for shopping malls, subdivisions, golf courses, and other developments.

"That's one of the main reasons my office was developed," Nick says, "to assist municipalities in land use decisions, to preserve and protect as much of our history as possible."

Sometimes those developments crash head-on into history. In Fairfield human remains turned up while contractors were grading a ball field. The medical examiner called Nick.

"What we rediscovered is an early-eighteenth-century cemetery that was part of the early Trinity churches. It was actually there 1712 to 1735. Supposedly they moved the bodies in 1881 but obviously they didn't move all of them. In fact they probably just moved the tombstones," Nick explained.

Then there are times when the past is deliberately uncovered, as in the excavation in East Haddam of the burial plot of Venture Smith. An African prince sold into slavery, he eventually bought his freedom and became a prosperous Connecticut landowner. Though acidic soil eroded most of the remains, descendants hope that some recovered DNA and artifacts will help tell their family's story.

Not every family's story had a happy ending, as Nick discovered in Griswold when remains unearthed

by a sand and gravel operation turned out to be victims of tuberculosis, and he discovered Connecticut's own version of vampires.

"One theory that developed in rural sections of New England was that maybe the dead that died of these diseases, our recent loved ones, remained undead and were capable of leaving the grave, feeding on living family members and thus spreading the disease from one person to another," Nick says.

So, Nick says, in an effort to stop what they called "consumption" or "wasting disease," they dug up their graves and "they broke into the chest and all that remained was the heart and they burned that."

And then there are family stories that lead to even bigger stories. Near the mouth of the Cove River in West Haven is the land that was Janet Ciarleglio's family farm.

"My mom took us out here all the time," Janet remembers. "We could just walk the field and pick up arrowheads; they just kind of washed up."

So many Indian arrowheads and points washed up that in the early 1900s the family sold some of them to the Yale Peabody Museum. When West Haven purchased the property to preserve as open space, Nick and Yale were called in, and a dig began that showed Native Americans lived here as long as five thousand years ago.

Cathy Iaccarino, a member of the town's open space commission, would like to see local students continue to probe the site's past.

"It's one thing reading it in a book. It's another thing discovering it for yourself. When you find that point and connect with someone who lived four

thousand years ago, history just takes on a whole new dimension," Cathy says.

And that's why Nick Bellantoni is passionate about finding what's buried in Connecticut.

"Not only do we have cultural diversity here but we had the Industrial Revolution, the military, the aviation sites, and shipwrecks. So all of us have a stake in this land and have left a fingerprint. It's that fingerprint that we try to uncover archaeologically to learn more about these histories that make up the totality of the state," he says.

Uncovering the past and solving its mysteries— it's positively Connecticut. 🌿

TRICKY WICKETS

Cricket in Connecticut

Baseball is the sport known as the great American pastime, but in early America the game was cricket. After nearly becoming extinct in this country, cricket is making a comeback, and here in Connecticut we have our rich ethnic diversity to thank for it.

On a hot Sunday afternoon in Norwalk, a cricket match seems like an analogy for the melting pot that is America. The game began in Great Britain, and these cricketers hail from all corners of the former British Empire, from the West Indies to Africa, India, and Pakistan. In spite of how they may have felt about colonization, they still love the British game.

Mirza Ghafoor of the Danbury Cricket Club says that's part of the fun.

"That's part of our common mentality if you want to call it that," he nods. "We like to beat them in their own sport."

In the eighteenth century cricket was so popular here that John Adams asked, "If the leader of a cricket club is called *president*, why not the leader of this new nation?" But while cricket maintained its status as an amateur and somewhat elite game in the United States, professional clubs formed in other countries, where the game grew. Meanwhile, here at home it was eclipsed by baseball, its distant cousin. After a large wave of immigration following World War II, cricket re-emerged in this country.

"It just brings people together, regardless of age groups," says Mirza. "Everybody hangs out together and plays together. The mental level when you are playing cricket is the same regardless of what age you are."

And there are players on each team ranging from their teens to their mid-sixties.

A *female* player though—that's a *different* story. Joan Alexander started playing cricket in her native Grenada when she was barely three years old.

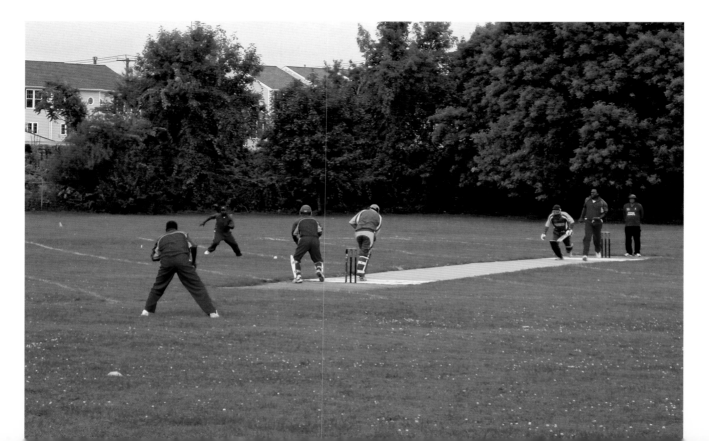

"My dad taught me and I've been playing ever since. I played for my parish team when I was eleven, and I played for my island team when I was fourteen, and I represented the West Indies National Team when I was sixteen," Joan says proudly.

Joan is one of very few women playing on this level in the United States, so she was delighted when she moved to Connecticut and found an active cricket community with two leagues in the state.

"I had to have cricket. It's like an addiction. Once you grow up doing it you have to have it. It's the source of life!" she laughs.

There were no women's teams, so Joan showed up to practice with the men.

"I think they felt sorry for me at first and said 'sure go ahead.' So then I pretended not to know how to play right. They waited until the very end to ask me if I wanted to bat and I said 'oh sure,' and then *I let them have it*. As I was walking away, one of the guys on the team called my name and said, 'Joan do you want to join the team?' And that was it. I've been playing with them for over twenty years."

Connecticut now has well over a dozen clubs sprinkled across the state, and hundreds of players. There might be more, if the game were a little easier to understand. Some fans say you have to be born playing it in order to understand the game.

"Like all sports everything hinges around the scoring," says Leighton Greenidge, president of the Southern Connecticut Cricket Association. "One team scores X amount of runs, the other team wants to beat that, so that's the basics. But there's so many

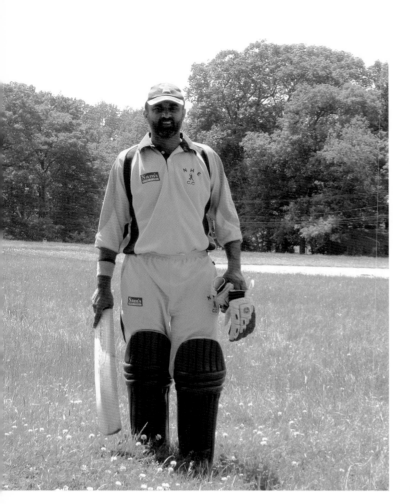

"Unlike baseball where the ball is coming on the fly, in cricket, the ball has to hit the ground," Leighton explains.

Batsmen at each end of the pitch alternate batting and score runs. The catcher is called the *wicket keeper*. An *over* occurs when the bowler completes six balls. A match may take all day, or several days. Leighton is experimenting with a shorter game, because he'd like to see cricket in Connecticut as popular as minor league baseball.

"I'm hoping within the next couple of years we can attract that kind of audience, a fan base and participation," he says.

Joan Alexander thinks the fans are out there.

"It's diversified. We have Jamaicans, Grenadines, Guyanese, we have Indians, we have Australians all competing and turning out. It's beautiful when we all come together like this and you have the same thing in common. It's actually great!"

For many of the players, and the fans, cricket is a reminder of home that's positively Connecticut. 🍃

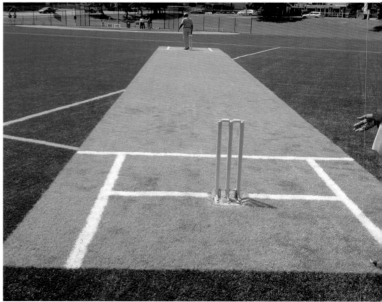

ways of getting there, it's very, very difficult for me to explain."

They use a bat and ball, but that's pretty much where the similarity to baseball ends. There are eleven players on each team; most rotate through all the positions. After each team bats an equal number of balls, the team with the most runs wins. The balls are red. The bats are English willow, flat on one side, with a hump on the other. The field is elliptical, and instead of a diamond there's a "pitch," a rectangle marked with lines known as "creases." At each end is a "wicket," made of three "stumps" topped by a pair of "bails." The "bowler" runs and then pitches.

Combos, Conductors, and Camp

Litchfield Jazz Festival

If your idea of summer camp is color wars and campfires, think again. At one cool camp in Litchfield, it's about combos, conductors, and concerts.

ON A SUMMER EVENING JAZZ LEGEND DAVE BRUbeck is one of the headliners at the Litchfield Jazz Festival. But before Brubeck takes to the main stage, he takes time out for the next generation of jazz musicians, students from the Litchfield Jazz Camp, even inviting one small boy to join him onstage at the evening performance. Several of the campers are playing at the three-day festival, which attracts about ten thousand fans every summer. Vita West Muir founded the festival and the camp, held on the bucolic campus of a private school.

"Because my really hardcore interest is in arts education, I knew as soon as I got the festival started, I would figure out how to do a camp," Vita says.

When Don Braden left Harvard's engineering school to play jazz, he learned from stars like Betty Carter, Freddie Hubbard, and Roy Haynes.

"My interaction with those guys was not a classroom scenario, but how they conducted themselves as musicians, the energy they brought to the bandstand, and how they handled the audience," says Don.

Don is an accomplished saxophonist who has recorded more than a dozen albums, worked as the music director for *The Cosby Show,* and toured with Wynton Marsalis. His passion was ignited as a kid at a summer jazz camp.

"Basically, it was a life-changing experience. Jazz camp was a guide for me that stuck in my mind as an effective tool for a young person. One of the reasons I've come full circle here is because of that."

As music director of the Litchfield Jazz Camp,

Don shares his passion with young musicians like eleven-year-old Brandon Becker Abbott.

"The teachers give you one-to-one, they focus on anyone who needs help. I'd say they teach me more in this month than I learn in the rest of the year," he says warming up for a lesson on keyboards.

Junior faculty member Zaccai Curtis remembers

that feeling. Now a touring professional who plays piano and leads his own band, he was once a camper from Hartford.

"We met a whole lot of music people here. It was a great place to play. We learned a lot of things, including theory. I think the greatest thing was the faculty," says Zaccai. "The faculty is unbelievable; you have an all-star faculty."

The focus on playing is intense. A professional jazz musician leads each student combo.

"This is a completely non-competitive program," explains Vita. "Campers don't audition to get in. They audition after they get here for the purpose of placement. So what we look for is the child who really wants to do this. We're just looking for that desire."

Vita is a dynamo, who sees the potential in each of the hundreds of kids who have attended the camp. Nearly a third of them get scholarships.

Though most campers are teens and college age, some adults come too, for the music theory courses, the private lessons, and the chance to mingle and play with the pros.

Vocalist Allegra Levy is living her childhood dream. "I went to one of these concerts called Pops and Jazz, and I saw this singer in a long black dress come out on stage. Her eyes were sparkling and she started singing this big solo. I said to my mom that's what I want to do and I was six years old."

A former camper, Allegra is a counselor now and says the camp has shaped her future.

"If I hadn't come to this camp, my fate would be completely different, there's no question. I wouldn't have gone to New England Conservatory, I wouldn't have a CD out right now, and I wouldn't be looking toward a future in jazz."

Campers come from all over the country—staying

as little as a week or as long as a month. Most sleep over, while some are day students, but for each, the experience is all encompassing.

"Here at camp, you learn about your soul through improvisation," says Allegra. "You learn more about emotional, deeper things."

Don says there's a reason for that. "We have a great faculty, a great staff and support system, so I think people feel like they can come here in a safe environment and learn a lot about jazz and hopefully about life too."

Vita can rattle off dozens of names of former campers now making lives making music. "It's a wonderful, wonderful feeling to see these children grow up and come into their fullness."

Musicians and aficionados, nurtured at the Litchfield Jazz Camp, a summer place that's positively Connecticut. ❧

Family Night Out

Mansfield Drive-In

"Come on down for the best show in town, the Mansfield drive-in," the jingle blasts from speakers set up around the parking lot. You don't hear many ads for drive-ins anymore, because there aren't many left.

"THE FIRST TIME I CAME AND SAW THIS PLACE IT really looked like a place that nobody loved, but it was really a beautiful piece of property," says pony-tailed owner Michael Jungden with a gleam in his eye.

When Michael took over the Mansfield Theater in the early 1970s, drive-in movie theaters all over the country were already becoming a thing of the past, thanks to rising land values and the popularity of cable TV and VCRs.

"I just thought that there was a way to make it work, that I could make something happen," says Michael. "I was also thinking about the fact that someday I'd be the only one doing this."

He nearly is—his is one of two active drive-ins left in Connecticut. Michael took a chance and added additional screens to the original one at the time most other drive-ins were going dark.

"It just so happened that the year that I put up the new screens they ran the cable for cable TV in town, so that took a bite out of me," he says shaking his head.

But his determination paid off and on a recent evening, cars from as far away as New Haven and even out of state lined up well before dark. Fran Burba

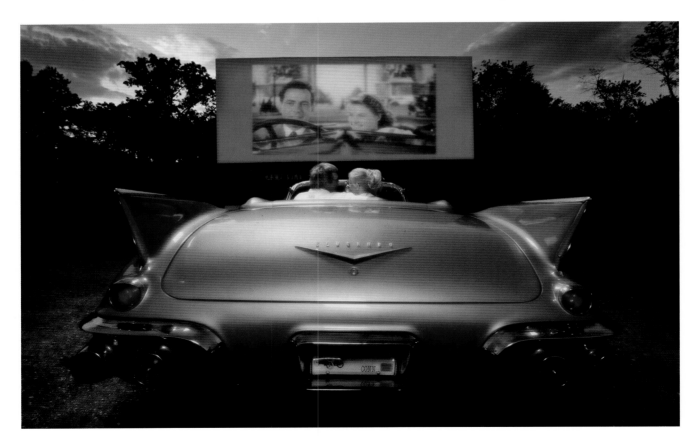

greeted customers arriving in a long line of cars and vans.

One driver tells her, "I am here from Florida to go to a drive-in, because we don't have them down there," and Fran responds as she smiles and makes change, "I've had customers all the way from Hawaii, Guatemala, Alaska, you name it."

In spring and early fall the drive-in is open Friday, Saturday, and Sunday but in peak season it's open seven nights a week. In spite of its remote location, the Mansfield Drive-In packs them in—up to one thousand cars a night.

As one driver hands her a twenty, Fran puts money back in the man's hand and says, "No, it's carload night tonight; that's way too much money, it's only eighteen dollars. Isn't that great?"

During the drive-in's midweek special for eighteen bucks, no matter how many people are in the car, they see a double feature of two first-run movies. That's a deal some families can't pass up, especially when they pack all the comforts of home.

Christine Parr and her two sisters have found a prime parking space and are outfitting their minivan roof with an air mattress, some baby bed rails, and a cooler full of snacks. She laughs and explains, "We very rarely get to go out all together with no kids and no husbands and stuff, so it's kind of like a girls night out. And we get to binge on junk food!"

Twenty-five years ago Coreen Margnelli came here with her boyfriend; now she brings her kids. "They like to come in their pajamas 'cuz it gets kind of late on the ride home."

Maritca Candelario and her kids are perched on the hood of their Camaro. She says, "I like it better because there's more space and fresh air."

Michael agrees that at a drive-in the rules are relaxed and so is the atmosphere. "You go into an indoor theater and everybody has to hush to watch the movie, whereas at a drive-in they sit in the car, they can talk to each other, they can bring their kids. If their kids are unruly, they can deal with them without having to disturb the rest of the crowd."

Jamie Langevin comes from South Windsor because she likes that "you can get up, you can walk around, and you can do whatever you want. The kids love it because they can walk around."

And people do, hopping from car to car, visiting friends and neighbors.

In the projection booth there are reels of film Michael estimates at five miles long, and there are still some speakers mounted on poles.

"When we started here we were limited because we could only sell as many spaces as we had speakers on the poles," he says. "People would come and steal the speakers and then you'd have less, and every Saturday you'd be out there fixing every speaker that was left." But most people enjoy the movie in stereo on their FM radios.

Though almost everyone packs their own snacks, the concession stand is booming, selling everything from ice cream to hamburgers and onion rings.

Michael doesn't mind people bringing their own. "If they stay through the second film, they're hungry, and there's always something they want that

they didn't bring with them, and the kids will always badger their parents into coming and buying them something."

In the heyday of Connecticut drive-ins there were some forty across the state, and across the nation the number of drive-ins peaked at more than four thousand. Today there are just over four hundred

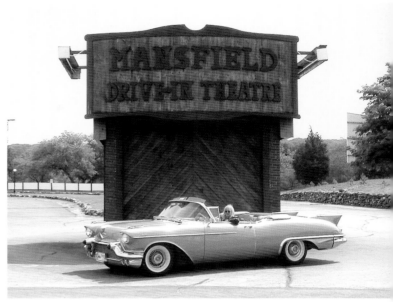

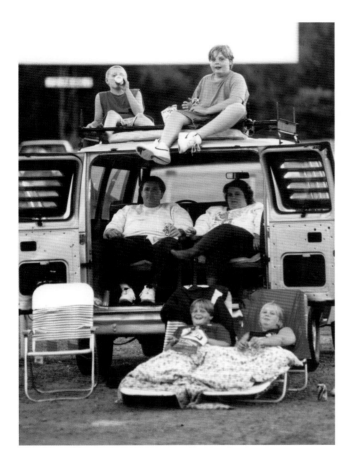

nationwide. One secret to Michael's success: "I do everything. I repair things, I'm the projection booth repairman, and I'm the soda machine repairman. When the soda machine breaks, I fix it because by the time Pepsi gets here I've already lost a few hundred dollars."

Before buying the drive-in, Michael sold auto parts, a job that wasn't nearly as much fun. "Nobody comes to see you when they're happy; they already have a broken car, whereas in this business everybody who comes in is in a great mood."

In a great mood and having a great time at a drive-in movie theater that's positively Connecticut. 🦋

POETRY OUT LOUD

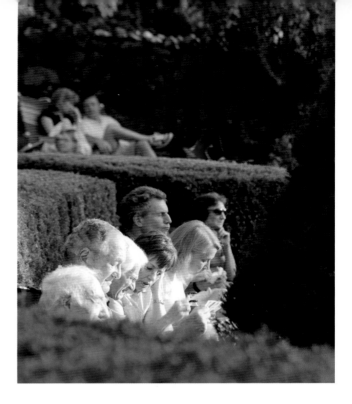

The Sunken Garden Poetry and Music Festival

Poet Galway Kinnell once called the Hill-Stead Estate's Sunken Garden a "little paradise for poetry" and so it has been for almost two decades, as the setting for the Sunken Garden Poetry and Music Festival.

> *I don't know what can be said of this life we all share . . .*
> *The defeats and victories that add up to a month or a*
> * lifetime*
> *I only know that life is an ellipse*
> *Each of us equal at each turn.*

POET LITA HOOPER'S WORDS SEEM TO FLOAT IN THE air on a summer evening in the Sunken Garden. The grand home's pioneering female architect and eventual owner Theodate Pope Riddle would have loved that, according to curator Cindy Cormier.

"Theodate wrote a lot and thought a lot about words. In our archives we have letters all beautifully penned and eloquently written," says Cindy. "This was a family that thought about the spoken and the written word. All museums are looking for a programmatic

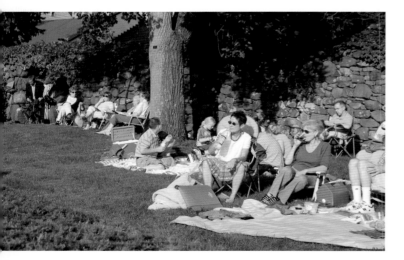

niche and this seemed like the right fit for this literary family."

Both literary and wealthy, Theodate's family often entertained writers including Henry James and Edith Wharton.

Theodate Pope Riddle designed the home in 1901 for her parents, Ada and Alfred Pope, as their retirement home and a place to showcase their collection of impressionist art that included Monet and Degas. Around 1920 renowned landscape designer Beatrix Farrand redesigned Hill-Stead's sunken garden for her friend and colleague Theodate.

"She moved away from the Victorian regimented styles of bedding into a more flowing mix of plantings, some shrubs, annuals, and perennials," says garden manager Paula Brisco. "She also interplanted things so you've got areas of the garden that look like a brocade."

Paula and a team of volunteers have restored that design.

"We actually read old garden books and garden seed catalogues from the 1920s, and we see what these plants looked like so we can go look for something that has the same color, bloom time, and height," she says.

As the garden reaches its summer peak, thousands enjoy its fragrances and blooms as they gather on lawn chairs and blankets to take it in, along with music and poetry. Bernita Sundquist has been coming since the festival started in 1992. She says the readings are like "receiving food for the spirit."

"These poetry readings are like theater," says Cindy Cormier. "A two-minute poem can transport you to another world pretty quickly."

That's something Connecticut's former poet laureate Marilyn Nelson knows well.

"It's as if the reading is created not just by the reader but by the relationship between the reader and the audience," she says. "When reading a poem alone, you're able to go back and reread a line or a phrase and mine it for something more than its surface value. I try to write for both. I write for the music of the voice and the sense of the sentences."

Poets at the festival have included Pulitzer Prize winners and high school students. On this evening, the poets have been nurtured by Marilyn at her Soul Mountain Retreat for writers in East Haddam. Like Opal Palmer Adisa, who was born in Jamaica.

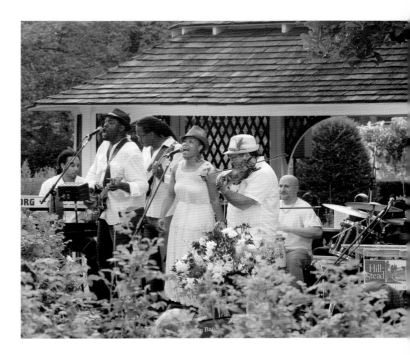

It doesn't come easy
A borrowed tongue that weighs heavy in my mouth
No matter how hard I try my lips cannot form the hard
 consonants
My aperture knows that these words are criminals forced
 down my throat.

As the poem continues, she slips into Creole and her island tongue.

Me no mute no more
Me open up me mouth
And words fall out like mango on rooftop come July
Everybody say how me a chat chat me always chatting up
 the place
Me tell them me not paying insurance upon me mouth.

"When you read a book, you bring yourself to it. When you have a poet read, they're giving you themselves," observes Bob Carr. "They're bringing their cadence, their history, their life to the poem."

Marilyn Nelson shared some of her own history in a poem about her father, a Tuskegee airman, as seen through the eyes of Professor George Washington Carver.

… a P-40 zooms in at five o'clock,
high as a Negro has ever been.

Such a shame, thinks the Professor.
Might-have-been plowshares, hammered
into swords. Sighing, he signs his shaky name
as Nelson tilts the stick to his left, pulls it
slightly toward him, pushes his left rudder pedal,
thumbs-up at the flight instructor, grins,
and makes a sky-roaring victory roll.

The applause is warm and full at the Sunken Garden at the Hill-Stead Museum—a paradise for poetry that's positively Connecticut. 🍃🌿

ALWAYS ASK FOR AVERY'S

Connecticut's Old-Time Soda Bottler

Move over Pepsi, so long Coke: With flavors like Bug Barf and Kitty Piddle, an old-time soda company in Connecticut is reinventing itself.

INSIDE AN ANTIQUE RED BARN, TUCKED INTO A residential neighborhood in New Britain, it looks like a mad scientist is at work in his laboratory, pouring brightly colored liquids into beakers.

"A little lime, a little citric acid, and we're all set to go," he mutters.

Actually it's Rob Metz, the owner of Avery's

Beverages, working on a new soda called "Drink Pink."

As Rob stirs the liquid in a big stainless steel tank, he explains that the passion fruit- and lime-flavored syrup will be combined with carbonated well water to become the new signature drink for the "Race in the Park," New Britain's annual breast cancer fund-raiser. That's why Rob says, "Drink Pink is the 'breast' soda in town."

Sherman Avery started making soda here in 1904, and there have only been a couple of owners since. But when Rob bought the company, he shook things up . . . a little.

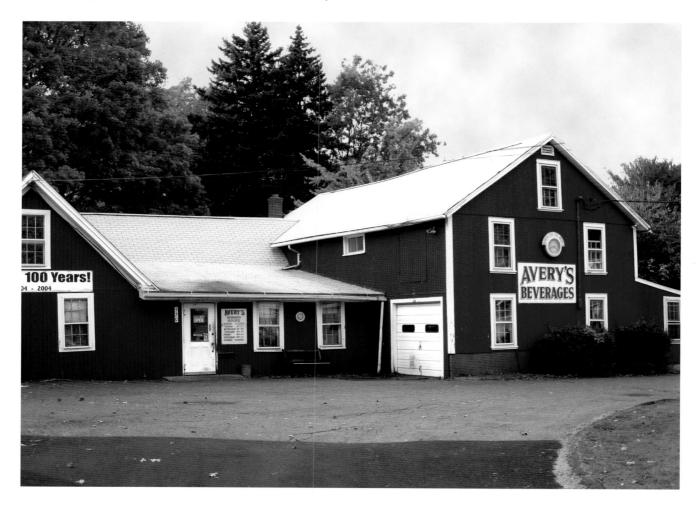

"We like the old-fashioned feel of the factory so we stepped it up a little to get us some better production, but we don't want to go too high tech," he says.

Not much danger of that. Rob bought new washing and bottling machines that he calls state of the art—state of the art in the 1950s that is. Avery's uses as many vintage bottles as possible—some of them are thirty years old. The clanking machine bathes the bottles in super hot water, and then rinses them five times before they are refilled. Rob calls that "ultimate recycling."

Rob makes a point that his recipes don't include newfangled ingredients like corn sweeteners.

"We still use real sugar and there's no caffeine in it. Some of these flavors you just can't get in the supermarket. Where you gonna go to find a good Lime Rickey or Sarsaparilla? You have to go to Avery's."

People come for the classics—birch beer, black cherry, orange cream, and three dozen other flavors. But Rob says people who drink Avery's like more than the taste; they like the tradition.

"We have people coming in here generation after generation who come in and say 'my grandfather brought me here' and they're bringing their kids or their grandkids here," Rob says smiling.

He's talking about people like Tony Pierkowski. "I grew up in New Britain and ever since I was a little kid we always got Avery's soda. It's soda made the old-fashioned way."

Tony drives from Somers to get his fix. But Avery's is one of the few businesses that still offers home delivery, though they're no longer using the horse and wagon Sherman Avery used.

A few local businesses carry it too. Fans like Mike Pastore duck into Leaves and Pages, a bookstore and cafe next to City Hall, for an afternoon refresher.

Mike is loyal to the brand because "Avery's is local. It's New Britain's own."

Arlene Palmer, who owns the cafe, likes serving Avery's and says it's more than just two small

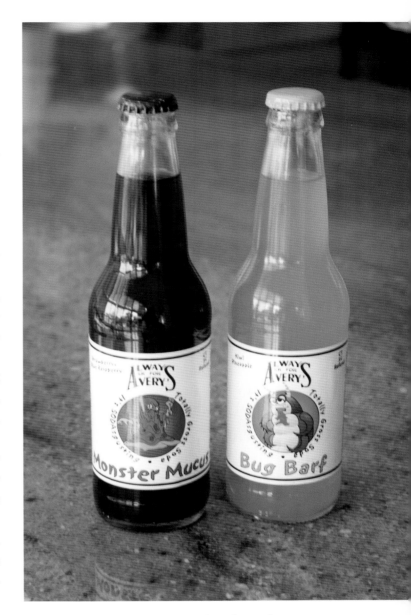

businesses trying to help each other. She supports Rob because "he does a lot for the community."

In addition to creating Drink Pink, with a portion of the proceeds going to fight breast cancer, Rob developed a limited edition Presidential Inauguration soda, which helped raise money for Foodshare, which supplies local food banks. Sometimes the sodas are made just for fun, like the two he concocted during the 2008 election: John McCream and Barack Oberry. Avery's staff kept a tally of which sold better. "John McCream got creamed," Rob laughs.

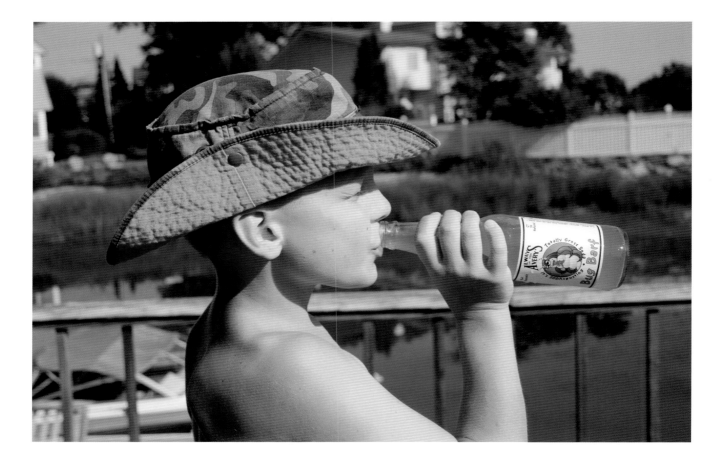

And sometimes there's a little social commentary added to the mix, like the Obama Stimulus soda, which has extra citric acid because, "like the economic stimulus package, it's hard to swallow."

Although they already offer three dozen flavors, Rob will whip up a special soda for your wedding or your sweet sixteen party or even your baseball tournament.

"You know when you're driving along and a bug goes splat on your windshield? Isn't that what this looks like?" Rob says mischievously holding up a bottle of bright green soda. He dubbed it Bug Barf and it's part of his Totally Gross soda line, created by and for kids, who come to Avery's for "make your own soda" parties.

"They started coming up with some interesting and wacky flavors and one was Swamp Juice, but it tasted really good, and we said 'we need to market this.'"

So I tried making my own. I'm labeling it Diane Smith's Used Mouthwash.

But while some of the names may be unsavory, all the flavors are tasty at Avery's Beverages, where the soda is positively Connecticut. 🍃

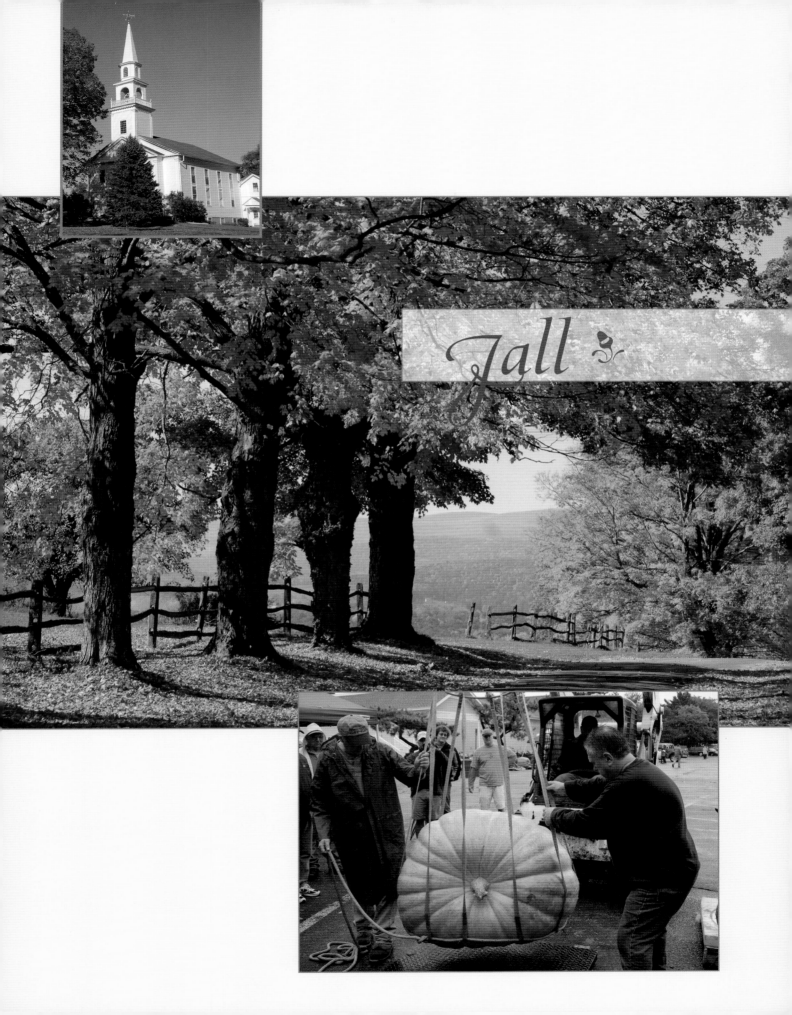

Fall 🍂

BARN AGAIN

Preserving Classic New England Architecture

Once they were everywhere in Connecticut—barns filled with animals, or tractors, or tobacco. As Connecticut farmland shrinks, its barns are disappearing. But not if Susan Vincent can help it.

SUSAN VINCENT LIVES IN THE NORTHEASTERN PART of the state, the section known as "the last green valley." Besides a lot of greenery, there are also a lot of barns.

"I'm a past board member of the Connecticut Trust for Historic Preservation, and I worked on their barn survey; in this part of Connecticut, there are over eight hundred barns still standing," says Sue.

Three of those barns are on the Vincents' Greystone Farm in Thompson.

"When we bought the farm there was only the large barn, and the floors were all rotted in it. We had to do a lot of extensive work on the floors and the beams and the siding of the barn."

But the barn was the reason the Vincents bought Greystone. Sue wanted a space where her extended family could spread out for parties. The big barn has been the site of her niece's wedding, family reunions, and fund-raisers for local charities.

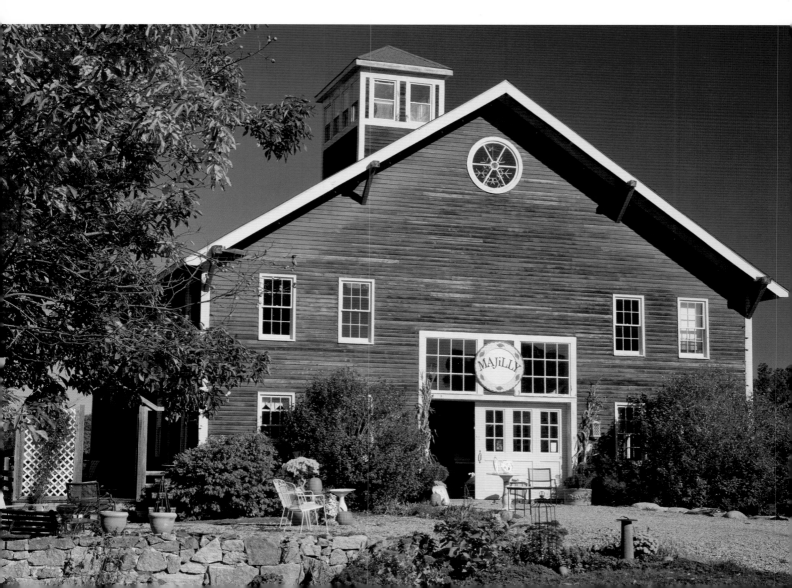

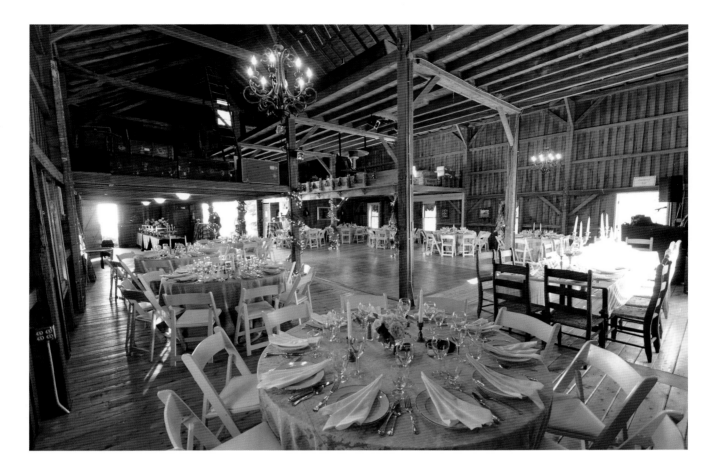

It's a classic New England–style barn, which was an improvement over the earlier traditional English barns, according to Aren Carpenter, who helped restore it.

"You could drive all the way through the barn, and then in the middle of it, you could stop with a large load of loose hay and they would have a hay track that would come down and pick it up, through the center scuttle hole to the hayloft," he says.

Sue added a kitchen but preserved many of the barn's original features.

"It has what are called cow stairs, so when the cows came in from the pasture, they came in underneath, and they came up those stairs to be milked. We had those converted a bit so we can go up and down, because downstairs is where we actually eat when we have parties," Sue says as she leads me down the wide shallow stone steps.

When another historic barn nearby was slated for demolition, Sue bought it and trucked it to Greystone in pieces. Now it's used for storing tractors, and sometimes as a dance floor for her parties. In Greystone's hayfield there's a third barn built with pieces of a barn salvaged in Canada.

Aren uses a combination of antique and traditional tools, and modern day construction equipment, which he says makes him appreciate how difficult old-time barn raising really was.

"That's one of the reasons, when they are torn down, I say 'oh my God.' People don't have any idea of how much work went into that building, to just wreck it, callously."

The Vanilla Bean Café in Pomfret was once a barn attached to a federal-style house, a trend during the middle decades of the nineteenth century. When Barry Jessurun bought the barn twenty years ago, it

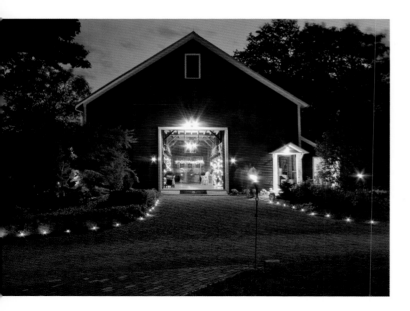

Although you won't find horses in the old stalls, there are generally a few puppies around. Breeding Labrador retrievers is another passion the Emilios share.

These days the nineteenth-century chestnut barn on Tyrone Farm in Pomfret Center is more likely to resonate with music than moo-ing, but for many years it was the centerpiece of the gentleman's farm where Bill McLaren grew up.

"We had four milk cows and then a small number of horses. The location right across from the house makes it very convenient," he says.

Bill, a retired navy intelligence officer, inherited the elegant 160-acre estate from his mother.

"After her death, we had to clean this barn out and it occurred to me, because this was no longer an animal space, that it would make a good people space. It's interesting to see how restorative a barn can be in people's psyches. There's an affinity between barns and people," Bill says.

The barn is now popular for country weddings. About 70 percent of Tyrone Farm's energy is generated by a solar array installed in the extensive gardens. While moving into the future of alternative energy, Bill hopes people won't forget the past and will take steps to shore up their aging barns.

"These barns weren't built to last forever. They were strictly functional in many cases, and after one hundred years or so, they'd probably just fade away," he says.

The Connecticut Trust for Historic Preservation is working to prevent that, surveying about 1,700 barns in the state so far. The trust offers grant money and expertise in saving a part of Connecticut's agricultural past that is positively Connecticut. 🌿

needed a lot of work, so he recruited his friends and family.

"We took it right down to the outside walls," says Barry, "and then just started rebuilding from there."

Barry never considered razing the barn—he says the warm homey feeling you get from the old beams can't be duplicated.

"It's what people from other parts of the country are looking for. Nothing says New England more to me than a barn, or a barn that's been turned into a home, or turned into someone's business."

Majilly is the name of the business the Emilios run from their nineteenth-century post and beam barn in Pomfret Center. They say they were "city folks who longed to live in the country" when they bought the dilapidated barn. They renovated it and now design and sell ceramics there.

"Our world headquarters is located on the second floor," says Martha Emilio. "We also have a workshop up there."

Connecticut's Blue-Blazed Hiking Trails

The next time you take a hike in Connecticut, think of the many volunteers who helped make your walk in the woods possible.

WE PILE OUT OF THE VANS, AND KIDS AND ADULTS grab tall walking sticks as hike leader Ann Colson points out trail markers. "You'll notice the blue mark on this phone pole. That's a signal we're on one of the Blue-Blazed hiking trails in Connecticut. We're going to turn into the woods here and keep on going and see where we end up. Come on, let's go."

This trail winds along the edge of Cockaponsett State Forest in Middletown.

"All of the trails in the Blue-Blazed system are maintained by volunteers. We have more than one hundred trail managers and 825 miles of trails in eighty-eight Connecticut towns," Ann explains.

Chris Woodside is one of those trail managers. "In our spare time we clear trees that have fallen down on the trail, and we paint the blue blazes to keep the trails clearly marked. We do this because we love the trails and we want them to be here for everyone."

For novices this is the road less traveled. But

hikers will tell you, if you want to really experience Connecticut, you've got to hit the trails.

"The first time I came up here, the thing that came into my mind was, I'm in Middletown, Connecticut, and the city is just a few miles away," says Chris. "It just goes to show you that we don't really always know what's right here where we live. This is one of the most beautiful places I've ever hiked and I've hiked a lot of places."

The views are courtesy of the state and of many private landowners who graciously allow hikers to cross their land so everyone can enjoy the scenery.

"You think of Connecticut as very developed but you can go off the back roads of Litchfield and think you're in the depths of Vermont or something. It's surprising how much wilderness there is in Connecticut," says hiker David Sullivan.

The trail takes its cue from the landscape, and we make our way over rugged mossy rocks, around crooked trees, accompanied by the sounds of nature as geese fly low over the reservoir, and a brook babbles as it meanders through the woods.

Along the way, hikers and the guides point out flora and fauna, including Mountain Laurels they judge to be more than seventy years old.

Along with the official state flower, young explorers discover the work of busy beavers, aphid-infested evergreens, delicate pink Sheep's Laurel flowers and the remnants of a wasp gall—a leaf that turned into a nest.

Chris leads us to the crossing of two trails. "We're now on the Mattabesett Trail, which is a wonderful trail, designed, built, and maintained by the Connecticut Forest and Park Association."

An army of volunteers from the Connecticut Forest and Park Association is dedicated to preserving the Blue-Blazed trails.

Last year "over 500 trail volunteers documented over 12,000 hours spent maintaining the Blue-Blazed Hiking Trail system," according to Eric Hammerling, the executive director of CFPA. "Many of these volunteers have been working for five to ten years (and in some cases many more) to maintain a section of trail they have grown to love."

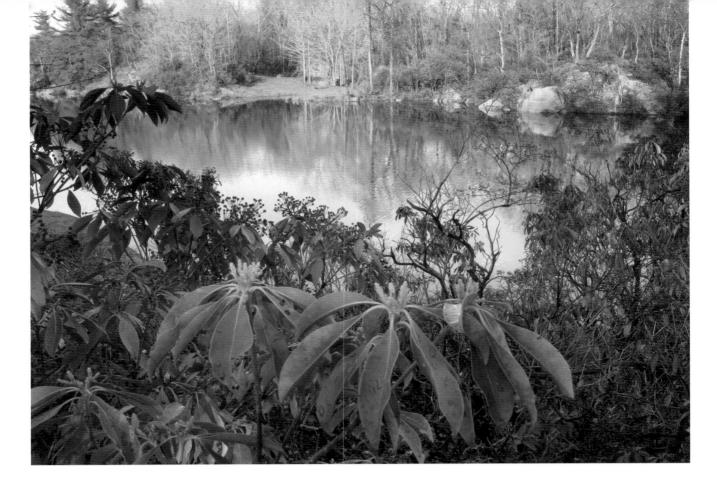

The group banded together in 1895 to save Connecticut woodlands from over-timbering and runaway forest fires. At that time 20 percent of the state was wooded; today 60 percent is, thanks in part to CFPA's role in forest management and conservation.

"There are 825 miles of trails in over eighty towns across Connecticut. If these trails were strung together and stretched southward or westward, they would reach respectively to just beyond Myrtle Beach, South Carolina, and to Indianapolis, Indiana. The distance of the trails packed into a small state is impressive enough, but the outstanding quality of our trails is also nationally significant," says Eric.

It's also significant that the Mattabesett Trail is part of the new federally designated New England Scenic Trail, a two-hundred-mile length of trail that travels through thirty-nine communities in Connecticut and Massachusetts. "The New England National Scenic Trail is within ten miles of approximately two million people and most do not know about or use the Trail. We hope that this designation and amplified efforts to publicize the Trail will help more people experience its beauty," Eric says.

The trail boasts classic New England views including panoramic vistas, heavy forested glades, and colonial landmarks.

These winding paths provide more than respite and recreation; they are a close-up and personal way to explore the state.

"You might only be going four or five miles in a whole day," says Chris, "but then the next time you come you'll pick up where you left off and you'll continue on that trail and see where it's going to lead you. There's nothing like it."

The Blue-Blazed Hiking Trails, pathways that are positively Connecticut. 🌿

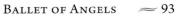

BALLET OF ANGELS

Along the Connecticut Wine Trail

When Sherman Haight opened Connecticut's first farm winery in 1978, many wine lovers scoffed and said this state couldn't produce world-class wines. Don't tell that to the thirty wineries now operating in the state, whose wines have captured medals in competitions all over the country.

CHARDONNAY AND RIESLINGS WERE THE FIRST grapes Sherman Haight planted at his vineyard in the Litchfield Hills.

"When we started out . . . I got admonitions from a number of really good agricultural colleges, including UConn and Cornell, who all said, 'Don't do it, don't do it, it won't work,'" Mr. Haight recalled. "I was determined to make it work—but it was a very expensive beginning. We made lots of mistakes—hopefully not too many of them twice, and it has worked out very well."

Today the new owners of **Haight-Brown Vineyard,** Amy and Courtney Brown, also cultivate Merlot, Seyval Blanc, and Marechal Foch on their twenty-five acres. All over the state wineries are trying out new varietals to see which will thrive in southern New England.

On the opposite end of the state, on a hillside in Pomfret that has been farmed since 1760, stands a barn that looks as though it might have been there nearly as long. Inside you'll find barrels of fine wines, not farm animals. Steven Vollweiler made wine in his basement at home, and his wife, Catherine, paired it with her wonderful cooking when entertaining friends. They dreamed of opening a winery, and spent nearly ten years searching New York's Hudson Valley, Long Island, and Connecticut for the perfect place to combine their passions for wine, food, and antiques. With the help of some UConn scientists, they found

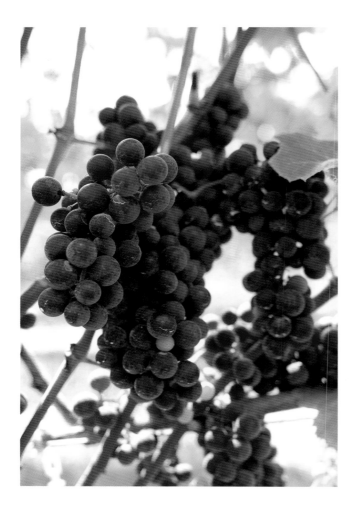

the right microclimate for a winery they call **Sharpe Hill.** From their vineyard they have a view of three states.

"We had to have hills for drainage and it was great to have a mistral, which is a continuous flow of air," Catherine says. "You had to have no frost pocketing and of course it couldn't drop below a certain degree."

The vineyard temperature is nearly 20 degrees warmer than average for the area, nurturing Chardonnay, Vignole, Cabernet Franc, and St. Croix grapes.

Sharpe Hill is the biggest winery in the state and its best-known wine is called Ballet of Angels. Wine dealers say it is the best seller of all New England wines. Its lovely label enhances the wine's popularity, and Catherine loves to tell its story. The label was derived from a nineteenth-century painting that she had long admired. When she sought permission to use the painting on her label, Catherine discovered a wonderful coincidence. Although the painting is owned by a museum in Cooperstown, New York, hundreds of miles away, the portrait is of a child who had grown up near Sharpe Hill. Catherine says that adds to the wine's "spiritualness."

In the tasting room, there are visitors from Massachusetts and Connecticut. Andy Esposito drove up from East Haven.

"I think the wines are every bit as good as most of the wines in the Napa Valley and they have the advantage of having a nice soft finish, so they're wonderful with a meal," he said, savoring a sip of a reserve Chardonnay in the tasting room.

They're especially wonderful with meals from Sharpe Hill's Fireside Tavern. In warm weather diners may eat outside in a wine garden modeled after alfresco dining spots in Europe. Inside the replica cow barn is an inviting early American–style dining room. The attention to detail in the construction and décor of Sharpe Hill transports guests to an earlier time and place but the wine-making is state of the art.

Karen Carpenter leads tours explaining, "There is such a science to it even in choosing which oak barrels. They are lightly toasted, medium toasted, American, and French oak."

If the atmosphere at Sharpe Hill is reminiscent of a colonial American farm, there's a taste of Portugal at **Gouveia Vineyard** in Wallingford. That's because owner Joe Gouveia hails from the small Portuguese village of Tranozelos, and built his winery from stone and old timbers, with a hint of nostalgia for home. The hilltop winery has an expansive view of the vineyards and beyond, and Joe and his wife Lucy invite guests to pack a picnic and spend some time.

"Sometimes visitors like to sit back and enjoy a glass of wine by our double-sided fireplace or outside on our patios to take in the spectacular setting sun. Sometimes three or four generations of families

will sit at a table by the window and play Monopoly while sharing cheese and crackers. Sometimes friends will sit together on our dock and watch the fish swim beneath their feet," says Lucy. The winery is so popular that since its opening in 2004 the family has already nearly doubled its size.

A little taste of Europe is noticeable in the style of the wines produced at a shoreline winery. If the sun reflecting off the grapes reminds you of sparkling emeralds, you're in the right place. **Chamard Vineyards** was the creation of a man who knows a thing or two about gems. Bill Chaney was the chairman of Tiffany and Company when he opened the winery.

Bill says farming is in his blood. He's the grandson of a Kansas wheat farmer. Research told him a Clinton farm just two miles from Long Island Sound would be a good place to make wine, with its mild winter temperatures and long growing season. So he bought a forty-two-acre farm that had been abandoned and overgrown and planted grapevines, mostly Chardonnay and some red wine grapes, Pinot Noir, Merlot, and Cabernet.

"The climate is certainly right and proper. It's comparable to some of the finest wine regions in France," Bill told me. That's why Bill hired Larry McCulloch to produce wine similar in style to French wines.

Pouring from a bottle of Chardonnay, the winemaker describes it as having "subtle fruit, a nice crisp acidity, and a touch of oak that we add to it which makes it complex as opposed to a California or Australian wine with its big massive fruit."

Larry sees a change in the wine with every harvest. "Each summer is so different that each wine has its own quality because of the season we're having. The wine is really made in the vineyard. As a fruit grower I know that if my crops are clean and everything is ripe then I have to do less in the winery. I guess we like to be referred to as winegrowers not winemakers."

Not long ago Chamard changed hands, and the new owner, Dr. Jonathan Rothberg, is a scientist

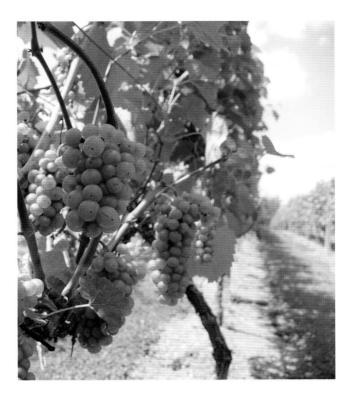

known for his work in genetics and biotechnology. He plans to apply those interests to winemaking to take Chamard to another level and add new wines to its roster. The winery has added special events including live music to attract visitors.

"I want Chamard to be a destination the same way you think of Mystic," said Dr. Rothberg.

Other wineries host art shows, dinners and cooking classes, and barrel tastings, and they even make personalized wines for your cellar.

According to the man many would call the founder of the Connecticut wine industry, Sherman Haight, the key was finding a way to grow the right grapes for the region.

"And we've done it," he says. "And now, the wine industry of Connecticut is growing like crazy, and we're part of that. So that's our biggest accomplishment. We found a way to make it work."

In just over three decades the state's winemaking industry has come into its own, producing vintages that are positively Connecticut. 🌿

GOING BATTY

Rehabbing Bats

For many of us, bats are the scary denizens of the dark. Hollywood and literary images of them, as vampires feeding upon human blood, have made them one of the least appreciated critters on Earth.

THAT IS UNTIL GERRI GRISWOLD CAME ALONG. During rush hour Gerri keeps watch over traffic on Connecticut highways.

"We're doing very nicely out here, no blemishes, and I have no complaints on my secondaries this morning—you're moving smoothly along," she says into her microphone, reporting the traffic on WTIC-NEWSTALK 1080.

Gerri is on the air several times every hour. Often snuggled beneath the lapel of her jacket is a brown bat named Poppy.

"She thinks she's a person so it makes her a very good animal to use for education," Gerri says, "and a great way to dispel all of the rumors about bats—that they are evil and wicked and latch onto your throat and suck your blood."

Gerri discovered the apparently orphaned newborn on her farm in Winsted.

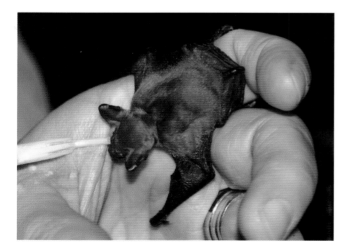

I asked Gerri, "Do you think she bonded with you because she thinks you're her mom?"

"No doubt about it. She opened her eyes for the first time and there I was. I never intended to keep her. It was my duty as a wildlife rehabilitator to release her, but when I gave Poppy her flying lesson she failed it. She flew across the room and then she crawled across the floor and walked up my leg," Gerri says with a fond smile.

Growing up on a farm with bats in the barn rafters, Gerri was enthralled with bats as a child. Today she is one of 238 licensed wildlife rehabilitators in Connecticut and one of the few who specialize in bats. Even at home, Poppy often nestles in Gerri's shirt pocket.

"They are crucial to life on Earth," she explains. "We are not necessary to life on Earth. If every human

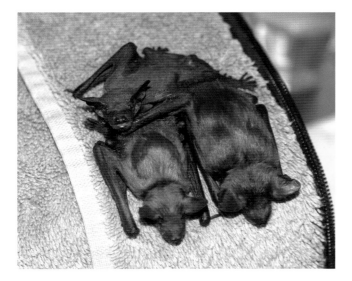

disappeared right now, what would happen to the planet? It would exist, but if you remove this tiny little thing in my pocket, in insects alone we would be doomed, we would be doomed. One cave of bats outside of San Antonio, Texas, eats 250 tons of insects a night!"

Gerri is fond of most kinds of wildlife; as her collection of antique taxidermy will attest, but spreading the truth about bats is her mission and she and Poppy bring the message to kids in classrooms and nature centers all over the state.

"I'm hoping after my talk they won't make the same mistakes that their parents make by not being educated. So whoever brought Poppy and me together, it was for a very specific reason."

Because of their voracious appetite for insects, the state is keenly interested in the health of its bat population according to Jenny Dickson, a wildlife biologist for the Department of Environmental Protection.

"Bats are the single largest predator of night flying insects that we have in the United States," Jenny says. "They consume just phenomenal numbers of insects, and that's everything from black flies to mosquitoes on up to moths, crickets, and grasshoppers."

On a warm summer night, Jenny and two assistants are surveying the bats in a park in Redding. They roll out a length of extremely fine, nearly invisible mesh, known as mist netting. Although a bat's sonar can detect objects as fine as a human hair, if a bat is intent on catching and devouring an insect in its path, it may not notice the netting. Just after dusk they begin to fly into it.

Jenny gently untangles the bat from the netting as she explains, "We figure out what kind of bat it is, we get their sex, we figure out if it is male or female. We get their reproductive status: Is it a female who has given birth recently? Is she still pregnant? Is it a male who is ready to breed?"

The bat is tagged with a numbered wing band for future study and released. There are eight species known to live in Connecticut, and several are threatened.

Orphaned or injured bats of all varieties are sent to bat rehabilitators like Gerri, who nurses them back to health on a diet of TLC and live mealworms.

If they are native species and recover completely, they are released. If not, they may become part of the road show Gerri takes to schools, explaining their role in insect control, pollinating fruit trees, how they hibernate in winter, and how humans have learned

about sonar from bats. She dispels myths that bats nest in human hair or are bloodsuckers or mice with wings. They are most closely related to primates.

And there's another lesson in Gerri's talk on bats. "They're discriminated against because they are not beautiful creatures; whales and dolphins are beautiful, and people love them. Bats are not necessarily pretty, and it's not fair to judge something whether it's the kid sitting next to you or anything else based on what it looks like."

But for Geri bats *are* beautiful. Her home is adorned with bat art; she wears bat hairclips, pins, and necklaces. As a licensed volunteer rehabilitator, she does it for love, not money.

"You know those of us that love what we do, we just do it. Call us crazy, call us batty, it's normal for us!" she says.

Batty? Well maybe, but it's absolutely positively Connecticut. 🐾

HISTORY DETECTIVES

The Legacy of Abner Mitchell

You could call them Connecticut's History Detectives. See how a bundle of old letters and a friend's promise turned some history students into super sleuths.

EVERY OLD HOUSE HAS AN OLD TALE TO TELL, BUT sometimes it takes a young person to tell it. In Washington, in western Connecticut, an attic full of boxes turned up a treasure.

"They were perfect little tissue paper letters with little writings, and I knew they were going to be valuable and needed to be read by somebody," thought Toppy Pickett when she came across them.

When Toppy couldn't make out the handwriting on the letters written by her great grandfather Abner Mitchell, she asked a friend for help. Paula Krimsky is a pro, an archivist at the Gunnery School in Washington.

"I took them home meaning to transcribe them for her, but I have a job and a family and I didn't get to them and I was feeling more and more guilty," says Paula.

My Dear Little Daughter

Your Papa is away down here in the woods but he thinks of his little girl very often and hopes she is well and a good girl, and that she will always mind ~~their Mama and all the rest there~~ *are a great many things a little girl can do for Grand ma and all the rest you can go and get things and be sure and go just as soon as she speaks and not wait a minute shall you go to school this summer has school begun and if so who is the teacher have you learned your letters I suppose when Papa comes home you will know how to read and perhaps will be able to write Papa a letter before he comes so you must try and be a good girl and remember your Papa*

A m m

Paula mentioned the letters to Mike Croft, a history teacher at Shepaug Valley Middle School.

"He said 'well I have eighty-seven students in my history classes and that's enough students to handle all the letters' and that's how the project was born," she says.

Mike turned his eighth-grade classroom into a lab for history detectives, to read the forty-nine letters Abner Mitchell wrote after being drafted to serve in the Civil War. Mitchell went, even though the town offered to send a replacement.

"Washington, Connecticut, was a hotbed of abolition; his own father-in-law was an abolitionist," Mike says. "So for Abner it may have been a very clear idealistic choice to serve in the war."

And a costly one. An exhibit at the town's Gunn Museum shows what the students uncovered.

"This is Connecticut where he started," says eighth grader Eddy Anderson, pointing to a route along a hand-drawn map of the eastern seaboard. "And then it goes down to Washington, D.C., where he joined the army."

In the year before he was drafted, Abner's happy home had become a dark place, as the eighth graders discovered.

"They gasped when we read the letters and realized that Abner Mitchell had lost his wife and then lost his son in a sledding accident," says teacher Mike Croft. "Then he lost three of his four remaining kids to diphtheria the week before Christmas and that family of seven was now a man and his five-year-old girl."

The letter reads:

"This is the day after Christmas. You will probably remember this day one year ago. I can but little realize that day, yet I can in imagination, a row of coffins that held nearly all my family as they stood in front of the desk."

Abner's last child, Mary, moved in with her uncle while he went to war. He wrote tenderly to her.

"Your papa is away down here in the woods but he thinks of his little girl often and hopes she is well and a good girl."

The letters tell of Abner's life as a soldier in the 6th Regiment Connecticut Volunteers, and of his enduring faith in God.

"My wish is that I may always be willing to follow His lead and trust Him for He is all wise and knows what is best."

The melancholy and loneliness came through to student Lily Bogue. "He was so far away from them and I put myself in the place of his parents."

A friend of Abner's wrote the fiftieth letter. Mike read a passage.

"The letter is to Abner's parents from a soldier in Stafford saying 'Dear Sir, I regret to inform you that your son has received a wound and it is considered mortal.'"

Mike's class recovered stories lost to Toppy's family and she was grateful.

"The most amazing thing is that they kept their enthusiasm for a whole year while working on this," Toppy said.

With the start of a new school year, Mike's eighth graders began a new project, researching and transcribing letters from Jessie Benton Frémont, the wife of explorer and politician John Frémont. Jessie wrote the letters to the headmaster of the Gunnery, where her son Charley was a student.

"Charley is a bad kid; she's worried about him," says Mike. "Some of the kids read this and think 'wow, this is the conversation that my mom had with the principal when he called last night to say I had detention.'"

Although there are many books about the Frémonts, the letters contain new information and a touchstone to history.

"It gives you more of a connection," says student Brendan Welsh.

Mike is already planning a project for next year's eighth graders because, he says, this is the way kids learn history.

"We ask them to know stuff and remember stuff but we don't actually ask them to do what historians do," he said, "so I wanted to ask kids to try and learn history by *being* historians."

And it worked. The students and the Gunn Museum won several state and national awards for their collaborative projects. Middle school historians, uncovering history that is positively Connecticut. 🦋

FRUITS OF THEIR LABOR

Cranberry Harvest

For one Madison family the fruit of their labor is the cranberry; for them, it's a labor of love to raise and harvest it.

WHEN THE EVARTS FAMILY SITS DOWN FOR THANKS-giving dinner, you can bet there will be cranberry muffins on the table. When it comes to cranberry sauce though, they prefer a can of Ocean Spray. That surprised me—because the Evarts operate the only licensed cranberry bog left in the state of Connecticut in Killingworth.

Vintage farm equipment, built by Ken Evarts's father and grandfather, is trucked in on picking day.

"Nobody else touches this machine. It's my baby. It doesn't have any wheels on it and it picks a little closer. I always try to think I can get more berries than the other machine. You have to be a 'one upper' to compete with this family," Ken laughs.

The harvest is always around Columbus Day, and the entire family pitches in, all five of Ken Evarts's daughters and their boyfriends, husbands, and kids.

"As little kids we rode up here with Grandpa Sid to pick," says Pam Evarts Landon, "and it's always been here. We don't know anything else for this time of year."

Pam's mom, Sandy, supervises the entire operation.

"There's kind of a job for everybody, no matter how big or small?" I asked her.

"Absolutely, and if there isn't one we make one!" Sandy declares.

On a sunny fall day the cranberry bog looks like a big field—but during the winter you could mistake it for a pond. Ken uses an old system of sluiceways and gates in a dam to flood the bog to protect the vines

from freezing. It's something this family has done for over one hundred years.

"It's been in my husband's family since 1896 when his grandfather Cyrus Evarts started it with several other men," Sandy explains.

Cyrus was inspired by a visit to a cranberry operation on Cape Cod.

"I have Kenny's grandfather's old log book, which says how much it cost them to go up to the Cape round-trip including the horse and wagon," Sandy says.

In the early days cranberries were picked by hand, then with a wooden scoop or rake, and it was back-breaking labor. In the 1950s the Evartses started using mechanized dry-pickers, which comb and cut the ground-hugging vines and churn the berries, leaves, and stems into burlap bags. The kids haul the bags by tractor to the blowing machine.

"It blows the extra chaff and weeds and so forth out, the kids pick them out, berries fall down through a grate, they go into a box underneath, and that box then goes to another machine, which we call the sorting machine," Ken explains.

Which divides the berries by quality as they bounce through. The bigger the bounce—the better the berry. Then the wooden crates of berries are hauled to the house Ken's father left them—where the berries are painstakingly sorted again and packaged into one-pound bags for sale. There's so much work involved that years ago Grandpa Cyrus's partners sold their part of the bog, and the Evarts family got into the construction business. The cranberry crop nearly died out.

"My wife and I have been trying to bring it back," says Ken. "We got down to two or three boxes one year. We have to pick every year to keep the vines going and it seems like the crops are coming back up."

This was a bumper crop of 1,400 pounds. Although the Evartses sell their berries, they say there's very little profit in it; in fact most years it costs them money. But they continue because it's their family's tradition.

"It's a lot of work but you don't really think of it as work because we're with our family," says Pam. "We're doing it with people we love and it's a lot of fun; we can joke and rib and tease and have a great time, we really do."

The Killingworth Land Conservation Trust wants to make sure that this tradition continues so they've designated forty adjacent acres, now known as the Pond Meadow Natural Area, as open space. One acre is maintained for local folks to pick their own cranberries once a year. The bulk of the land is being managed as a habitat for several endangered species of plants including grasses and wild orchids. Land Conservation Trust president Sue Davenport says that means keeping invasive plants from taking over and preventing the land from "turning into a red maple swamp."

Dave Gumbart, a member of the land trust, says the bog is not only a "unique habitat that offers biodiversity of plants" but he notes that it was a major part of the town's history and culture. "We want to stay in touch with our past and be good stewards for the future, so one hundred years from now people will still be picking cranberries here."

As for the Evartses, they hope to keep their part of the bog operating for years to come. Keeping a family heritage and local history alive—something to give thanks for—that's positively Connecticut. 🌱

Whimsical Winvian

Unusual Luxury

Connecticut is known for lovely inns nestled in beautiful countryside. But there's a unique resort that's setting a new pace.

FROM THE ROAD WINVIAN LOOKS LIKE MANY OF its neighbors in the Litchfield Hills—a lovely saltbox from 1775—set on a farm studded with typical New England barns. But looks can be deceiving at this luxury resort in Morris. Step inside one of those barns and your jaw drops.

"Helicopter" is the name of one of eighteen cottages at Winvian. Spending the weekend in the decommissioned Sikorsky-built Coast Guard chopper was the wild dream of one of fifteen architects who designed these over-the-top cottages.

"He was convinced I was going to say no," recalls Maggie Smith, the resort's owner, "but I was intrigued and since so much of what we're doing here is whimsical I thought it'd have punch and a wow factor."

Maggie was right! "Wow" was exactly what I said when we crossed the threshold. Reserve this cottage and enjoy drinks or a movie inside the chopper's fuselage, sleep in comfort in the hangar, or live your fantasy of piloting a rescue chopper. The helicopter won't lift off, but the controls are still inside.

Want to reclaim your youth? Climb high into the "Treehouse" cottage, which is suspended thirty-five feet above the ground. With no two walls running parallel and materials that look like they were scavenged from a luxury lumber yard, this is the playhouse the most creative kids in your neighborhood might have built.

"We approached this whole project with a real sense of humor. We wanted to tweak things enough to have people smile, and you do see it as guests are walking around. We wanted to instill a sense of wonder and awe that's almost childlike, and to look at things from a different vantage point," Maggie says—the vantage point of people who can afford to spend up to $2,000 a night for a curious cottage.

"I think it's incredibly unusual bordering on wacky in some of the cabins," says travel writer Michelle da Silva Richmond. She thinks guests go to Winvian for more than luxury—they want an experience—to go home and tell their friends "guess what I did this weekend."

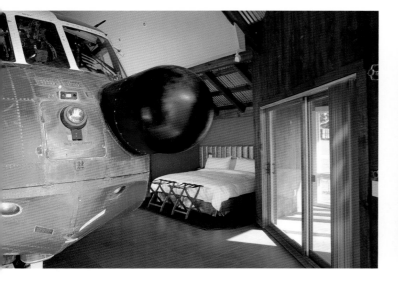

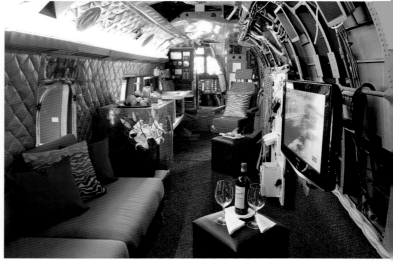

That might include pounding on your chest and feeling like a caveman if you spend the weekend dwelling inside "Stone," a cottage disguised as a New England stone wall, with boulder upon boulder piled up in a grassy meadow. A double-sided massive fireplace dominates the living room and bedroom, and animal hides hang in place of draperies. The Flintstones never had it this good!

"When you open the door you should feel like you have stepped way way back in time," says Maggie as we continue our tour. "That architect insisted on using resources right from the earth and everything on a very grand scale."

That's a dramatic contrast with the femininity, finesse, and detail of "Artist." Leaded glass, mirrors framed with shattered teacups, and etched windowpanes create a cottage that resembles a 1930s getaway for a budding painter.

If you can tear yourself away from the plush cottages, there are several intimate dining rooms tucked into the main house that Vivian and Winthrop Smith once called their country home. Winthrop was the founder of Merrill Lynch and they named their farm Winvian, a combination of their first names. The farm is still in the family, with their former daughter-in-law Maggie Smith converting it to a highly unconventional

resort. As part of Winvian's nightly rates, guests can help themselves to bottles in the wine cellar and enjoy three meals a day prepared by a chef who worked in some of the nation's most elite restaurants.

"The guest never sees the same meal twice," says executive chef Chris Eddy. "So whether they are here

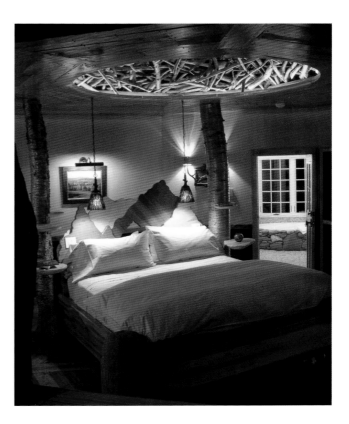

for two days or four days we're constantly introducing them to something new and different."

You probably won't be eating hot dogs, though you might want to toast marshmallows on the screened-in porch if you choose Winvian's "Camping" cottage designed by architect John Martin.

"The first thing you see when you wake up is the ceiling which has clouds and sky painted on it. As you look down, you see the window with trees embedded in the glass, giving the feeling of looking out from inside your tent."

Martin supervised the fourteen other architects involved in designing Winvian.

"Most architects are used to doing the whole project on their own and being in charge so when you have fifteen people in charge it makes it more challenging," he says diplomatically.

Each cottage has Connecticut roots—like "Secret Society," based on the tomblike structure of Yale's Skull and Bones.

A luxury bath reminiscent of Stonehenge is tucked into a cabin inspired by Mark Twain's *A Connecticut Yankee in King Arthur's Court.*

There's the lighthouse-like "Maritime" cottage evoking Long Island Sound, and "Woodlands," which brings the outside inside with trees supporting the loft and a burbling waterfall separating the bedroom from the tree trunk vanity sinks.

Guests at Beaver Lodge snuggle beneath down comforters and gaze up at a real beaver dam, carefully reconstructed from one found on the property, which borders the 4,000-acre White Memorial Foundation, a wildlife conservation area.

As travel writer Michelle da Silva Richmond says, "This is just something a little out of the ordinary that only a certain percentage of the population can pay for, and as I say when you've been there done everything . . . this is the next best thing!"

Winvian—it may be the ultimate escape that's positively Connecticut. 🌹

WE LOVE A PARADE

Helium Balloon Wranglers

When I was a kid, my family attended the Macy's Thanksgiving Day parade in New York City, and I wondered what it would be like to be a balloon wrangler, marching down the street tethered to a helium character. In Stamford I had my chance, and it was Miss Piggy and moi!

IN STAMFORD THE HOLIDAY SEASON STEPS OFF THE Sunday before Thanksgiving with the UBS Parade Spectacular featuring twenty-five balloons, thirteen award-winning marching bands, floats, dance troupes, and a celebrity grand marshal . . . baseball great Tommy John.

"When they asked me to do it, I said sure; then I started doing some research and I found out this is huge!" Tommy says, as he gets ready to climb on the back of a convertible to join the parade, which has become one of the biggest helium balloon parades in the nation.

The parade is said to draw over 200,000 spectators, and then there are all those people behind the scenes . . . more than a thousand volunteers like balloon handler Sonya Van Norden and her team from the Boys and Girls Club of Stamford.

"It's a lot of fun. Number one we get to do it with all the staff, so it's a great camaraderie event. Then when you see the kids from the club on the side with their parents and they're waving to you and calling your name and shouting, it's something to look forward to every year," she says.

Sonya's a veteran with five years as a balloon handler—and three with the lovely Muppet Miss Piggy on her pillow balloon.

The fun starts Saturday afternoon when families flock to the "balloon blow up" on Hoyt Street. When inflated they are as tall as nearby office buildings, but

the balloons arrive in medium-size canvas bags. Like Miss Piggy, most are made from rip-stop nylon and coated with PVC.

"She is forty-five feet tall, sitting on a Kermit patterned pillow. The pillow is a digital print, and it's magnificent," says Steve Thomson of Fabulous Inflatables, as he unpacks Miss Piggy from the bag. "She is wearing a diamond tiara, a diamond bracelet as you know every queen should, and she takes about 4,500 cubic feet of helium."

Steve Pope's Aimtek truck provides all the helium they'll need for the entire parade—about 150,000 cubic feet. A tangle of hoses leads from the truck to each balloon.

A cold wind blows down the block, wrapping one balloon handler in pink nylon as he struggles with a popular balloon. "We're blowing it up with fans right now to get the air flow through it. This is Pink Panther, one of the larger balloons in the parade."

After they're inflated the balloons are tied down for the night, but they will all be topped off with more helium in the morning. A change in temperature can make them expand or contract.

On parade day the performers include mother and son stilt walkers joining a cast of clowns that includes one better known as the chairman of the chamber of commerce.

"My clown name is Tickle Me Pink," says Joyce Mazur, "but my friends call me Tickles."

Most of the year the mayor is in charge of Stamford. "It reminds people of who we are and what we are and how great a city Stamford is," says former mayor Dan Malloy, "and how great a state Connecticut is!"

But on parade day Jami Sherwood calls the shots, standing at the corner of Summer and Hoyt Streets, signaling each unit when to step into the line of march.

"We have such great teams in each section that my job is the easiest one here," Jami says, and then whistles for Big Bird and Curious George to move forward. "I just let them all go and wish them well and have a great parade."

Meanwhile Sonya's team of twelve handlers is ready to rock with Miss Piggy and one novice handler . . . me!

"There's a lot more resistance than I thought there would be," I confided nervously to Hector Torres, the handler on the next line.

As we turn onto Summer Street the crowd demands a "spin," meaning all the handlers on our balloon trot in a circle, trying not to get tangled in each other's lines, as we twirl Miss Piggy in midair while plucking her under the overhead power lines and out of danger. The cheering of the spectators is exhilarating.

"I am having the time of my life right now," Hector laughs, a little out of breath.

Tens of thousands of people line the route to get a glimpse of their favorites.

"Oh it's great," says Kristen Slinsky of Bethel, holding her heavily bundled-up toddler in her arms. "Cassie's having such a fun time seeing Elmo and Big Bird and Thomas the Tank Engine."

Rachele Ligi of Stamford is a regular at the parade. "We love it. We come here every year." Her sister Carolyn Ligi says, "We have our own tradition. We don't have to go to New York to see a big parade!"

And as she says it, Santa in his sleigh comes around the corner, kicking off the season with the UBS Parade Spectacular. In Stamford it's a holiday tradition that's positively Connecticut. 🌿

ROCK STARS

Stone Walls of Connecticut

Take a drive or walk almost anywhere in Connecticut and you'll see them—the stone walls constructed generations ago. We take them for granted, but what if they disappeared? It's happening all over the state, and some people are taking action to preserve a piece of our past.

STONE BY STONE—THAT'S HOW A MASON BUILDS A wall. *Stone by Stone* is also the name of the book that has been called a manifesto on the history of New England stone walls. Its author, University of Connecticut geology professor Robert "Thor" Thorson, moved here from Alaska.

"The first time I stepped out in the woods here and I saw a stone wall with a tree growing out of it surrounded by other stone walls, it struck me that it was a ruin and I have been attached to stone walls in an interesting way ever since," he says.

In communities like Hebron the locations of stone walls now appear on survey information filed by developers with town planner Mike O'Leary.

"It's in response to the town saying 'these are significant elements of the landscape' and we want to see if we can work those into the final designs so they're preserved," he explains. "We find developers are responding very well to that."

As new homes go up, old stone walls like the pair lining what was once a colonial cart way or cattle path are being saved or, if necessary, moved and reassembled nearby.

"Hebron, like a lot of towns in eastern Connecticut, has a rural history, an agricultural history," Mike says. "Stone walls are very often the fabric of the community, a part of the community that I think people recognize and want to maintain."

Thor says that's one element in an equation that makes Connecticut the epicenter of stone walls.

"To be what I call 'signatures of the landscape' you need three things in place. One of them has to be a livestock farming economy, because you need to clear the trees to have animals on the land. You need to be haying and taking care of property where fences matter." And he goes on, "You have to have glaciated soils, and those soils have to have a third element, and they have to have hard slabby crystalline rocks. If they don't, then the stones would be crushed by the glacier."

Bill Anderson, the owner of Blackledge Country Club in Hebron, comes from a long line of local farmers, so when his family converted an old farm into a golf course he respected those remnants of history.

"Actually we get a lot of comments from our customers that come in and say 'those stone walls are beautiful' and it's part of the character of the golf course."

But what about properties that don't have that historic feature? Professor Thorson is concerned about what he sees as the theft and sale of stone walls to property owners who want to bring a piece of New England to their plot of land, no matter where they live.

"People are willing to pay quite a bit of money for it and so stones are being strip mined off otherwise beautiful abandoned farmsteads," he laments. "Often that stone is going to places where it doesn't even look right. In fact it looks architecturally out of place."

New Englanders are noticing, taking interest, and taking action. And Thorson's books *Stone by Stone* and a children's book called *Stone Wall Secrets* have led to a grant that enables Thorson to develop a school curriculum on stone walls.

"To have it be the nugget to which literature, to which history, to which science and math attach, because there is plenty of mathematics here. We can talk about dimensions of height and width and size and weight and mass and curvature and all of that," Thorson says. There's also plenty of history here, which brings us to our cultural heritage to talk about farmers and early colonists and pioneers. I would argue that stone walls are better known in literature than anywhere else, through poetry and imagery."

Professor Thorson believes we have what he calls "a reverence for stone" because "it is a way to connect back to the founding of our country, not just the founding of New England but our whole country."

Saving stone walls, a growing movement that is positively Connecticut. 🦢

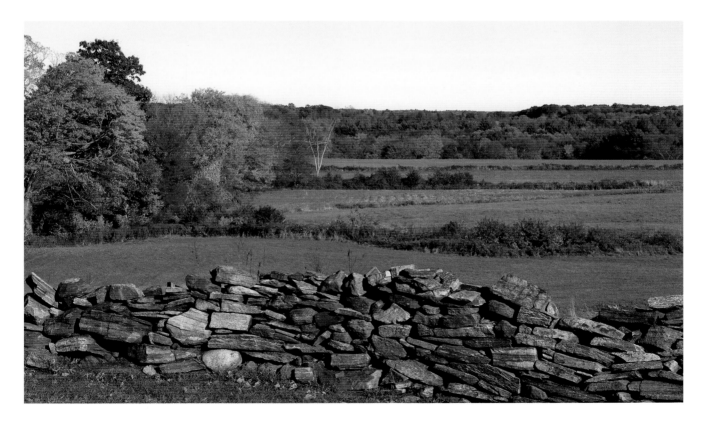

EARTH BELOW, SKY ABOVE

AT THE YALE PEABODY MUSEUM OF NATURAL HISTORY in New Haven, inside the new Hall of Minerals, Earth and Space, you can check out weather all over the world in real time and see meteorites that have blasted into Connecticut. But the minerals, rocks, and gems are the real stars.

Visitors are dazzled by the Benjamin and Barbara Zucker family collection of historical diamonds, rubies, and sapphires that includes a ring that dates back to the days of Marco Polo. The exhibit traces the history of diamond cutting and polishing.

Professor Jay Ague, curator of mineralogy, explains that the collection "goes back to the days of Benjamin Silliman, really the first professor of natural history in the United States. He started off right here at Yale in 1802 and fairly early on he began collecting minerals for teaching his students. As a consequence we have things in our collection that you just can't find anywhere else."

The gallery showcases the world-renowned collection and highlights properties like fluorescence and radioactivity. Some spectacular specimens from our own state reveal details about Connecticut that few of us know, including the history of abandoned copper and other mines.

"This Barite crystal came from an underground mine in Cheshire that was more than four miles long. Connecticut is mineral rich, the source of many fine garnets and amethysts as well as building stones like Portland Brownstone and Stony Creek granite," says Ague.

The famous pink granite quarried in Stony Creek can be seen everywhere from the base of the Statue of Liberty, to Philip Johnson's AT&T (Sony) skyscraper in New York City, to a 40-ton pedestal right outside the Yale Peabody Museum. A bronze torosaurus is proudly perched on top.

A visit to the gallery reveals a world below the surface that is positively Connecticut. 🐛

Second Chances

Ruth Foster's life changed dramatically twice. The first time was when an accident left her with a brain injury and a severe hearing loss. The second time was when Haley, an Australian cattle dog mix, became her constant companion.

"I'm a lot happier now that I have her. After the accident I sort of went into a depression thinking this is so unfair, why do I have to go through this?"

Haley is a service dog who alerts Ruth to sounds she would otherwise miss like a knock at the door, a ringing telephone, and a kitchen timer.

"She's definitely made my life better. I have independence, I can go wherever I want, and I can be home alone."

Haley was a rescue dog, and she got her second chance at life when she was "incarcerated" at the York Correctional Institution in Niantic. She was part of the Prison Pup Partnership, a program that allows inmates to raise and train service dogs for people living with disabilities.

A black Lab named Barney lives with an inmate named Debbie in her small room. The dogs arrive as puppies and stay at least a year, learning the skills they'll need to help their future companions.

In the training room, Debbie and the other inmate dog handlers put Barney through his paces. Every week a professional trainer from National Education Assistance Dogs comes and works with the women and all kinds of dogs, ranging from Labs, to poodles, and even a shih tzu named Dandy. So far thirty dogs have graduated from the program at York.

An inmate named Lakitha says, "I'm glad that I can do something for someone else. I feel like I am making a difference to someone."

And there are other benefits. Corrections supervisor Ellen Hurlburt says the dogs have a calming effect on the prison. "People seem to be happier and less anxious with the dogs around."

Another corrections officer, Kris-Anne Kane, agrees. "When you're having a bad day, you can go get some puppy therapy just down the hall so I love it."

In the training room an inmate named Nancy is sitting in a wheelchair. She is a veteran, training her fourth dog, this one a yellow lab named Cody.

Nancy, who is serving time for killing a woman in a drunk driving accident, says training Cody for a life of service gives her a chance to make amends.

"It helps to know you're still part of something. You are contributing back to society."

The dogs adapt quickly to the routine of prison life, going everywhere with their handlers, and sometimes taking furloughs into the community for more socialization.

Lisa is serving time for conspiracy to commit assault. When she was sentenced she left three children behind. In prison she has raised three companion dogs. Soon to be paroled, Lisa says she'll be a better mother, because the dogs have taught her "the importance of patience and discipline and consistency. That really does matter a lot."

Nearby at Gates Correctional Institution some inmates and some animals are getting another chance for a better life. The Second Chance Corral is where horses and the occasional goat are housed when the agriculture department seizes them from neglectful or

abusive owners. Some of the horses arrive near death, not much more than skin and bones, but inmates like Zack give them a healthy dose of TLC.

"After a while you can tell a big difference not only in their weight, but in their personalities," he says. "You can see it in their eyes, in their facial expressions. You can really tell when a horse starts to trust you."

A former agriculture commissioner and several volunteers built the Second Chance barn. They needed a place where neglected animals could recover. They are often sick and not vaccinated, so commercial stables don't welcome them. Complicating matters, horses are often seized in large numbers according to Maureen Griffin, the supervisor of the department's animal control division.

"Some of the owners have a syndrome known as hoarding or collecting and the people can't give them up. In their minds they love these animals and that's what makes it sad when they can't feed or care for them properly."

Over the months of their rehabilitation, Maureen sees a difference not only in the animals, but also in the men who care for them.

"A lot of them are very reluctant to exhibit any kind of emotion, but if you come down here when no one is looking sometimes you'll find them in a stall just quietly petting one of the horses or cleaning it, trying to take care of it. I listen to them and they all talk to the horses when they go in there and they all know the individual personalities of the animals."

Most of the inmates working as stable hands have never been around horses before. I wondered how the horses react to them and an inmate named Brett told me, "Some are better than others. They have good days and bad days, but for the most part they seem to be getting a lot better."

The stable has another function beyond being an infirmary of sorts. Each of these horses from the Morgans to the miniatures is being held as evidence in a legal case against their owners.

In the safety of *this* lock-up, the horses learn to respond to the touch of a human hand again, offered in kindness.

"It's nice for the horse to first come in and really be kind of a wild animal because of the conditions they were in," says Zack. "Then when you come in here and start handling them a lot more and they start to trust you more it's gratifying. It's gratifying work."

Warden John Tarascio says for some of the horses, who will be auctioned off after they've recovered and the state's custody cases are completed, this is truly a second chance at a better life, and for some of the inmates who have helped them . . . it may be too.

"Many of our people come in and in essence they've been abused," the warden says thoughtfully. "They've had a tough life full of crime and drugs and this gives them an opportunity to feel good. When they take that back to the community, it gives them a chance at success."

At Gates and York there's a second chance for inmates and animals that is positively Connecticut. 🎐

Putting the Pieces Together

The American Mural Project

Call it a quilt, lovingly pieced together, or a tapestry woven across all fifty states, or a tribute to the working people of America. Sharon artist Ellen Griesedieck calls it the American Mural Project, a mammoth work of art ten years in the making (so far) that will eventually be bigger than a basketball court.

ELLEN IS AT WORK WITH A PAINTBRUSH, STANDING atop a scaffolding some fifteen feet in the air. Vast slabs of aluminum honeycomb, like those used in airplane construction, are the canvasses for Ellen's paintings of people at work, like the gargantuan portrayals of men on an auto assembly line.

"Some part of me is very George Plimptonesque," admits Ellen. "I really love living other people's lives. I found when I was starting to do these working paintings that I loved being up on the beam with Bob the ironworker two hundred feet up on the West Side Highway."

She started with large individual paintings, but when Ellen tried to capture Boeing workers building a 747 she realized she had to go bigger, and that's when the American Mural Project was born.

When complete, Ellen envisions the mural as 125 feet long and nearly five stories high. It is more than a painting. It is composed of many materials, including ceramic tile, fabric, and blown glass.

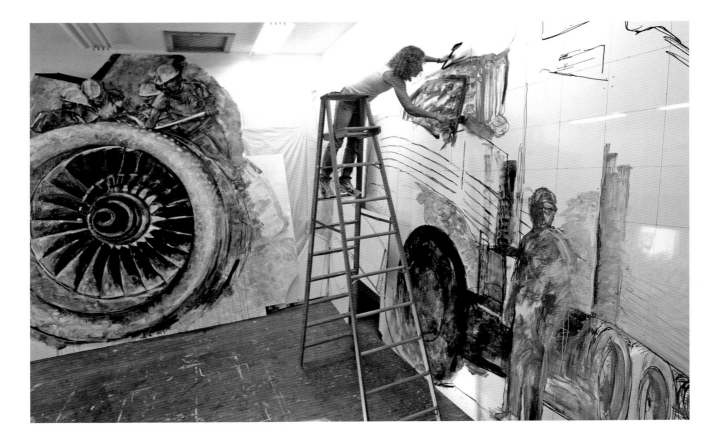

"It's a mural that can only fit into a building the size of the Parthenon, so when you're standing back from it, you've got to have this thrill of the surface itself. It's just got to be screaming out to you to come closer," she says.

The mural is about Americans at work, and *by* Americans at work. Ellen is planning collaborative projects in all fifty states.

"This is about everybody who goes to work and says I love what I do, I have a commitment to work. If you can say that about the work you do, then you should be tributed," she says.

Mark Grusauski's regular job is restoring antique airplanes in Canaan. Ellen called him in to fabricate one portion of the mural.

"Each project is taking a lot of time and effort and creativity. You think about walking into this thing when it's done and it's going to be amazing," Mark says.

Mark and his partners created a blown up Plexiglas version of rice paper origami made by Japanese Americans who had lived at the World War II internment camp Manzanar in California. That's one of eleven states so far where Ellen has organized projects to put together sections of the mural.

Artist Sandy Boynton is a friend of Ellen's and an advisor on the project.

"It's so profoundly collaborative I think that's what she loves most about it," says Sandy. "Ellen's a people person; so I think that's what energizes her."

In Minnesota Girl Scouts from Minneapolis and Native American children living on the White Earth reservation combined nature and plaster of paris for their segment. One of the scouts was Ellen's niece.

"On this project we were trying to weave all the different paw prints together as if you were on a track going through the wild," says Taylor Healy. "I think it turned out really well."

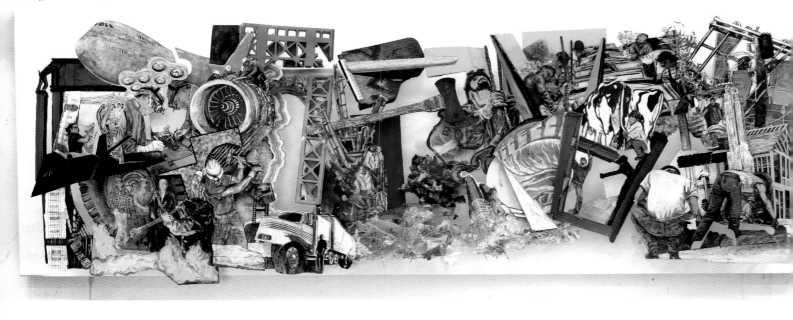

In Gee's Bend, Alabama, Ellen teamed up with women who are famous for stitching quilts from cast-off work clothes. To make the quilt, Ellen collected clothing from at least one person in each of the fifty states.

"Amazingly these people didn't hang up on me when I called; they sent me their clothes. Oscar sent me his uniform; he's a parking valet in L.A. We had doctors' scrubs. Ringling Brothers' circus sent us four boxes of circus clothes," she says laughing. Add a flight suit from a pilot of the Stealth aircraft, a parka from a member of the Aspen Ski patrol, even satin boxing trunks from Muhammad Ali, whom Ellen got to know during her career as a professional sports photographer.

Each state project recognizes something about that region. Connecticut is represented in the scenes from a foundry, since the corner of Connecticut where Ellen lives was the birthplace of the American Iron Age.

Dylan Morehouse was in middle school when his class worked on that part of the mural.

"Thousands and thousands of people are taking part in this and I was one of them. In twenty years I will be taking my kids to see it and just looking at this and saying 'yeah I did that.'"

The mural will be installed in a former textile mill complex in Winsted. Ellen bought two of the old buildings, and is raising money for renovations that will raise the roof to accommodate the height of the mural. She plans a visitors' center where workers ranging from pilots to heart surgeons to coal miners and truckers will come to tell their stories, and the story of working in America.

"So in the end if you walk in to see the American Mural you should be able to find yourself in there," she says. "Everybody should be able to say 'there I am; there is some symbol in there that is me.'"

The American Mural Project, a portrait of our country with roots that are positively Connecticut. 🌿

HOME IS WHERE THE ART IS

Connecticut's Art Trail

Fall is a great time to get out hiking along Connecticut's many beautiful trails. But if "roughing it" isn't your style maybe you'd prefer another kind of trail . . . the Connecticut Art Trail.

THE CONNECTICUT ART TRAIL IS NOW A PARTNERship of fifteen art museums and sites across the state, but it was launched in 1995 to unite the places that demonstrate the influence this state had on American impressionism. Today it may be the most beloved style of art in this country, but impressionism was a tough sell in the 1860s according to Eric Zafran of the Wadsworth Atheneum.

"It was especially difficult for the Americans to take to what they felt was a really modern and horrible new style of painting that was so direct and free," says Eric. "They couldn't read the pictures originally and they were given advice that you had to stand twenty feet away so you could get in focus when you looked at the picture."

In the Cos Cob section of Greenwich, the **Bush Holley House** was the first impressionist art colony in Connecticut.

"Cos Cob at the time was considered a pastoral, bucolic setting, an escape from New York City where most of these artists were working," according to Heather Cotter, the director of education at the house.

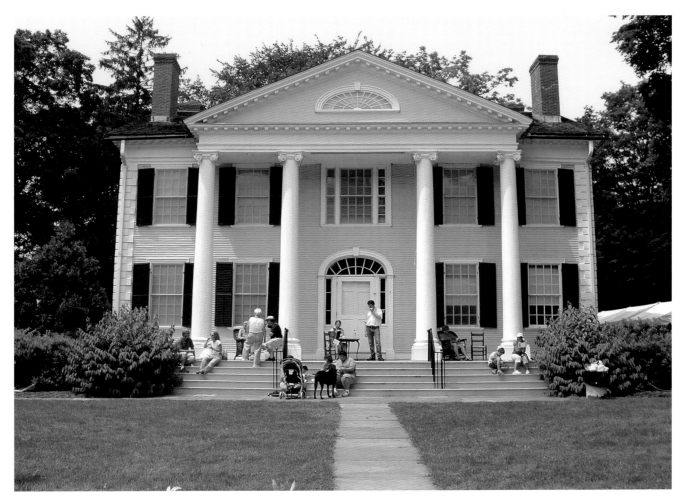

Artists like Elmer Livingston MacRae and J. Alden Weir turned this into a bohemian enclave.

"They shared their meals together, they shared this home together, and they became very interested in sharing their ideas about art and art making," Heather explains.

A recent exhibit at the **Bruce Museum** in Greenwich highlighted another side of American impressionism as artists depicted what curator Susan Larkin called the "Beauty of Work."

"The French impressionists announced their modernity with images of people at leisure dining open in the air, strolling in parks and gardens, sailing and canoeing, or just lolling in a hammock. The American impressionists showed an almost equal

fascination with workers and worksites," Susan says.

Willimantic's thread mills fascinated J. Alden Weir, who also drew inspiration from the orchards, pastures, and stone walls of his Wilton Farm. **Weir Farm** is now Connecticut's only national park, and the inspiration for his paintings can be enjoyed from a network of walking paths.

There's no gallery at the farm—but some of Weir's works are displayed at other state museums. His "Road to the Land of Nod" and "The Laundry in Branchville," as well as "Weir's Orchard" by Albert Pinkah Ryder, are all on loan to the Wadsworth Atheneum in Hartford.

The oldest college art museum in America is the **Yale University Art Gallery,** where works by Europeans like Cézanne, Corot, and Millet are complemented by Americans William Merritt Chase, Childe Hassam, and Willard Metcalf.

Those Americans were among the two hundred or so artists who made Florence Griswold's boarding house in Old Lyme the biggest impressionist art colony in the United States. They even used her home as their canvas, painting on her walls and doors. Jeff Andersen, director of the **Florence Griswold Museum,** says, "We invite you to see those works but then see the setting in which they were created, and walk through the spaces where they lived, played, and worked."

The **Lyman Allyn Art Museum** in New London benefited from the affection these artists felt for the shoreline. According to curator Nancy Stoola, some of their finest paintings were donated by the artists' heirs, like a view of the Connecticut River from Old Lyme donated by the widow of William Chadwick.

Backtrack from New London and Old Lyme and follow the trail up Route 9 to **New Britain's Museum of American Art.** Founded in 1903, it is believed to be the first museum entirely dedicated to American art. The museum has focused on collecting Connecticut artists, including nineteen paintings by Childe Hassam.

"They liked him for his choice of colors and they liked him because he had such an active brush stroke. It becomes almost a staccato arrangement of shapes

and forms," explains Douglas Hyland, the museum's director.

The **Hill-Stead Museum** in Farmington is the most personal and maybe the most exhilarating collection on the trail. Ada and Alfred Pope's daughter designed their home to showcase their art collection, which includes paintings most of us have only seen in prints or postcards. During their travels to France, Alfred Pope bought impressionists' work as the paint was still drying.

"When he goes on vacation, he buys Monet paintings," laughs director Cindy Cormier. "When we go on vacation, we come home with much humbler souvenirs."

The drawing room highlights four haystack paintings by Monet. There is also a painting of dancers backstage, a moment captured in time by Edgar Degas.

The **Wadsworth Atheneum** in Hartford is not only the nation's oldest public art museum, its collection is a veritable encyclopedia of art through the centuries. Eric Zafran points out one pivotal work by Monet.

"He thought the seashore was an ideal place for an impressionist painter to work because you get that mix of light and sun reflecting off of the ocean and sand."

The painting of Monet at work in his country garden is reminiscent of the pastoral scenes of Connecticut that drew American impressionists to places like Old Lyme, Wilton, and Cos Cob. But the story is best told on the trail.

"We can't present in one place the sheer diversity of that story, the complexity of that story, but together our institutions working collaboratively can tell the story unlike anywhere else," says Jeff Andersen.

The impressionist art trail has been so successful that it has expanded and added six museums, featuring other genres of art. Now known as The Connecticut Art Trail, it is a way to appreciate the state's contribution to fine art. And, of course, it's positively Connecticut. 🌹

THE PRICE IS RIGHT

Goodspeed Opera House

2008 marked the fortieth anniversary of Michael Price's tenure at Goodspeed Musicals—the longest for an executive director in American theater. More than four million people have seen over 11,000 performances in this Connecticut landmark.

HAPPY DAYS: A NEW MUSICAL IS ONE OF THE RECENT productions at Goodspeed Opera House . . . but there have been a lot of *happy days* at Goodspeed in the four decades since Michael Price became executive director.

Happy Days is one of the more than two hundred musicals Michael Price has produced, including sixty-three world premieres. That's more than any other theater in America.

"I liken the theater to hits, runs, and errors like a ball game," says Michael with a grin. "We've had a lot of hits, a lot of runs, and a lot of errors. Some of my favorite pieces here did not resonate with the audience so those are the errors."

But Price's batting average is major league—he's had many more hits than errors. One of the biggest was *Annie.*

"It was not a production for children. It was an adult musical dealing with FDR and Herbert Hoover and the Depression. It has now become a piece that youngsters enjoy, but we didn't see it at that point," he says.

And at first, Price passed on the show, until his wife, Jo-Ann, made him re-think that a year later.

"The tunes, the tunes were the thing that sold me on that show. I couldn't get 'Hard Knock Life' out of my head," he recalled. "We were walking through Hyde Park in London and I was whistling some tunes from *Annie* and Jo-Ann said 'why you don't try to put that back together again.'"

He did—and in 1976 created a show that went on to win hearts—and the Tony award for best musical.

Another home run, *Shenandoah,* premiered at Goodspeed and went on to play Broadway for more than two years.

"I took the actor John Cullum to see the writer and director five times before they said yes. That was the show that gave John Cullum his first Tony award and then he went on to have a great career in the theater," Michael says.

Michael Price has nurtured some five thousand actors, musicians, directors, choreographers, designers, and technicians. In 2008 some of them gathered with politicians and theater patrons to honor his fortieth anniversary at Goodspeed.

The songwriter Paul Williams composed the music for *Happy Days: A New Musical.* He talked about the cachet of working with Michael Price.

"If you tell someone you're working at the Goodspeed you get an 'oooo.' *Happy Days* and Goodspeed will always be associated and as long as high school kids are singing these songs twenty years from now, I'll always tip my hat to Michael and say thank you, you were part of that."

Michael Price's enduring love affair with the Goodspeed started when he was a theater student at Yale. But it was his professor of architecture who gave him the advice that set his life's course.

"He said 'Price, I've got a project for you; they're renovating the Goodspeed Opera House. Go and write about the timber structure, and by the way, if you can turn it into a theatrical piece, you can submit it to The Drama School and get double credit on the same piece.'"

As Michael says—one thing led to another and Goodspeed hired him as production manager.

"I lasted about six months, this smart ass kid right out of Yale. I got put on a raft and sent down the river," he laughs looking out his window at the beautiful view of the Connecticut River.

Five years later (1968) Michael was rehired and this time he stayed.

There were some tough times, just before Price came back. In 1966 *Man of La Mancha* nearly bankrupted the theater. But *La Mancha* went on to great success on Broadway and Price guided Goodspeed back onto solid footing.

"We have a loyal audience. They are the fans in the stands that allow us to fail, and obviously we don't fail too often because we always come back for another season," he jokes.

"The fantastic thing about Goodspeed and Michael Price is that they champion the old school musicals," says actress Donna Champlin. "We visit these classics and we learn how to do different styles that we don't really have the opportunity to do many other places."

Senator Chris Dodd is not just a neighbor to

Goodspeed; he is also a fan. "It's become such a jewel in the Connecticut crown to have this only theater in America dedicated to this unique form of theater, the American musical. It is really a special gift for our state and it would not have happened without Michael Price."

Still there are challenges in the theater Price calls a gorgeous little jewel box.

"We are doing the impossible when we have twenty-five actors, ten musicians, and a number of stagehands in a four-hundred-seat theater. We have the highest number of artists per seat in the country and we need more seats."

But for now he says, "These are really heady happy days in this theater. I love coming to the theater every night and you know something? You can have your cake and eat it too."

Happy Days and some memorable "Tomorrows"—all part of a score that is positively Connecticut. 🥀

Leading Lady

Westport Country Playhouse

After seven decades of productions described as "a living textbook of twentieth-century American theater," the Westport Country Playhouse was in danger of collapse. That's when actress, director, and Westport resident Joanne Woodward took a leading role.

IN 2002 WHEN THE WESTPORT COUNTRY PLAYHOUSE production of *Our Town* opened on Broadway starring Paul Newman, "The Westport Country Playhouse just immediately became *voom:* much more apparent and noticeable and notable," according to its artistic director emeritus, Joanne Woodward.

Staging the play with Connecticut's most beloved actor was a stroke of brilliance at a critical time for the playhouse, when Joanne Woodward had stepped in to save it. It not only brought notoriety to the playhouse; it brought in some revenue, as the theater embarked on a major makeover.

The actress has a lengthy history with the playhouse. She first visited it as a drama school student more than fifty years ago. "I was so taken with it. The theater was so marvelous," she recalls.

Little did Woodward know then, that after making a life on stage, in film, and in Westport, she would devote herself to preserving the playhouse, and improving it with an $18 million renovation.

"When I started thinking about it I thought 'yes, we'll renovate this theater,' and we all sort of felt we didn't want to change it too much," Joanne says. "But like Topsy it grew and grew and it got changed because it needed to, it had to be."

As associate artistic director, Anne Keefe was Joanne's partner in the project.

"We sat down for meeting after meeting after meeting and did some pie in the sky dreaming, and I have to confess that I never thought this would happen."

For help Joanne Woodward called upon influential friends, businesses, and a community of theater people like actor Christopher Plummer.

"This theater had to be saved because it has such a wonderful history," Plummer says. "There are more extraordinary people who have performed here than any other theater on our continent."

Plummer himself, the veteran of more than one hundred films, got an early start here. The stage was also graced by luminaries from Tallulah Bankhead, Paul Robeson, Henry Fonda, and Helen Hayes, to a teenage Liza Minnelli, and recently Richard Dreyfuss, Gene Wilder, James Naughton, and Paul Newman.

The original barn was built when Andrew Jackson was president. It had been a tannery and a cider mill. But in 1930 Broadway producer Lawrence Langner was looking for a place to present theater in the summer.

"So he was looking for a place to work on projects outside of the city where it might be a little cooler," says Keefe, "and he happened to buy this barn."

The fare was more than straw-hat summer theater, including Shakespeare and Ibsen for its sophisticated audience. Over the years, the barn began to crumble, on the verge of being torn down or falling down. But it was a beloved local landmark that needed a major overhaul.

Inside the theater the old wooden walls look familiar, but the pew-like wooden benches are gone. In their place there are new seats with arms.

The orchestra pit, new stage, and up-to-date mechanics expand the range of productions that can be mounted in the playhouse. New heating and air conditioning means the theater can operate year round. And thanks to better acoustics, a summer thunderstorm won't drown out the dialogue on stage. And yet it still has the feel and the charm of the old playhouse.

Or as Christopher Plummer put it, "It's kept the same atmosphere inside but it's now a helluva lot more comfortable!"

One week before the grand reopening of the theater, Joanne Woodward admitted, "It would have been cheaper to tear it down and build a new theater but I couldn't have done that to the ghosts! I really believe in ghosts and certainly theatrical ghosts are very much a part of the background, the sets, and the walls." She was already looking forward to handing over the baton to the next artistic director.

"They won't have just this quaint adorable theater where the water comes down on you when it rains, and there are mice crawling around. They will have a house that is beautiful and still looks to some degree like our old theater. It's a theater in which they can do practically anything," she says with a smile.

"I think we all hope that this theater will put Westport on the map for theater nationally," adds Anne.

"It's so beautiful and it's still very much our theater, all grown up and come into full flower," Joanne says with satisfaction.

Preserving and reviving the Westport Country Playhouse: For Joanne Woodward, it was an offstage performance that was positively Connecticut. ❧

THE KATE

If you survive long enough, you are revered—rather like an old building.

—Katharine Hepburn

FOUR-TIME ACADEMY AWARD WINNER KATHARINE Hepburn was one of the brightest stars in Hollywood, but in Connecticut we count her as one of our own. Hepburn was born and is buried in Hartford, but her heart and soul are in Fenwick, a seaside borough of Old Saybrook. Kate's father, Dr. Thomas Hepburn, bought the summer cottage in Fenwick in 1911 and according to Hepburn's niece, Katharine Houghton, "From that very first summer to the very last day of her life, Fenwick was her home, a refuge, a paradise."

It seems fitting then that the people of Old Saybrook chose to remember their most famous resident with the nonprofit Katharine Hepburn Cultural Arts Center, a 250-seat theater that opened in 2009. The Kate, as it is known, is housed in a historic building that once was home to the Old Saybrook Musical and Dramatic Club. Ethel Barrymore and Norma Terris were among the stars who performed there. The building was eventually converted to town offices, but now once again, after a beautiful renovation, it resonates with the applause of audiences enjoying theatrical performances, music, dance, and lectures.

Executive director Chuck Still says the center is not "an homage to the past, but a living breathing organism touching lives and entertaining and enlightening people." About The Kate's namesake Still says, "If we can catch just a sliver of her spirit, find just a bit of her fire, the Center will glow unrivaled along the shore. Her life flared so bright and glowed so long that it sets a strong standard, a high threshold, to which to aspire, but it is our name and thus our standard. We cannot aspire to less."

The Katharine Hepburn Cultural Arts Center . . . a tribute to a star whose home and heart were positively Connecticut. ❧

THE GREAT PUMPKIN

A Fascination with Giant Squash

Since Charlie Brown brought us the legend of the Great Pumpkin, there's been a fascination with giant squash. But for one Fairfield gardener, it's nearly an obsession.

"I THINK IT'S SORT OF A LEFTOVER KID PHASE. I really like pumpkins, people just like pumpkins!" says David Garrell.

His license plate says pumpkin doctor, and he is. David Garrell is also a medical doctor. His drive to grow a giant pumpkin started by accident.

"In my quest to plant every pumpkin seed available, I planted one that simply came with the company's name on it, no details about the variety. I wanted to try it and it grew into a giant pumpkin, like over two hundred pounds, and I was just really taken aback by that," he says.

Then the doctor discovered the culture of giant pumpkin growers and learned that if a pumpkin could grow to two hundred pounds on its own, with help it could attain gargantuan girths of four hundred, six hundred, and even, the one he produced that is his biggest so far—1,002 pounds. But that takes work, and a lot of attention to detail.

"It has to have the correct angle from the vine, which is basically ninety degrees; otherwise as it grows really big it'll tear itself off the vine. So in the beginning you really want to move that thing an inch

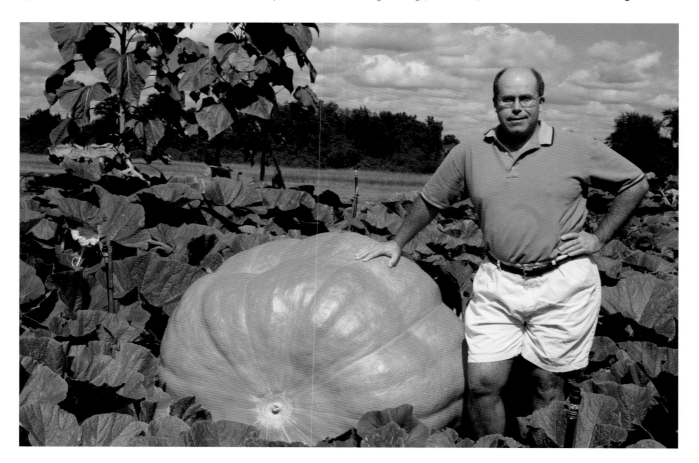

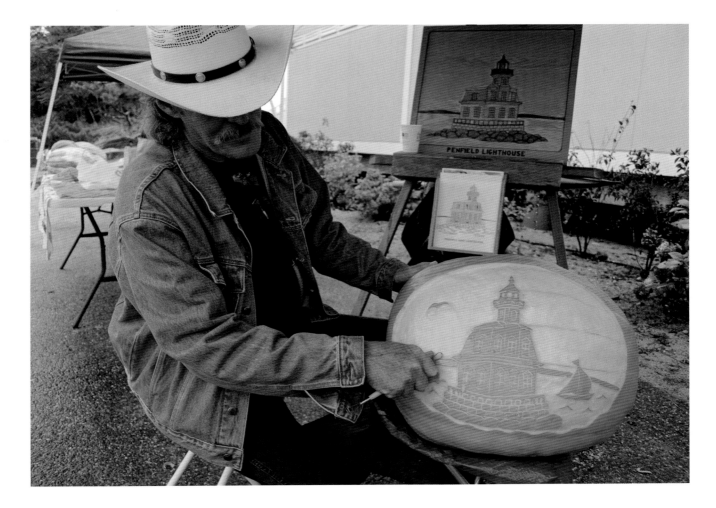

a day until you get the proper angle," he explains. Further, pumpkins want just enough wind, water, and sun—but not too much, hence the tarps David tosses over the pumpkin patch at certain times of day. If it grows too fast, a pumpkin can split, and David has glued some cracks with latex and fungicide. Beauty and brawn it seems usually do not mix.

"Some of the biggest pumpkins in the world tend to be not very aesthetically pleasing. They're whitish and they're ugly. They're sort of fibrotic, scarred and bad shapes. It's very hard to grow a perfectly round orange pumpkin that's going to be a really big one, because orange pumpkins' walls tend not to grow as thick."

The pumpkin doctor is working on his own genetic crosses, trying to find the perfect combination of good looks and heft, a task he says is easier now that he has beaten at least one record for growing the biggest Connecticut pumpkin. As many pumpkin growers will tell you, tension builds as the fall weigh-off season approaches.

"This is a gentleman's hobby, and you have to be a good sport about it, and I was, but deep down it looms."

But as another giant pumpkin grower, Steve Jepsen, says, "We're a good group. Bad people don't bother to grow giant pumpkins. It's a lot of work for not much reward."

Except seeing the smiles these orange giants put on faces in pumpkin patches and local fairs. That's why gardeners like David Garrell, the pumpkin doctor, are hard at work on new varieties that are positively Connecticut. 🪶

HAY IS FOR HORSES—AND HOUSES

A Straw-Bale Cottage in Old Saybrook

The Irish writer George Moore said, "A man travels the world over in search of what he needs, and returns home to find it." That proverb describes the life of artist and farmer David Brown. For David, raised in Old Saybrook, the journey home lasted many years and tens of thousands of miles.

"YEARS AGO IF SOMEONE TOLD ME THAT I WOULD BE living in Saybrook now I would have found that a little disturbing," David Brown says. " I probably can only do that because I've seen the other side of the world both literally and figuratively."

A painter, David took a year off from college to study art in Europe but didn't stay long.

"At the time you could take buses over land through places like Turkey, Iran, and Afghanistan. I traveled to India, and thought 'this is what I was looking for.'"

David traveled for over a decade and lived for about five years in Nepal, one of the least developed nations on Earth, where he taught English to young refugees from Tibet.

"Part of what I discovered living in this village was that people can be happy without all the things that people living in suburbia think they need to be happy," says David.

And that knowledge continues to guide his life. When David returned home to Old Saybrook, he moved into a cottage that is anything but the typical suburban home.

"It's just bales of hay stacked up, covered with chicken wire and stucco and then a roof added onto that," David says as we step into his one-room home. "It's a great, very environmentally friendly system. It's inexpensive, it's renewable, and the hay is great insulation. It's warm in the winter and it's cool in the summer."

His Hansel and Gretel–style cottage sits in the midst of the 350-acre Great Cedars Conservation Area.

"The cedar shingles were hand split from trees on the property. The paneling inside is sassafras and oak and poplar. The hay is from the hayfield," David explains.

"After I came back to Connecticut, the property's owners called me and said 'we need a new tenant and we want someone who will farm the property organically,'" he said. "I think they were also interested in the fact that I'd lived in Nepal without electricity or plumbing so that it wouldn't bother me that I didn't have those things."

Now David owns just over twelve acres, where he has farmed and painted for more than twenty years.

Although his lifestyle might seem spartan to us, David says he lives in luxury compared to the life of his students in Nepal, who had fled from their Tibetan home called the Village of Happiness.

"It was called Shabroo, which is s-y-a-b-r-o-o, which almost seemed too ironic to me that I divided my life between Saybrook and Syabroo," David muses.

Living in Nepal convinced David that a home made of hay, measuring twenty by twenty feet, with propane for cooking and to provide some light at night, is enough: that and his painting.

"When you're a farmer, you find out that you don't make the schedule," he grins. "Nature just tells you

this is the day for the cherries, this is a day to plant, and then everything else is painting . . . ideally."

David wakes at dawn to feed the chickens but reserves late morning for painting. Midday is devoted to farming. David grows much of his own food, and sells shares to local families, who get boxes of fresh vegetables once a week, in season. His organically grown flowers are abundant, and he says "I get florists calling me all the time now, because they have brides who want locally grown organic flowers. They used to say to me, 'why do we need organically grown flowers—we're not eating them.' Now they're catching up."

Late in the day, he paints again and leads art classes on the farm.

David aspires to live like the French impressionist Monet who once said, "A perfect life is half gardening and half painting."

Tours are offered by appointment and visitors from more than fifty countries have found their way to the hay house.

"They almost always say, 'you live in my grandmother's house' and they might mean in Ireland, Greece, Tibet, Nepal, India, Norway, or Africa, but somehow I ended up in the generic grandma's house," he laughs.

David's way of life inspired Jeannie Newman to produce a documentary about the Hay House. His philosophy came to influence her life.

"This is someone who is living his life differently than the average American," Jeannie says. "I discovered that it was possible to live lightly on the land and leave less of a footprint."

Some of David's former Tibetan students have emigrated to Old Saybrook and their prayer flags waft in the breeze above his fields of flowers. Not long ago David realized a longtime dream when he and his friends erected a stupa, a Buddhist spiritual structure symbolizing peace and unity.

With his work on the land, and his art, David seems content staying in one place.

"I was traveling to find answers and I felt like I found them. Now there's a part of me that likes being in my hometown," David reflects. "You know, going downtown and knowing everybody by name."

And so David Brown's journey ended where it began, in Old Saybrook. A journey of many miles and many years led a man back home, to a home that is positively Connecticut. ❧

Winter ❄

My Little Chickadee

Gordon Loery and the White Memorial Foundation

In 1958 the Russian satellite Sputnik fell to Earth, Eisenhower was president, The Bridge on the River Kwai won Best Picture, and Gordon Loery started the research he continues today.

Studying birds has been Gordon Loery's passion for more than half a century. When he was a freshman at Yale, a faculty advisor gave him some advice that set his life's path.

"He said if you don't do anything else while you're here, find something that you really care about and that means something to you. Then when you graduate go out and find somebody to pay you for doing it," Gordon remembered.

"He said too many people go to college to prepare themselves for a good paying job, with the idea that they could do the things they really like to do in their spare time," Gordon said and then added, "He said you're not gonna have that much spare time."

So armed with a master's degree from what was then the "brand new" conservation school at Yale, Gordon went to work, researching Connecticut's bird population. Most of that time has been spent at the White Memorial Foundation and Conservation Center in Litchfield. The foundation includes four thousand acres of fields, water, woodlands, a wildlife sanctuary, and trails in the northwest hills focused around an education center and museum.

Gordon is retired from the center now, but still comes by to capture, band, and release birds, like the young blue jay he holds firmly in his hand above.

"I can get an idea of the age from the color of the mouth," Gordon says. "It's all pink inside so I think it's probably a hatching year bird. By the time they're maybe three years old, they're completely black inside the mouth."

"In birds you can use a wide variety of characteristics—leg color, eye color, and Gordon just mentioned the mouth color," adds White Memorial's research

director James Fisher. "Sometimes they'll have unique patterns on the wings for just a short period of time right after they've left the nest."

James says Gordon's long-range research is benefiting humans too.

"We use bird species as indicators of critical habitats. These are habitats that are very important for ensuring clean water and clear air for future generations, and if birds tend to be our thermometers or barometers, they tell us when something is changing," James explains.

So Gordon isn't just monitoring birds—he's tracking environmental changes.

Although he bands and tracks several species of native birds including blue jays, most of Gordon's work for fifty years has focused on the black-capped chickadee. He calls them quite intelligent and full of personality. They in turn seem to have a fondness for Gordon. Many have been returning to his research area for years. But Gordon says their numbers have declined over five decades.

"Which I attribute to the maturing of the forest," he says. "Chickadees like to excavate their own cavities for nesting. So they need trees that are fairly soft. It's very difficult to dig into an oak tree."

Gordon says as the softer gray birch trees disappear, so do the chickadees. Gordon files data with the National Fish and Wildlife Service about the birds' longevity and the intrusion of other species into their habitat.

That's the kind of research you can't hurry.

"I read in the professional journals about long-term studies of five years. Five years is not long term, it's just the beginning. So I've always been a great believer in sticking to something long enough to get some interesting results," he declares.

As Gordon clamps a metal band around the blue jay's leg, he is filling out meticulous records, which he files with the U.S. Fish and Wildlife Service. "Each species has a number and so this is the number of the species, and then this is age and sex, and then these are the dates, and then these are the locations," he says pointing to long columns of serial numbers in his field manual.

James says Gordon's work has provided the foundation for the next level of research now under way at White Memorial.

"Scientists are always taught that you can only stand as tall as the person that came before you, and we stand very tall around here because of Gordon, so we're very happy and proud of that," he says with a smile.

Gordon Loery, for fifty years, a conservationist and scientist who is positively Connecticut. ❄

BLADES OF GOLD

Del Arbour Designs

She puts the sizzle in skating; that's why champion fig-ure skaters turn to Milford designer Del Arbour. For more than forty years this former skater has outfitted them all, from beginners to Olympians.

SKATING TO *SLEEPING BEAUTY* AT THE SYMPHONY on Ice in Hartford, Chelsea Chiappa (right) enchanted the audience of 16,000. In her crystal studded dress, the Deep River teenager looked like a princess lured from the pages of a fairy tale, thanks to the queen of skating costumers Del Arbour.

The New England champ's dress began with a conference at Del's workshop in Milford. As they lis-ten to Chelsea's music for her routine, Del describes the outfit she has in mind. "I want to keep it delicate, so we have nude mesh here, a little beading, chiffon perhaps or mesh."

When Chelsea was younger and just beginning to compete, her mom bought her costumes off the rack.

"I'd bring them home and I'd spend five hours sit-ting there pinning crystals on the dress," says Chelsea's mother, Andrea Chiappa. "When Chelsea made it to her second New England regionals, I thought 'okay you can't go there looking like I made this'." That's when Del started designing especially for Chelsea.

Novices like Chelsea's younger sister Tori may start out with Del's ready-to-wear lines, which range in price from $50 to $500. More advanced skaters are seeking one-of-a-kind costumes, which start at about $400 and can cost into the thousands.

"I like to talk to the skater, get their ideas, their feel, how they feel the music, what the music is telling them," says Del. "I think it's important they've con-tributed to the design because they're all alone on the ice and they need to know this is part of them, and they're very comfortable."

Suzy Dee has coached skaters and staged skating shows for years and says Del is the best designer she knows.

"Del is extremely classic," says Suzy. "Her lines are beautiful. They complement skating."

Del's office is lined with photos of champions who have called on her to create their winning looks, some-times at the last moment. When U.S. champion Kim Meissner's luggage was lost on a flight to Paris, her manager called Del, who whipped up costumes and shipped them overnight.

Del thinks of the ice as her canvas. "It's the music, the skater, the dress, it's all part of this painting. It's part of the illusion and you want the audience to feel comfortable. The dress can't be sticking out like an orange dress with pastel kind of music. And the dress should go along with the ability of the skater. Not too much or too little."

Designing the costumes is about art, and athletics. The costume has to work with the skater so she can

stretch and move uninhibited. That's a lot easier since the invention of Lycra, which wasn't around when Del was skating competitively.

"We skated in gabardine and we'd cut it on the bias so it would stretch and after two or three wearings it didn't have memory so it wouldn't go back, and you were constantly redoing it," she recalled.

Costumes are made in a multitude of fabrics and colors and encrusted with Swarovski crystals. Del's business partner Jon Zell says there is a Del Arbour look.

"They tend to be more simple, more elegant streamlined styles. We don't do a lot of very busy-looking things," says Jon. "Both Del and I have a certain taste. I say we try to dress princesses rather than showgirls."

Patterns for skirts, sleeves, bodices, necklines, and trousers crowd a rack in the room where seamstresses stitch as many as sixty pieces together to create one dress. After that beading, stenciling or airbrushing enhance the richly hued fabrics—yet most of these costumes can be machine-washed.

"I love wearing Del's dresses," says Chelsea. "They're so pretty, they sparkle, and every one is different, so it makes you feel special that you have a one-of-a-kind dress. I just hope they like my skating as well as my dress!"

Chelsea will be packing her Dels (as she calls them) when she heads to Hungary. She has dual citizenship and a shot at skating on Hungary's Olympic team. Her sister Tori dreams of the Olympics, too.

"I'm kind of along for the ride," says their mom, Andrea. "They want to go to the Olympics so I guess that's where we're going."

And if they do—they'll take something special with them.

"We tell everybody that every dress that goes out of here has a little bit of magic to help them through," Del says with a warm smile.

A little bit of magic—make that sparkle—that's positively Connecticut. ❄

A NICE CUPPA

Bigelow Tea

If the old proverb is true—that failure is the mother of success—then one giant failure (the 1929 stock market crash) led to one very big success and a family business that's going strong after sixty years.

SITTING DOWN WITH A CUP OF TEA SHOULD BE MORE than just sipping a beverage; it should be an experience, according to Cindi Bigelow, the co-president of Fairfield-based Bigelow Tea.

"That's why my grandmother started sixty-one years ago flavoring a product, making it a little special," she says.

In the Roaring Twenties Ruth Campbell Bigelow was in great demand as an interior decorator in New York City. But when the stock market crashed, so did her business. Ruth decided to go from home fashion into the food business.

"Her first food product being a Chinese spice that we used to call Cooking Companion. I think its original name was Zowie," says Cindi.

Ruth soon discovered her cup of tea, when she started experimenting with a colonial recipe for tea flavored with spices and orange rind.

"She sent some to a friend of hers who was having a social occasion and she called the next day and said 'what did your friends think of this product?' and the hostess said, 'it was a huge hit and it was a source of constant comment.'"

The name and the company lasted, and so did its spirit, all carried on today with the help of Ruth's granddaughter Cindi.

Constant Comment was the only tea RC Bigelow produced until the 1970s, when Cindi's father and mother began blending tea in their own kitchen.

"I would come home from school and there was a team of people there with all kinds of white cups sampling different things, and I'd just have to work around them to get my snack," she reminisced.

Today RC Bigelow blends nearly eighty specialty teas at their plant in Fairfield.

We watch as Al Pangrac, the blending manager, removes the tea leaves from sacks and pours them into large bins.

The tea leaves, harvested in places like Sri Lanka, are then vacuumed through wide tubes in the blending tower to a room upstairs where the different varieties are mixed. As many as twenty different ingredients may be combined in one tea.

After blending, the tea is bagged and individually wrapped in a foil envelope. Julie Falcon tests them every five minutes to make sure the packages are well sealed. Then the tea is boxed, packed, and ready to be shipped.

In the tasting laboratory, Cindi gives us a little lesson in cultivating and harvesting tea. "I'm talking about the *Camellia sinensis* bush. This bush grows all around the world; it can grow to about forty feet tall." Cindi emphasizes that Bigelow tea leaves are picked by hand.

"You could use a machine but then you're going to get a lot of stem. It's very cheap, but it's not going to be the right cup of tea, at least in the world of Bigelow," she says.

Besides their well-known black teas like Constant Comment and English Teatime, Bigelow is now turning out an array of green teas. Green, oolong, and black teas all come from the same plant. The difference is how long the leaves are exposed to air, or fermented. Green tea is the least fermented, black tea the most.

Microbiologist Lisa Feather leads a team of tasters. Besides taste she says there are other characteristics to be judged. "We also do a lot of sensory tests for color and aroma to make sure the quality standards are there."

Recently Bigelow added a holiday line including a tea that tastes like eggnog and one that's a ringer for a slice of pumpkin pie.

Cindi Bigelow prides herself on meeting the standards set by her grandmother—using fine teas with no stems or fillers.

"There is a legal size of the leaf called "dust" for tea bags. It is very inexpensive, and a great tea bag filler, with no flavor. We will not use tea dust in any of our teas," she says.

Cutting corners on tea is not an option . . . and neither is leaving Connecticut.

"For us it's just a commitment to the state I guess. It's a loyalty, a love of Connecticut, and we love being in Fairfield."

Walking through the plant Cindi laughs and jokes with the workers, and it's clear she sees them as more than employees. She likes to think of them as family, as a team. "I do have to attribute our being here to our employees and their desire to continue to trim costs and allow us to manufacture here effectively."

In an office decorated with teapots collected by her parents and grandparents, Cindi wonders if one day another generation of Bigelows will manage this business founded by her grandmother.

"To work in a company where you can make the lives of people that you work with better is good. And if you can make a product that's great for customers, that's great. And it is a gift to love what you do," Cindi says.

RC Bigelow, still blending tea that continues to be a "source of Constant Comment" and that is positively Connecticut. ❋

CHOCOPOLOGIE

In a European-style café in historic South Norwalk, Fritz Knipschildt is turning out gems. Opening one of his handmade paper jewel boxes reveals some of the world's most exquisite and highly acclaimed chocolates. Although he is not even forty, the Danish-born master chocolatier is wowing food writers with his unique and daring flavors.

Visit Chocopologie for a delicious snack or a meal, and you'll also get a behind-the-scenes peek at how the handmade chocolates are made.

On our visit Fritz pointed out some of his favorites. "This is caramel mint, black currant ganache dusted with a little bit of real gold, this is filled with passion fruit, this is praline, amaretto mocha, classic truffle, and tangerine red chili."

Yes, that's tangerine with red chili pepper. And those are just a few of the unusual herbs and spices the European trained chef has combined with chocolate. Try strawberry ganache with lemon thyme, or marzipan and cherry

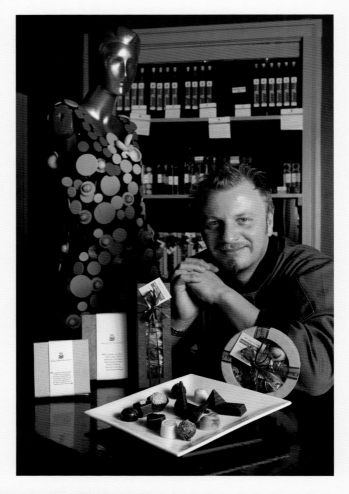

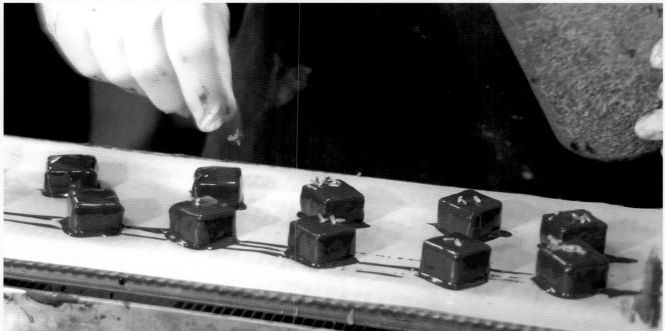

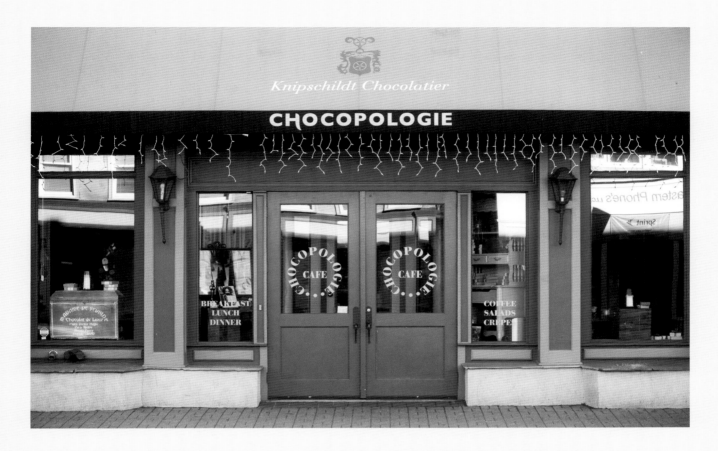

topped with tiny marigold petals. Fritz and his staff of a half dozen make each decadent bon-bon, petit four, and truffle by hand.

Fritz's philosophy of chocolate making: "The concept was to make something fresh with no preservatives, no additives, and quality raw chocolate and get in some great ingredients from around the world. And then produce a fresh product that would have a limited shelf life and not just last for a year. We all know that good food is not meant to last."

If these sweets last in your home more than a few minutes—you have a lot more willpower than most. I tried the tangerine and red chili pepper.

Fritz described the chocolate as "not really that spicy. It's just nice and hot." "You do feel the heat on the back of your tongue," I noticed after one creamy bite.

There are molded pieces that are crafted with attention to fine detail and some even glitter with edible precious metals like gold and copper.

"Each chocolate goes through five sets of hands before they actually are placed in the box. There is a lot of passion behind this," Fritz notes.

That has paid off with rave reviews by everyone from Oprah to Martha Stewart to Gourmet magazine, which called Fritz's chocolates "the best in the world." At Chocopologie they make delectable edibles that are positively Connecticut. ❋

THE ICEMAN COMETH

Masterpieces That Melt

He's the Michelangelo of ice—armed with a chainsaw, a drill, and a blowtorch, Bill Covitz can coax the fantastic from a three-hundred-pound cake of ice—a prehistoric pterodactyl, a thirteen-foot-tall Cat in the Hat, the flying monkey from the Wizard of Oz. *If you can imagine it, he can create it for your next party.*

AFTER YEARS OF TAKING THE HEAT, BILL GOT OUT OF the kitchen. The professional chef, who has worked in some pretty ritzy kitchens here and abroad, now calls an icehouse in Waterbury his workshop.

"The cooking certainly satisfied a lot, pleasing people and presenting the food, but the ice sculpture I think is more momentous," says Bill. "There is instant gratification because it's the center of the room and a lot of the time it's personalized or customized." Working in a freezer cooled to 16 degrees means dressing in a parka, ski pants, and insulated boots year-round. "I am not a big fan of the cold, but when you're working and it's physical work you stay warm enough," he says.

When Bill gave up cooking for carving, he wondered if he could make a living sculpting ice, but business at his company Ice Matters has snowballed. In their busiest season he and his assistant Matt Terzano create their ice art sixteen hours a day, six days a week. It's hard work.

"I've had blown backs, and a double hernia operation. Your wrist gets sore, your elbows, your back. It's an exhausting job but it's well worth it from the satisfaction that we get," Bill says. He adds, "But it's not for the weak-hearted."

Special freezers turn out three-hundred-pound blocks of crystal-clear ice for Bill to carve.

For the company's more popular designs, Bill uses

a computer-driven router to cut out the silhouettes. From there, it's on to power tools and precision hand detailing.

Matt Terzano is wielding a small chisel and chipping into the ice, creating facets in its smooth surface. "These accent the light," he says. "All the little details are shown better when the light hits them."

And for the final touch—a gas torch creates a high gloss polish.

"When we're finished, a lot of people think it's crystal or glass. They want to go up and touch it and they can't believe it's actually ice," he says.

And though his creations are the "icing" on the cake for weddings, bar mitzvahs, birthday parties, and corporate events, Bill really revs up the chainsaw for ice carving competitions like the one held in Chester.

Bill's work is known to be daring. "When you compete you need to push the limit if you want that edge. You need to be able to take the risk and be willing to fail and finish last."

Spectators like Gordon Turnbull are enthralled. "He's seeing something that's hidden inside a block of ice. I don't know what he's seeing but he's removing a whole bunch of stuff that's in the way and he's unwrapping a secret."

In 2007 in Norway Bill helped supervise a unique musical ice festival.

"We made all the instruments out of ice; we took the water from the lake and we sculpted it into instruments, then held a concert," he says.

Besides carving instruments that were actually played, Bill carved a throne from six-hundred-year-old glacier ice for the Norwegian princess.

"That's the kind of stuff that takes me away from the business, which I love and I am proud of, but it gets me into new things. That's where I still find the love and the art for the ice," he says.

Bill has won just about every award they dish out

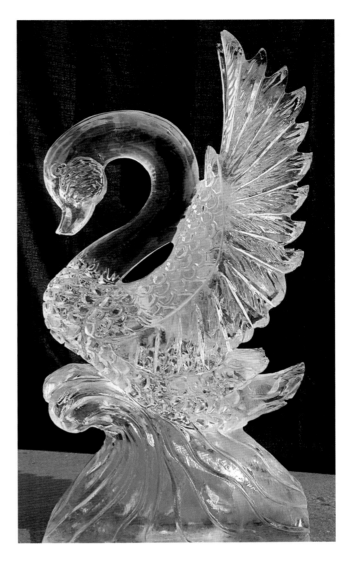

in ice carving including national championships, and he doesn't mind that his elaborate artistic endeavors disappear into puddles.

"The sculpture is meant just for the event, and the presentation when the guests just walk into the room," he says philosophically.

Or as his fan Gordon Turnbull put it: "It's like music in a way; you do a performance then it's gone, but the memory lingers. It's art."

Art lovingly crafted from ice that is positively Connecticut. ❄

THE SECRET LIFE OF PLANTS

Ecology and Evolutionary Biology Greenhouses

Drive into UConn and you can't miss Gampel Pavilion or the statue of the Husky mascot. But tucked away on this campus in Storrs there's a rain forest, a jungle, and a desert.

ALL THOSE HABITATS ARE RE-CREATED INSIDE THE university's three greenhouses to make homes for plants so rare that some of them are almost never glimpsed outside their own piece of the planet. The director of the greenhouse calls it the most diverse collection in the northeastern part of the United States.

"There are bigger collections at New York and Montreal," says Clint Morse, "but we've got some oddball things that they don't have."

Clint supervises a collection of more than 2,500 species packed into 10,000 square feet under glass, all of it open to the public.

"We basically cover the gamut, from primitive plants to highly evolved grasses, orchids, and things

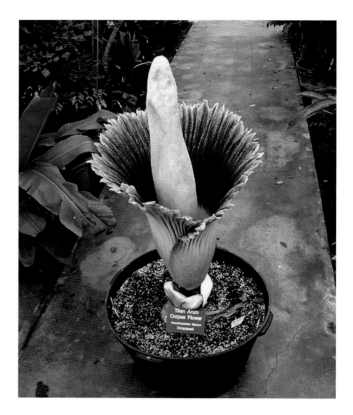

like that, plus things that have different symbiotic relationships," and he adds, "economic plants that are important for man whether it be food or medicines or dyes."

The collection even includes the papyrus used by the ancient Egyptians to make paper and the plants the dinosaurs nibbled for dinner.

"This is part of our smaller collection of cycads, which is part of our primitive plant vegetation types from when the dinosaurs roamed the Earth," he says, with a hint of wonder. "Grasses and flowering plants had not yet evolved."

There's an abundance of flowers here including six hundred varieties of orchids, some with flowers you might not know are orchids at all until you take a very close look, and others that are big and showy.

"The flower is designed to be pollinated by an insect of a specific size and it has to be lured into a particular position on the flower to do that. A number of the orchids have patterns that are not visible to you and me except under ultraviolet light. The flowers actually produce landing patterns on the petals so the insect has little landing guides to come into," he says.

That's one of the plant world's survival strategies that Susan Lechter points out when she leads tours of the greenhouse.

"I like to show people the secret life of plants, how they defend themselves with chemicals or spines or with growing in inaccessible places, how they attract pollinators, and just the way that they live," Susan says.

Some plants grow inverted leaves or little pitchers to gather rainwater and attract insects needed to help the plant propagate. The "ant plant" thrives in the Indonesian rain forest and its base provides a perfect apartment house for the critters.

"Ants would live in these chambers and patrol the plant and protect it from predation by other insects and animals. So the plant is providing housing for the ants and the ants are providing protection for the plant," says Clint.

Other plants protect themselves. Look quickly at a row of flowerpots, and they appear to contain nothing but gravel. Actually they are home to South African succulents that look like "living stones."

"So that they can avoid being eaten by animals and also to avoid exposing too much surface area to the hot desert conditions, the large portion of the plant body is actually subterranean," explains graduate student Matt Opel. "The tops of these modified leaves have small windows to allow the light inside the leaf and actually go below grade to undergo photosynthesis, rather than producing a lot of typical leaves above ground." During the dry season they virtually retreat below the ground.

The carnivorous plants are the favorites of visiting school kids. The Venus flytrap looks pretty harmless compared to the fly bush from South Africa. One of the world's largest carnivorous plants, its leaves, sticky and drenched in resin, can catch small birds.

"The fly bush also has a symbiotic relationship with a kind of bug that can navigate the plant, called an assassin bug. These predatory bugs eat the other insects caught by the plant and the excretions of the bug fertilize the plant, so it gets a lot of its nutrients kind of indirectly through the insects that it catches."

But why would any plant—like the Voodoo Lily—give off a stink that will send you running out of the room? The answer is not for the faint of heart.

"Those flowers are pollinated by flies and carrion beetles so the flower is typically a dark reddish-brown color. It has the same chemicals that rotting corpses would give off in an effort to attract these insects which are basically looking for dead carcasses to lay their eggs in," says Clint. "They will try to lay their eggs in these flowers and in doing so they will transfer the pollen and pollinate the plant."

When its larger cousin, the Corpse Flower, bloomed here a few years ago, 22,000 people filed past to breathe in its foul aroma. For many that was an introduction to the fascinating world inside these greenhouses.

"What I really want to do is expose people to how interesting plants are, because usually they're just kind of a green backdrop to our lives," says Susan.

"Plants really have a strategy and they have behavior although it's very slow behavior. They can't run away like we can but they can grow toward the light or produce more of a compound to discourage things from eating them, and so plants really have an interesting life."

You can learn more about the secret life of plants by visiting the greenhouses Monday through Saturday. The UConn greenhouses provide a window into the world of plants that's positively Connecticut. ❄

The Institute for Exploration at Mystic Aquarium

Mystic Aquarium audiences tune in for a live look under the sea with famed explorer Robert Ballard, thanks to technology that means he can run expeditions from the deck of a boat or from his office.

AT THE INSTITUTE FOR EXPLORATION AT MYSTIC Aquarium, audiences can watch and interact with divers exploring the Monterey Bay Marine Sanctuary, thanks to Bob Ballard. The famed explorer has been bringing us along on his undersea expeditions since he started the visionary Jason Project, giving thousands of school kids the chance to join him from all over the world using cutting edge technology that gives him "telepresence" on the ocean's bottom. That's what Ballard calls his you-are-there style of exploration that brings kids and adults on expedition with him without leaving their classrooms or theaters. Telepresence uses high bandwidth Internet 2 and satellite technology to beam the exploration back to the shore live.

"I don't like to hand things off. I like to dream it up and do it. I have always moved back and forth between dreaming up a new way of exploring and then going out to explore," Bob says.

Dr. Ballard's remarkable career includes more than one hundred deep-sea expeditions. He helped prove the geological theory of plate tectonics, and explained the chemistry of the oceans. He located John F. Kennedy's *PT 109*, the German battleship *Bismarck*, and

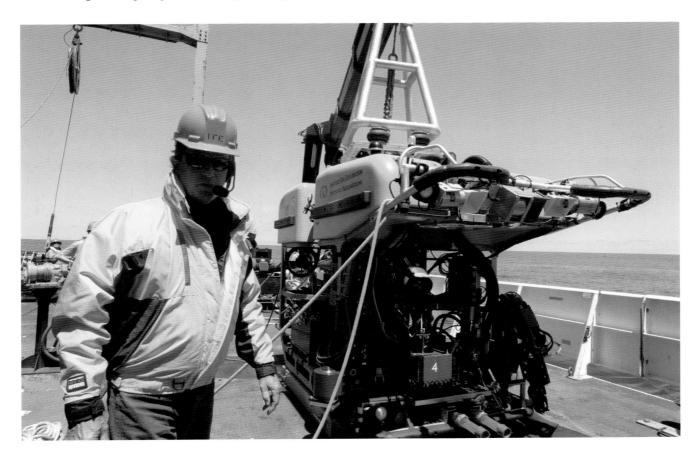

the aircraft carrier *Yorktown,* but his name is synonymous with the *Titanic.*

"So I find the *Titanic,* and when I get home the phone rings and it's my mom. She says 'it's too bad you found the *Titanic.'* And I said why, and she said 'because you're a wonderful scientist, you've done incredible stuff but they'll only remember you for finding the *Titanic.'* And aren't moms right?" he says with a grin.

As a kid in San Diego, Bob Ballard set his life's course when he read Jules Verne's classic science fiction novel *20,000 Leagues Under the Sea.*

"I went out to the tidal pools where I became an explorer because every twelve hours they changed, and I always wanted to be the first set of footprints in the sand," he remembers.

He got his chance when the navy assigned him to Woods Hole Oceanographic Institution on Cape Cod. Ballard pioneered deep diving submarines on the first manned expedition of the largest mountain range on Earth, the Mid-ocean Ridge. That showed him what was possible, and what was needed.

"To descend to 12,000 feet it takes two-and-a-half hours each way. So it was like I was commuting to work five hours a day and spending very little time on the bottom. So I began to dream of another way of doing exploration."

He dreamed up technology that can be guided from a ship's deck or from Mystic Aquarium, where he is president of the Institute for Exploration. Ballard has been assisted on his journeys by his robotic

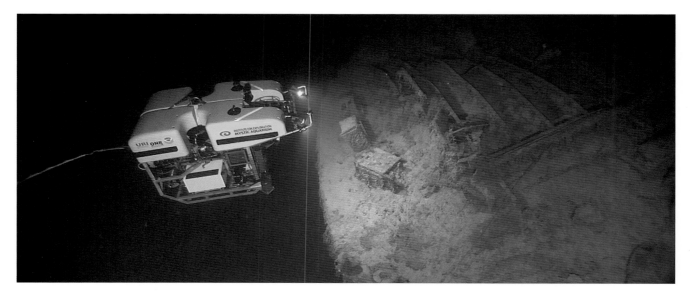

creations, remotely operated vehicles with names like Argo, Angus, and Little Hercules.

As the explorer-in-residence for the National Geographic Society, Ballard teams up with historians, geologists, archaeologists, and oceanographers to go where no one has gone before. He estimates there are a million ancient shipwrecks waiting to be discovered.

"A shipwreck is a time capsule that contains human history. They're waiting to be discovered, and that's what my job is, to find those time capsules," he says.

In the Mediterranean he tracked down ancient trade routes traveled by sailors transporting huge vessels of wine.

"I figured they drank all the way to Rome and I found six centuries worth of wine bottles they threw over the side; then I drove along that debris trail, that clutter of litter and there were my shipwrecks!"

Ballard also set his sights on the Black Sea—where low oxygen levels leave shipwrecks perfectly preserved.

"The Black Sea is probably the largest museum on Earth but we couldn't get in there during the Cold War. I don't know what you were thinking when the Berlin Wall went down, but I said I am going to the Black Sea and we were the first in!"

Ballard's next frontier is what he calls "the unknown America," the 50 percent of the country that is under the ocean. He'll explore and map it with the new U.S. research vessel *Okeanos.* He's also looking for new talent to help him.

Jim Newman is the chief engineer on many of Ballard's projects. "He's inspiring people by sharing the kind of work we do. I think he's made a big difference to the level of interest in not just science and oceanography but learning in general."

Ballard is known for stepping outside his office in Mystic and introducing himself to students who are visiting.

"The kids in school right now will explore more of the Earth than all the previous generations combined," he says. "They are going to make unbelievable discoveries."

It's been decades since Ballard played on the California beaches, but like his childhood hero, he has lived his dream.

"I'm doing what I really always wanted to do. When I was five years old I wanted to be Captain Nemo and I think I pulled it off," he smiles and adds, "and I never want to stop."

Recently Dr. Ballard named his newest high-tech research ship E/V *Nautilus,* after Captain Nemo's submarine, from the Verne book that influenced him so long ago.

Dr. Bob Ballard is more than an explorer; he is a teacher and pioneer who is positively Connecticut. ❇

Welcome to the Wheel World

Senior Skaters

If a roller rink in Vernon isn't the fountain of youth, it might just be the next best thing. Lace up your skates and see how senior skaters in their seventies are turning back the hands of time.

"GET BEHIND HER NOW, HOWARD, NOW PUSH, HOLD, swing," says John Scollo.

Like any pair of athletes preparing for an upcoming competition, Howard and Flo are spending more time in training with their coach, John Scollo.

"Now press this edge, come up the floor and around; don't rush," John urges.

"Skating together you either do it right or it doesn't work. And it takes practice. It takes lots and lots and lots of practice and we have the time to do it," says Howard Fiedler.

These roller dancers have more time for polishing their technique, now that they are retired. Seventy-six-year-old Howard Fiedler and seventy-two-year-old Florence Dahlstrom began skating together more than twenty years ago.

"One night Howard came down and said would you like to learn the dances and so he piqued my interest in dance," says Flo, talking about the beginning of their partnership.

They've been winning titles in roller dancing since they were in their fifties.

"A lot of guys wanted to skate with her all the time, and you just have to horn your way in and that's what I did!" says Howard with a delighted laugh.

They skim the wooden floor with an easy grace. Their power and control you notice later, along with the wordless communication that comes from skating together for a long time.

"Some of the steps are difficult. If you're doing them with another person and put your foot in the wrong place well, two people hit the floor and we've done that many times!" says Howard.

Their partnership has survived the ups and downs of life too.

"I lost my husband so my skating friends are like another family," Flo says.

And for Howard, a former engineer turned high school physics teacher, roller-skating has been a proven stress buster.

"When you're skating, you don't focus on anything but what you're doing. That was the part I learned to love. When I left the rink at night, I could sleep. There was nothing else on my mind," says Howard.

Their coaches John and Luella Scollo are in their seventies too. Former world champions, they met on the roller rink. They've added judging and coaching to their full schedule of competition on the senior circuit.

"My friends warn me," says Lu, "you're gonna fall and I say hey, I could fall down the stairs. If I'm going to fall, I want to be having fun when I fall."

On a Wednesday night at Ron-a-Roll in Vernon, they aren't the only senior skaters at the rink. As a teenager Gert Wrothe loved skating.

"I stopped for forty-two years and then I came back and I've been skating eleven years now," she smiles. "A friend of mine kept after me to come skating and I said 'oh no, I'll probably fall and break my hip. I can't do that.' But my grandson had a birthday party and I went to the party and put the skates on and I did good, so that's what brought me back."

Now Gert skates at least twice a week with Frank Stager, a World War II fighter pilot.

"You have to use all your senses, your balance, your physical strength, it's like flying an airplane really," says Frank.

They temporarily clear the rink when the young "jam skaters" take over.

But they stand by to see what's new.

"I can't keep up with the young whippersnappers now, but I used to do some fancy stuff too," says one senior.

"I call it unwinding the clock because we keep going around the rink to the left, counterclockwise, so every time you go around it's one minute more that you can survive probably," laughs Frank.

Frank may have something there. The oldest skater at Ron-a-Roll is ninety-three-year-old Polly Funk. "I say it's a great sport, hang in there, and keep skating."

"On an average night we'll go around almost two hundred times, skating. Turn that into miles and that's over ten miles, so you're really putting a lot into using your body," says Howard.

Flo chimes in, "My friends marvel at what we do. They sit and play cards and do things that are very sedate and therefore they're overweight and have problems, but I feel if you keep moving nothing can land!"

So Howard and Flo go on practicing their foxtrot, waltz, tango, cha-cha, boogie, and blues dances striving for their next medal.

"People who do the gold medal dances are still working on perfecting it and as you know there's no such thing as perfection," says Flo. "On any given night you can be tripping over your feet or you could

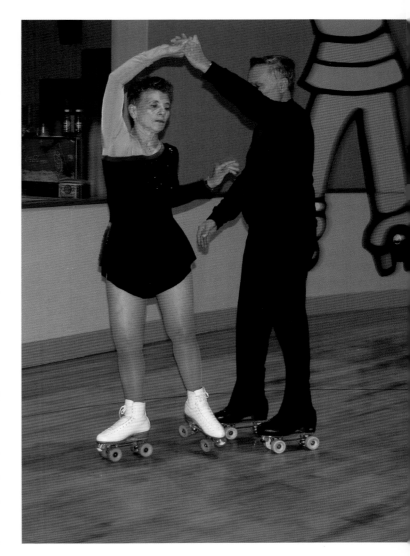

do it very well, but for the most part everyone cheers everyone else on and encourages them because it's a learning process that you never finish."

Not if you are dedicated athletes like these senior skaters, who are positively Connecticut. ❄

WHISPERS OF THE PAST

Reclaiming the Pequot Language

Away from the din of the Foxwoods casinos, in a quiet place on the Mashantucket Pequot reservation, the whispers of the past are being heard again.

THE PEQUOT LANGUAGE NEARLY DISAPPEARED when the Treaty of Hartford ended the Pequot Wars more than 350 years ago and forbade tribal members from speaking their language. Now the Mashantucket Pequots are reviving and learning their native tongue.

The tribe is bringing Pequot alive with a reclamation project that painstakingly seeks the origins of the lost language along with its words, pronunciations, and grammar.

"It makes your heart beat a different beat, it adds something to your life," says Tabitha Cooper, a young member of the tribe who is volunteering in the language reclamation project.

At the tribe's museum and research center, Terry Dzilenski, a dedicated scholar the tribe fondly calls "Terry D," studies maps, bibles, and other references that date back to the seventeenth century including letters from Ezra Stiles, founder of Yale, and a missionary named John Elliot.

"Elliot thought if he translated the King James Bible into the Native American language of Wampanoag and then could teach the natives how to read, they'd be that much closer to a Christian conversion.

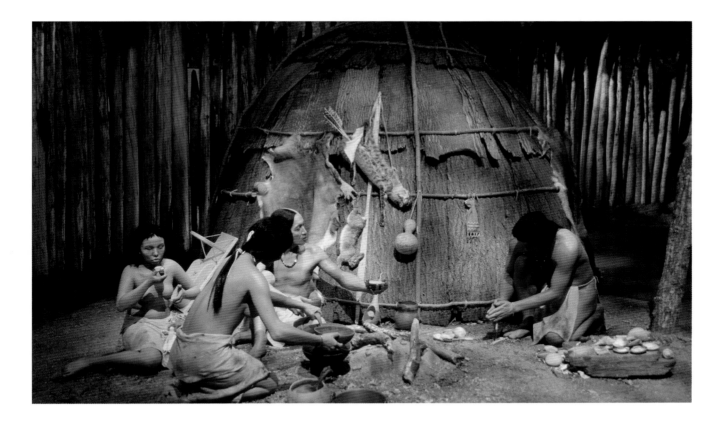

It's ironic because on one hand settlers were trying to Christianize the native people which meant taking their language away," says Terry, "and here we are in this century having to use those exact resources to rebuild the lost language."

In the museum, sixteenth- and seventeenth-century Northeastern Native American life is demonstrated in lifelike displays, but the narration is in Passmaquoddy, a language that survived Pequot.

In another part of the exhibit English words are translated into other Native American languages like Abenaki, spoken by tribes in what is now Maine, Vermont, and New Hampshire, and MicMac, which was spoken in northern New England and the Canadian Maritimes.

One day Valerie Jones hopes those displays will compare the better-known languages with her own, Pequot. She is assisting Terry in trying to rebuild the language. "I just can't wait to start speaking fluently," says Valerie.

Fidelia Fielding, the last fluent native speaker, passed away in 1908. Terry calls Fidelia's diaries, which now belong to Cornell University, invaluable because they come from a tribal member and not from an outsider.

Terry, Valerie, and Albert Zamora scour records in places like New London Town Hall and the local historical society.

"Mostly what I look at are land records, but there are also vital records that could have genealogical information," Terry says, "I'm looking specifically for Pequot names and Pequot deeds."

Growing up in California Albert was familiar with other Native American languages but never heard his own until recently.

"It's a great honor to be able to do this research and come up with all the tribal members' names and all the place names in Pequot. This has blown me away," he says. One goal is creating a dictionary. Linguist Jessie Little Doe has helped Terry nail down

about two thousand words. They still have a long way to go since most linguists define a language as truly restored when the dictionary contains 50,000 words.

Jessie Little Doe uses her own reclaimed language, Mashpee Wampanoag, as a blueprint for rebuilding Pequot. "Nashqua, nashkiton. That's a woman and that's a man," she explains, and then holding up shoes says, "umaskaas . . . this is a shoe, these are shoes."

Jessie feels that reconstituting Pequot and other Native American languages is her calling. So she went back to school, earning a master's degree in linguistics at M.I.T.

"My nation needed a linguist in order for us to fulfill our language reclamation prophecy, but we couldn't afford to hire one, and it's the sort of work where you need someone in the community indefinitely. It's a lifetime of work and nobody wants to live with us forever," she laughed. "It's best you get your own folk working on their own things."

Pequot and Wampanoag are among thirty-three languages studied at several academic conferences on revitalizing Native American languages held at the Pequot Museum. Since then Jessie has developed a curriculum for teaching Pequot, and she and Albert hold classes on the reservation for students starting as young as three years old.

"I'm hoping that by the time I'm done here on this Earth that not just my Wampanoag nation but all of the nations east of the Mississippi will have thriving language projects of their own," Jessie says.

One of the most eager students is eight-year-old Na'shya Carter, who is growing up on the reservation.

"I think it's a good thing to do because I want to keep our nation going and I like to learn about my culture," the little girl says as she writes with a pencil in her Pequot workbook.

Besides formal classes Terry organizes projects for young people that incorporate Pequot language use, like art workshops and cultivating an organic garden.

Jessie Little Doe points out that most English speakers have some familiarity with place names in Native American languages . . . even the name of our state, Connecticut.

"Which is actually quinnee tuckut . . . so quinee tuck is Long River, the 'ut' at the end is just what's called locative. They just mean 'the place of something' so Quinneetuckut is the place of the long river—which is what Connecticut means and how it got its name," she says.

To the Mashantucket Pequots, reclaiming the language is more than reclaiming a part of their culture.

"Language is no less sacred, it is no less important than the land that we came from," says Jessie. "If you ask most Indian people in the country, 'if you could ask for something back what would that be?' I promise you the majority of Indian people in this country would say, 'I want my land back.' If your people are in that land and your language is within those people, then having that land back and having your language back is the same—it's who you are and it's a part of you."

A part of a people who were—and are—positively Connecticut. ❈

Connecticut's Other Huskies

Dogsledding

Say the words Connecticut Huskies and nearly anyone in the state will think "basketball," thanks to our championship teams at the University of Connecticut. But for some lovers of dogs and winters, "Go Huskies" takes on a whole different meaning.

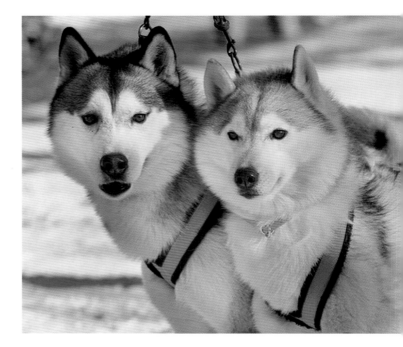

IF THERE'S ONE THING I HAVE LEARNED ABOUT Connecticut, it's that in spite of its small size, both in geography and in population, you can find just about anything here. A few winters back, when it was snowing heavily someone commented that the best way to get through the winter would be by dogsled.

Dogsleds in southern New England I thought? But by that afternoon I met a pack of local mushers, people who weren't complaining about the snowy weather, but reveling in it.

As we pull up at the Wyatt house, a chorus of piercing wolf-like howls fills the air. On bitter cold days, winter days when most dogs and their people are looking to curl up by the fire, Lloyd and Joanne Wyatt's dogs are howling to go out. These Siberian huskies are undaunted by January in Higganum, even when the wind chill is 20 below zero. That's when the Wyatts pack their van with huskies and a dogsled and head into the snow.

"When they hear us rattling around the house, they start screaming, and they can't wait to go," says Lloyd. "They're full of energy and they love to do it."

After they're unloaded at a nearby state park, Kezelkum, Karakum, Kavik, Koriak, and Mira anxiously wait on their gang line. One by one Lloyd and Joanne hitch them into their harnesses attached to their handmade sled. The team is so pumped the sled has to be tied to a post to hold the dogs back. Then Joanne hops on the runners and they're off—with a shout of "Hike" (not "mush"). A friend of Joanne's and his team are soon right behind, making tracks through the sunny, snowy fields of Haddam Meadows State Park.

Lloyd and Joanne's dogs are used to working together as a team.

"They've been together for years so they don't fight," says Joanne.

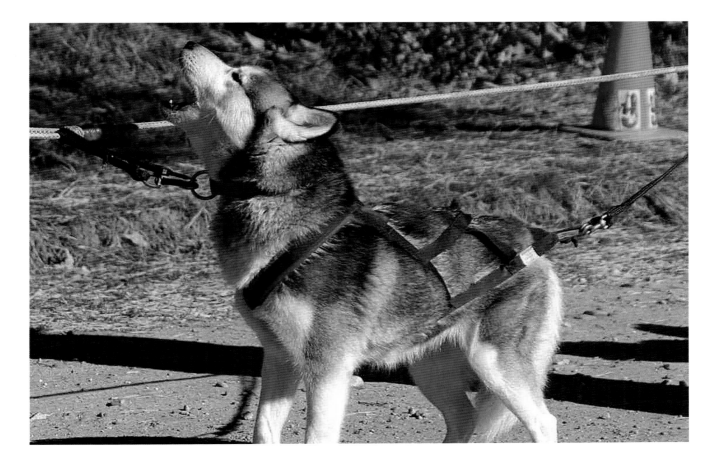

That doesn't mean dogsledding always goes smoothly.

"You have to be in charge when you have five dogs because if they're in charge, you're in trouble. So I make sure I am in charge," Joanne says confidently. Turns out that's not always the case.

After a couple of good runs, the dogs get away from Joanne while she is trying to turn around. Joanne and sled disappear from view behind a stand of trees, hundreds of yards away. A few minutes later the dogs and sled come hurtling at us, without their driver. Soon Joanne comes trudging back on foot.

"They took off like a shot, dragging me behind them," she calls.

But Joanne comes back laughing, because she and Lloyd are really hooked on running their dogs.

"It's all based on our love of the breed. We're here to use the breed for what they were intended," says Lloyd. "And you're out there in the fresh air and it's a lot of exercise so it's good for us too."

Lloyd explains that the Siberian Husky was originally bred by the Chukchi, a tribe of Siberian nomads, who traveled by sled over the frozen land. The dogs are very strong and able to go long distances. In spite of their wolf-like appearance, the dogs are known for their gentle nature and friendliness toward strangers.

The Wyatts are active members of the Connecticut Valley Siberian Husky Club and I can see why. After just one ride in "the basket" of the sled, it's easy to forget about frozen fingers and toes and take pleasure in the joy of the dogs running in the deep white snow. When the snow melts, the Wyatts resort to sleds with wheels.

Sled dogs . . . you don't have to head to the Arctic to find them. They're positively Connecticut. ❄

Dashing through the Snow

Allegra Farm Sleigh Rides

People often say the winters in Connecticut aren't like they used to be. They seems to remember seasons that were a lot colder and deeper in snow. But John Allegra doesn't reminisce about the past ... because he's living it every day.

It's a scene right out of a Currier and Ives print: a coachman cloaked in bearskin, a Victorian lady in a bonnet, and a horse-drawn sleigh. But this is reality, at least for John Allegra, who runs a business imbued with the character of another era.

Allegra Farm in East Haddam is the last working livery stable left in New England according to John. "We're like the old time version of today's limo services," says John. "In the days before cars, lots of people couldn't afford their own carriages and sleighs, so they rented them with the horse to pull it. And that's still what I do."

John's horse-drawn carriage business is year-round, but when the snow flies it means a chance to hitch up the matched pair of Arabians, bundle up and set off into the lovely countryside for a sleigh ride around Lake Hayward. John's farm is surrounded by four hundred acres, plenty of space to enjoy a taste of the New England countryside.

John has restored a fleet of carriages and sleighs and collects the vintage costumes that help set the mood. He tells visitors, "This is as close as you'll ever get to the real thing, because this is the real thing."

And for us passengers all wrapped up under

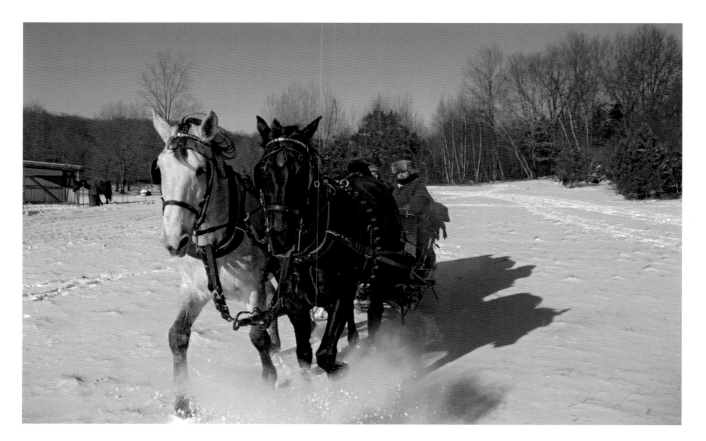

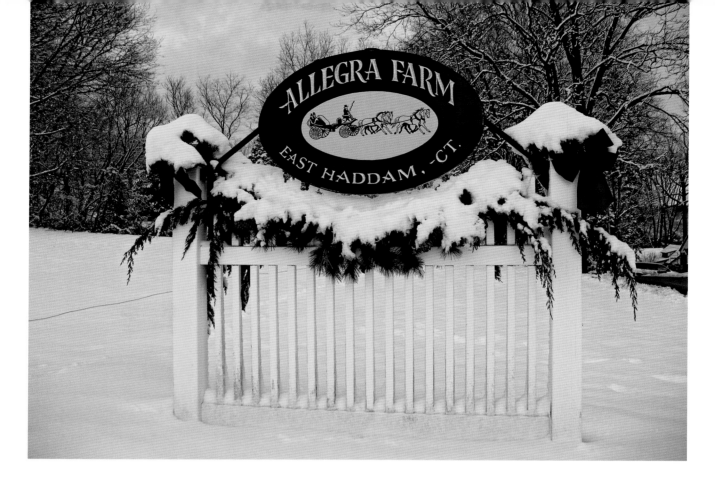

buffalo lap robes, with our hands in furry muffs and the snow flying under the blades of the sleigh, it's enough to make us feel like singing. Pretty soon we are breaking into a hearty chorus of "Jingle Bells" as the sleigh winds its way through the fields and woods. As twilight draws near, romance often warms the wintry air. John recalls: "We have had people propose during the sleigh rides in the middle of a blizzard. I'm always hoping she will say yes, and there haven't been any yet that have gone astray."

John's passion for the past is evident inside his barn. Besides his two dozen horses, ranging from Standardbreds to the Clydesdale-Hackney crosses he calls "Bud Lites," John has more than fifty vehicles from the nineteenth century that he has restored. The barn is filled with memorabilia, carriages, coaches, and sleighs—even two horse-drawn hearses. You can tour The Horse Drawn Carriage and Sleigh Museum of New England by reservation.

Visitors can watch John restore the vehicles, repair antique harnesses, and re-create carriage wheels. John has appeared in lots of TV shows and movies ranging from *Sex and the City* to a documentary on Mark Twain. John says that's because "everyone else uses fiberglass reproductions of carriages. Mine are all restored antiques, and people want the real thing." He has driven carriages in all sorts of places, including every year at the Viennese Ball at the Waldorf Astoria in New York City. That means taking his carriage and horses up three flights in an elevator.

Allegra Farm generally offers sleigh rides as long as there is snow. They might even build a campfire for you if you're hardy enough for a winter picnic. When there is no snow, they offer carriage and hayrides.

In his fourth decade of running the livery business, it's clear John still really enjoys his work. "We meet a lot of special people. We make dreams come true . . . and that's what it's all about."

His passengers couldn't agree more after a sleigh ride into the past that is positively Connecticut. ❄

SWEPT AWAY

The Norfolk Curling Club

About the only people not thrilled when the groundhog declares an early spring are the members of the Norfolk Curling Club. Their allegiance to their sport not only makes the winters go by more quickly—it has brought friendship and camaraderie to fans and players of all ages for fifty years.

WHEN CURLING WAS TELEVISED AS AN OFFICIAL Olympic sport in 1998, the world was intrigued. Most people had never watched a game before. In Norfolk they'd been waiting for the rest of us to catch up.

Retired math teacher Bill Brodnitzki loves the sport. "Oh it's wonderful, the stones striking each other, the rumbling sound as they move on the ice. Every curling match begins with a handshake, and we say 'good curling,' and each one ends in a handshake."

The dense granite "stones" or "rocks" are mined in Scotland, where the game began around 1520. Curling has moved indoors mostly, but it's still played on ice. The basic idea is to deliver the "stones" as close as you can to the "tee line," the bullseye in the center of three concentric circles known as the "house." Each team delivers eight stones in a period—known as an "end." The team with the most stones closest to the tee wins each "end." A typical game is eight or ten ends long.

Sounds easy—until you realize the stones weigh forty-two pounds each, and you are aiming for a target that's at the opposite end of a sheet of ice 146 feet long and 15 feet wide. That's like trying to precisely place that stone halfway across a football field.

While Jonathan Barbagallo prefers a showy 360-degree delivery, most players slide in something resembling a bowler's stance. Pushing off from the "hack," a rubber foothold in the ice, the player releases the rock with the handle at about a quarter turn so your hand is angled in or out. As you push off and slide on your bent front leg to send the stone down the ice, it curves . . . or curls—hence the name of the sport.

George Dyer is president of the Norfolk Club. "There's a rotation on the stone no matter what you do; even if you try to throw a straight handle it will pick up a turn one way or another and it will bend either way."

That curve or "curl" allows stones to hide behind or to guard other stones in the house, part of the game's strategy. The complex nature of stone placement and shot selection makes curling a bit like chess on ice.

The ice is slippery, but not smooth. Droplets of water are applied, which freeze on contact and create a pebbled surface. That creates friction on the stone and that's where "sweeping" comes in.

"In my early curling life we actually used bristle brooms and corn brooms," recalls Bill. "Then they found a fabric head puts more heat on the ice and that's what you're trying to do with sweeping, put heat to the ice, warm the ice, and get it to travel farther and straighter."

Good sweepers can extend a rock's travel distance by up to ten feet.

But that means the sweepers have to hustle.

"We used to yell 'sweep' but now its just 'hurry' and when you hear 'hurry' you get right on it," says George.

Calling the shots is the skip, who points his broom to show team members where they should place the rocks.

"The skip is really the strategist of the team and has to read the ice; that's the first thing. He has to determine how much the ice is swinging, what the speed of

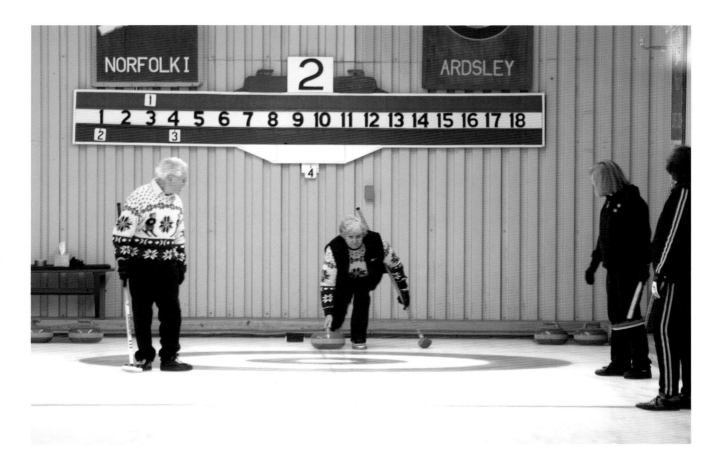

the ice is, and all the little fine nuances of the game," says Star Childs, who has played since childhood.

The skip is also the final shot maker of each end. "So you can either be the dog or the hero depending on how you perform," he laughs.

Star's mother, Elisabeth, helped get the Norfolk Curling Club started. Those first curlers in Norfolk played on local ponds and depended on Mother Nature to harden the ice, so sometimes games couldn't get under way until 11 p.m. Star says, "They tried it out in the winter of 1955 on natural ice and decided that was so much fun they ought to build a curling shed."

The club is looking for new players for its leagues and tournaments known as "bonspiels." They'll teach you the game, if you can abide by the curling code that calls for "good sportsmanship, kindly feeling, and honorable conduct."

As one player pointed out, "It's a very friendly sport, and you'll find that every shot no matter how poor is somehow complimented or encouraged." Even if it *is* your opponent's shot.

Curling—an age-old game with a spirit that is positively Connecticut. ❄

ABRACADABRA

The Society of Young Magicians

Some Connecticut kids are finding new ways to show off their talents. How are they doing it? Simple. It's magic!

ABRA-CA-DABRA!

Gloves turn into a snow-white dove.

A boy makes a Houdini-like escape from a straitjacket.

Silvery hoops unlink mysteriously in midair.

How do they do it?

It's magic of course. Tricks as old as time, preserved and performed by some very young magicians.

"Really nothing is that new. There will be a slight twist but it's all just the ancient secrets passed down through the generations," says seventeen-year-old Graham Fishman, who is dressed in a black tuxedo.

The man sharing the closely guarded secrets is magician Bill Andrews.

"It's all deception for pleasure," says Bill. "I don't claim to have any special powers of any kind, but I do like to have a good time when I'm performing."

Magic has mesmerized Bill ever since he was a boy and saw Houdini's brother perform.

"We went to see the show and I came out walking four feet off the ground, I was so excited," he remembers.

Bill has been making magic ever since, entertaining sailors during World War II and spicing up sales meetings as an exec at Revlon. After retiring Bill started the Stamford Society of Young Magicians. For twenty years he and a team of mentors have met monthly to coach magicians of the future. Magicians like Graham.

"I do sleight of hand. I do magic with the birds which is also sleight of hand," says Graham. "It's the hardest so yeah, to me it's the best kind of magic."

These would-be David Copperfields learn close-up magic like card and coin tricks. And they learn the fine points of stage magic, creating illusions that involve knives, doves, and other props. They're also taught timing, technique, and presentation.

Kayla Dresher is among the few female magicians in the group.

"It's fun being a girl because you get to spice things up a little bit. Normally if I'm in a show I'm the only girl so it's fun to come out and be all me," Kayla says with a big smile.

At seventeen, the Wallingford high school senior is one of the older members of the society, but children as young as seven can join.

Connor Ingmanson is only ten but already performs at birthday parties and magic shows. Connor demonstrated a few card and coin tricks.

"It's just like awesome! You get to go on stage, and it's just a great group to be in," he says.

Jonathan Krackehl joined the society when he was Connor's age.

"The common thing that people miss is there are two pieces to magic, there's the trick and then there's the performance. Anyone can do a trick with the proper practice and knowledge but not everyone can do magic," he explains.

Now a seasoned magician, Jonathan is teaching the next generation. He's coaching several students gathered around in a class.

"Take the little tricks and make them into magic. Make them something more, really bring it out! A trick can last seconds, but magic can last minutes or hours," he tells them.

And its effects can last a lifetime, as Bill tells parents.

"This is an opportunity to enhance self-esteem and communication skills because we concentrate on that," he says.

Rehearsing for the society's spring show, Graham may look like a natural on stage, but it wasn't always that way. "Magic has made me more confident, made me feel better about myself, and given me a way to be creative. Magic's done a ton for me," he says.

The Society of Young Magicians: It's more than hocus-pocus—it's positively Connecticut. ❄

Simply PURR-fect

Feline Heaven on Earth

What happens to your feline companion when you're gone or can no longer take care of kitty? If she's lucky—she goes to kitty heaven . . . right here on Earth.

THE 175 CATS LIVING AT THE LAST POST IN FALLS Village snooze on full-size beds and open front cribs, or in a sunny window in spacious heated cabins that are designed with posts and beams for climbing or lounging on. The doors have flaps, so the cats can let themselves outside where they have several acres of heavily fenced property to roam.

"I've lived a life of adventure and I've had a wonderful time," says Jeanne Toomey, the director of the animal sanctuary. A retired journalist who once covered murder and mayhem from Manhattan to Mexico, Jeanne runs the cat haven, living on its thirty-seven wooded acres bordering the Housatonic River. She calls this her last post too. Jeanne is enjoying a quieter life, satisfying the side of herself she describes as "an animal nut."

The cats that retire here are not just cared for—they are coddled.

"We put out wet food and dry food. If they have no teeth when they get very old, we get Gerber's baby food for them," Jeanne points out.

A veterinarian visits weekly and the cats are tended—and loved—by workers who know the residents by name and habit.

"Can all these cats live together and get along okay?" I asked Heather Waldron. "We find some of them are more dominant than others, but most get along pretty well," she says, letting a few out onto an enclosed deck to lounge in the sun.

Some of the cats are adoptable, but most will live out their lives here at the bequest of their owners.

FOUNDER: PEGEEN FITZGERALD

Some arrive escorted by estate attorneys carrying checks for their continuing care.

"When possible, we try to get people to leave $5,000 per cat, and then in the event of the owner's death or disability we send out a van and we pick up the cat or cats. We have made compromises and taken in others without much money, but the bequests are our major source of support," says Jeanne.

One widow left Last Post her seventeen cats and an eye-popping $600,000 inheritance.

"My position is that the rich cats support the poor cats," says Jeanne.

Cat lover and New York radio icon Pegeen Fitzgerald started Last Post. She and her husband, Ed, presided over a beloved breakfast show for more than forty years. They broadcast from their Manhattan apartment and their Connecticut weekend

home, talking about their social lives, their marriage, their passions for reading, traveling, and for animals. Jeanne, then a newspaper editor and columnist, met them while reporting on the maiden voyage of the SS *United States* in 1952.

It was Jeanne's nose for news that led to the encounter. "I thought I should go up on the top deck in the kennel and see how the animals were traveling to Europe in the greatest of luxury. As I was going into the kennel, a distinguished-looking couple was coming out, and they identified themselves as Ed and Pegeen Fitzgerald and they took my name and phone number and we parted. When I got back to America they phoned and invited me to be on the air with them."

Jeanne became the news anchor of the show, and great friends with the Fitzgeralds.

"They did a great deal of good for people as well as animals. They rescued hundreds of animals every year and they took in people who were down on their luck. In their guest room they had a sign that said 'can we be of any help or are you in enough trouble already?'" she recalled fondly.

Since the Fitzgeralds invited listeners into their lives, it's no wonder so many felt they were part of the family and started leaving their beloved pets to the couple. In 1982 Pegeen bought thirty-seven acres of land in northwestern Connecticut for a wildlife sanctuary and cat shelter, and before she passed away, she asked Jeanne to carry on her work—rescuing animals.

The Fitzgeralds' habit of helping people continued too. David Haines and his wife, Stephanie Fox, lived on the property while David worked on his Ph.D. and Stephanie her law degree. They brought their own cat with them.

A commander in the first Gulf War, David found a Kuwaiti kitten that he credits with saving his life. "The kitten was batting something around and upon closer inspection it turned out to be a part of a cluster bomb. We carefully retraced our steps and nobody got

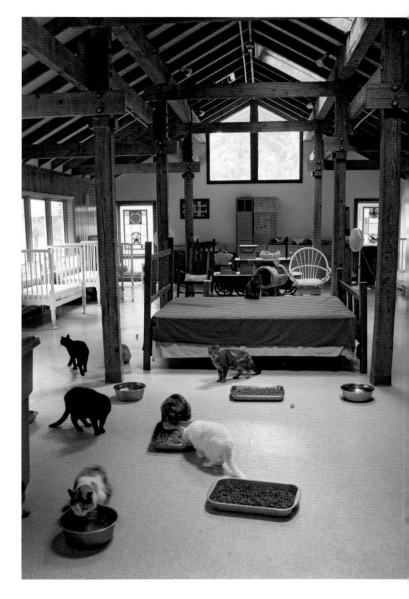

hurt or killed, and we decided if we hadn't seen this little calico kitten playing with the thing that one of us might have stepped on something." He brought her home when he returned from Kuwait. Stephanie said she felt a little like a stray herself when Jeanne took all three of them in.

Although the Last Post is known as a haven mainly for felines, a few other furry friends have found their way inside, including Silverbell, the goat who was discovered wandering around Times Square on New Year's Eve. A few dogs reside here,

and every day Heather or one of her co-workers drives them into town for burgers at their favorite fast food place.

Jeanne Toomey has since retired and moved away, but the staff remains devoted to the Fitzgeralds' mission and so are the donors and volunteers who help keep the shelter going.

"If you like cats you can't help but feel completely loved," says board member David Bolton about visits to the Last Post. "You're like a pied piper. You're like a celebrity with an entourage."

As for the cats, one of the staff members, Cathie Demereski says: "They don't ask for much. A little TLC and a bed to sleep in, some food, a fresh litter box, that's all they ask, and they give lots and lots of love in return."

And at the Last Post their affection is rewarded in a style that is positively Connecticut. ❄

HOOP DREAMS

Preserving and Promoting the History of Women's Basketball

With a half dozen national championships on their record, many fans consider Storrs, Connecticut, the women's basketball capital of the world. There is no bigger fan of the women's game than a Rocky Hill man who has kept its story alive.

WHEN MEGHAN PATTYSON PLAYED AT UCONN, SHE made women's basketball history. She scored over a thousand points, helped lead the Huskies to three Big East titles, and in 1991 was part of the team that went to the Final Four of the NCAA Women's Basketball Tournament, the first time a Big East team made it that far.

But even Meghan was impressed when I took her to meet John Molina and tour his home, packed with memorabilia that traces the history of the women's game to its earliest days in 1893.

The first collegiate game was played at Smith College that year in March. The doors to the gym were

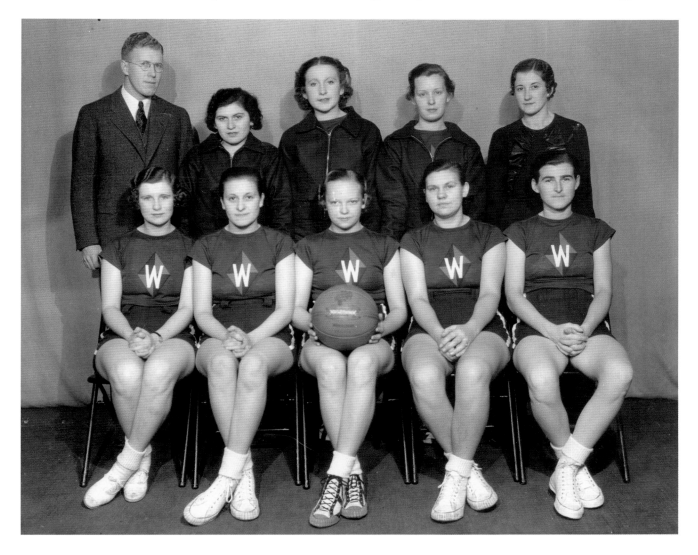

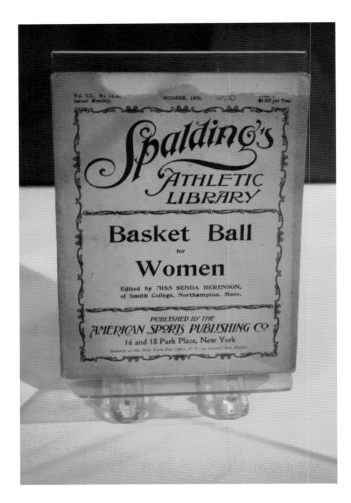

John is a computer programmer for the state of Connecticut, but in his spare time he spends twenty to thirty hours a week researching women's basketball history. His collection has been called the most comprehensive in the world, and perhaps the most significant, since it includes some material from the game's inventor James Naismith, as well as its first rulebook edited in 1901 by the "mother of the game" Smith College coach Senda Berenson.

Meghan reads aloud from one page: "In this book it talks about the concern about women playing basketball because women were considered to be more selfish and not as team-oriented as a man. Can you believe this?"

John's collection is so large that displaying just a portion of it takes up three rooms of his Rocky Hill home. One room is dedicated to mementoes from the All American Red Heads, the first women's professional team.

"The Red Heads were started in 1936 by a man named Ole Olson. His wife was a hairdresser and she and her lady friends used to play basketball at night. One day they decided to all dye their hair red," John says.

So began a dynasty that lasted fifty years. The Red Heads played men's teams, and at halftime while their male opponents rested and strategized in the locker room, the Red Heads put on a stage show. In spite of that they won 80 percent of their games. In 2004 John became the only man ever inducted as an honorary All American Red Head. Former players and their families from all over the country send him artifacts from the team, knowing he will keep their history alive.

Although the Red Heads played by men's rules, John's collection illustrates the evolution of rules for the women's game. In the early days there were nine players on a side and the court was divided into three zones. No player could leave her zone. At that time there was no snatching the ball. Ladies had to remain

locked and no men were allowed in to watch because it wasn't considered socially acceptable. Still, modesty ruled the design of the uniforms.

The photos of players in ankle length black shifts stunned Meghan.

"How you play basketball in this is staggering to me," she said.

John has amassed photos, programs, and uniforms from every decade, but his most treasured keepsake is a photo of his grandmother Bernice with her club team from the J. B. Williams soap factory in Glastonbury.

Meghan was impressed. "People always talk about the UConn women as being pioneers in the game. Well these women were the true pioneers of basketball. They did it in the day when it just wasn't done."

ladies even on the basketball court. Eventually though, they would have a league of their own.

John has souvenirs from all the women's professional leagues over the years, including the ones that signed some of UConn's biggest stars. More than twenty uniforms from the WNBA are hanging in his collection.

But why this passion for women's basketball? John says he grew up a sports fan. But in the 1980s the big salaries and big egos of pro athletes turned him off. Then one day he turned on the TV—and discovered the UConn women's basketball team.

"It was sports the way it was when I was a kid. It was pure, it was team-oriented, it wasn't all these egos, and I got hooked," he says.

Looking through John's collection Meghan says the game has evolved not only since those first games over a century ago but also has advanced a lot since she graduated from UConn in 1992. She played when the women's team didn't even have its own locker room.

"It was a very different game," she says, "Coach Auriemma has often joked with me and said, 'at one time you were one of the best players on our team and now you wouldn't even make our team!'"

John says his collection is evolving too. He has shown parts of it in a yearlong show at the Connecticut Historical Society and at the Naismith Memorial Basketball Hall of Fame in Springfield. He loves sharing his collection and hopes to open a museum one day. After all he says, "If *Spam* has its own museum, shouldn't women's basketball have one? If I can find someone to help build it, I think a lot of people will

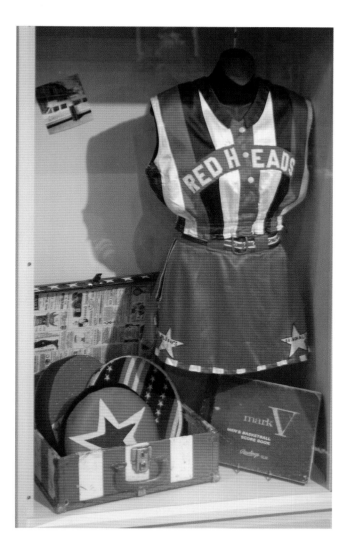

come see it. If you build it, they will come—at least I hope so!"

Preserving and promoting the history of women's basketball—one man's field of dreams that is positively Connecticut. ❄

ACKNOWLEDGMENTS

As you may have guessed from reading this book, I am hard pressed to name my favorite season in Connecticut. On an 85-degree day with a light breeze on Long Island Sound, summer is my favorite. While walking through an ancient burial ground framed by a stone wall and littered with leaves of yellow and scarlet, it's autumn. The softness of spring and the aftermath of an ice storm have their wonders and charms too. This book is an attempt to capture a little of each of the seasons, and it happened because of many people.

Thanks first to Erin Turner, the editor who lives in Montana but "gets" Connecticut. To the team at Globe Pequot Press, it is a joy to work with you. Lisa Franco has been my friend for more than twenty-five years. Now she is my collaborator on this book. Thanks for getting me organized, keeping me on track, and always

being willing to make one more call or send one more e-mail to check a fact or find a photo. Producers aren't just for TV shows.

Thank you to all the organizations and friends who searched for photos that would capture the essence of each story. Thanks to the talented photographers who found moments that others might have missed.

These stories came to life first as *Positively Connecticut* segments on television. As a producer Michele Russo made sure *Positively Connecticut* was a consistently vibrant, diverse, and heartwarming program. There are not enough words to express the many ways she has supported me.

Thanks to CPTV for being a home for telling Connecticut's stories, and to the executives who supported them. Thank you to the sponsors who made the programs possible, especially to People's United Bank, Comcast, and the Connecticut Commission on Culture and Tourism. Bette Blackwell, you made every TV story even better than I had imagined. Ed Gonsalves, thanks for always "making it happen." Thank you to the creative team in the field, always willing to get just one more shot or one more interview.

To Ray Dunaway, thanks for making *Positively Connecticut* a priority.

To the people within these pages who shared their lives and their stories, you enrich us all and reinforce the reasons to love Connecticut.

To Mom and Dad and Grandpa Trunk, thanks for teaching me that the first draft is only the beginning.

To my husband, Tom Woodruff, who stepped up as photo editor, thanks for your love, patience, endurance, and enthusiasm. ⌁

For More Information

Blight Spot to Bright Spot:
The Knox Parks Foundation
> 75 Laurel Street
> Hartford, CT 06106
> (860) 951-7694
> www.knoxparks.org

Go Fly a Kite: ConnectiKITERS Festival
> http://connectikiters.org

Cowpies to Cowpots: A Freund Farm Innovation
> 324 Norfolk Road
> Route 44
> East Canaan, CT 06024
> (860) 824-0650
> www.freundsfarmmarket.com/cowpots

Connecticut's Cavalry: First Company
Governor's Horse Guards
Drilling and training sessions are open to the public
for observation at First Company Governor's Horse
Guards headquarters:
> 280 Arch Road
> Avon, CT 06001
> (860) 673-3525
> www.govhorseguards.org

There is also a Second Company Governor's
Horse Guard:
> 4 Wildlife Drive
> Newtown, CT 06470
> (203) 426-9046
> www.thehorseguard.org

By Any Other Name: Elizabeth Park Rose Garden
Elizabeth Park is located at the corner of Prospect
Avenue and Asylum Avenue on the Hartford/West
Hartford line. The park is open daily, dawn until
dusk. Greenhouses are open Monday through Friday,
8 a.m. to 3 p.m.
> Friends of Elizabeth Park
> 1555 Asylum Avenue
> West Hartford, CT 06117
> (860) 231-9443
> www.elizabethpark.org

The Shrine: Lourdes in Litchfield
Open dawn to dusk year-round. Mass six days a week
May through mid-October at 11:30 a.m. Group
pilgrimages can be arranged.
> 83 Montfort Road
> Litchfield, CT 06759
> (860) 567-1041
> www.shrinect.org

Green Thumb Graduates: Master Gardeners
To apply for the master gardener program:
Leslie A. Alexander, State Master Gardener &
Education Program Coordinator, UConn's Home
and Garden Education Center
> 1380 Storrs Road, Unit 4115
> Storrs, CT 06269
> (860) 486-6343
> www.ladybug.uconn.edu

Magnificent Maestro: Conductor Gustav Meier
Concerts are presented at:
> Klein Memorial Auditorium
> 910 Fairfield Avenue
> Bridgeport, CT 06605
> www.bridgeportsymphony.org

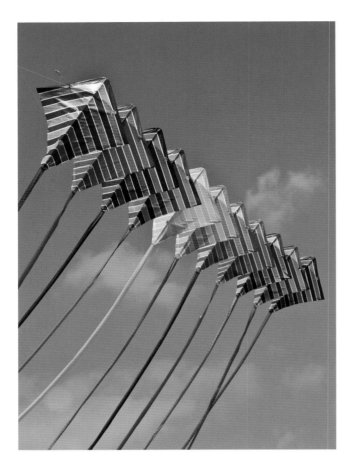

Living in a Glass House: Philip Johnson's New Canaan Masterpiece

All tours begin and conclude at the Glass House Visitor Center from May 1 through November 30. Tickets are required and advance reservations recommended.

 199 Elm Street
New Canaan, CT 06840
(203) 594-9884
http://philipjohnsonglasshouse.org

Doorknockers: Cindy Erickson's Connecticut Doors

For more information or to order a poster:
 www.conndoors.com

For more information about the Art Refuge:
 (860) 663-1169
www.joanlevyartist.com

Railroad Revival: Restored Rail Lines, Historic Depots, and Steam Engines

Railroad Museum of New England, Inc.
 242 East Main Street
Thomaston, CT 06787
(860) 283-RAIL (7245)
www.rmne.org
Danbury Railway Museum Inc.
 120 White Street
Danbury, CT 06810-6642
(203) 778-8337
www.danbury.org
Essex Steam Train and Riverboat
The Valley Railroad Company
 One Railroad Avenue
P.O. Box 452
Essex, CT 06426
(860) 767-0103 or (800) 377-3987
www.essexsteamtrain.com

Quacks like a Duck: Livingston Ripley Waterfowl Conservancy

Guided tours are offered at 2 p.m. Sunday during May, June, September, and October.
 Duck Pond Road
Litchfield, CT 06759
(860) 567-2062
www.lrwc.net

Railroad Gardening: Connecticut G Scalers Club

Connecticut G Scalers Club meets once a month.
 www.ctgscalers.org

Two If by Sea: The *Mystic Whaler*

Mystic Whaler Cruises
 City Pier
 35 Water Street
 New London, CT 06320
 (800) 697-8420
 www.mysticwhalercruises.com
Maritime Aquarium at Norwalk
 10 North Water Street
 Norwalk, CT 06854
 (203) 852-9700
 www.maritimeaquarium.org

Seas the Day: Sail Connecticut Access Program

 Brewer Pilots Point Marina
 Westbrook, CT 06498
 Dockside phone and information: (860) 304-6588
 www.sailctaccess.org

Keepers of the Flame: Connecticut's Lighthouses

Sunbeam Fleet
 Captain John's Sport Fishing Center, Inc.
 15 First Street
 Waterford, CT 06358
 (860) 443-7259
 www.sunbeamfleet.com
New London Ledge Project Oceanology
Reservations are required and can be made by calling
(860) 445-9007 or (800) 364-8472.
 Avery Point
 Groton, CT 06340
 www.oceanology.org
Sheffield Island
 Norwalk Seaport Association
 (203) 838-9444
 www.seaport.org

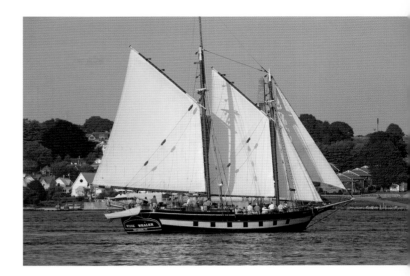

See Shells on the River: Crewing on the Connecticut

Riverfront Recapture, Inc.
 50 Columbus Boulevard
 Hartford, CT 06106
 (860) 713-3131
 www.riverfront.org
Interested in building a hovercraft with your family
or class?
 Contact Jim Benini at Parish Hill High School:
 jbenini@parishhill.org
 (860) 455-9584

Mystic Marine Trainers: Teaching Old Sea Lions New Tricks

Mystic Aquarium
 55 Coogan Boulevard
 Mystic, CT 06355
 (860) 572-5955
 www.mysticaquarium.org

Wish upon a Sunflower: Farm-Fresh Ice Cream

Buttonwood Farm
 471 Shetucket Turnpike
 Griswold, CT 06351
 (860) 376-4081
 www.sunflowersforwishes.com

To Market to Market: Grown in Connecticut

For locations and times of farmers' markets across the state, visit www.CTGrown.gov.

For farm dinners, contact the River Tavern:

(860) 526-8078

www.dinnersatthefarm.com

Trailer Flash: Airstreamers

For more information on the Charter Oak chapter of the Wally Byam Caravan Club, visit:

http://connecticut.wbcci.net

Blue Ribbon Bakers: Country Fair Cook-Offs

The North Stonington Fair is usually held early in July. For details on all the state's fairs and the baking competition, visit www.ctfairs.org.

Dogged Determination: Sheepdog Trials

The Bloomfield Sheepdog Trial is no longer held; however Beverly offers lessons, clinics, workshops, and dog training at Sheepswood Farm in Andover.

www.beverlylambert.com

To find out more about Frisbee dogs or to attend an event or a demo:

http://yankeeflyers.com

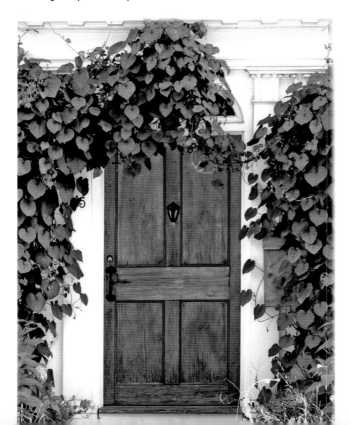

Connecticut's Unsolved Mysteries: Digging Up the Past

Connecticut State Museum of Natural History and Connecticut Archaeology Center, Wednesday through Friday, 10 a.m. to 4 p.m.

University of Connecticut

2019 Hillside Road, Unit 1023

Storrs, CT 06269-1023

(860) 486-4460

www.cac.uconn.edu; www.mnh.uconn.edu

Tricky Wickets: Cricket in Connecticut

www.ctcricket.homestead.com/cricket.html

www.sctcassoc.com

Combos, Conductors, and Camp: Litchfield Jazz Festival

For details on the festival and on camp:

Litchfield Performing Arts

P.O. Box 69

Litchfield, CT 06759

(860) 361-6285

www.litchfieldjazzfest.com

Family Night Out: Mansfield Drive-In

Mansfield Drive-In

Junction of Routes 31 & 32 in Mansfield

(860) 423-4441

www.mansfielddrivein.com

Pleasant Valley Drive-In

Route 181 off Route 44 between New Hartford and Barkhamsted

(860) 379-6102

www.pleasantvalleydrivein.com

Poetry Out Loud: The Sunken Garden Poetry and Music Festival

The home, a national historic landmark, is open before the performances for a self-guided tour of its wonderful collection of paintings by Monet,

Degas, Manet, Cassatt, and Whistler. Picnic suppers are available. The six biweekly poetry and music performances feature world class and emerging poets from June through August.

Hill-Stead Museum Sunken Garden Poetry Festival
 35 Mountain Road
 Farmington, CT 06032
 (860) 677-4787
 www.hillstead.org

Always Ask for Avery's: Connecticut's Old-Time Soda Bottler
Avery's Beverages
 520 Corbin Avenue
 New Britain, CT 06052
 (860) 224-0830
 www.averysoda.com

FALL

Barn Again: Preserving Classic New England Architecture
For more details on the barn survey:
 CT Trust for Historic Preservation
 940 Whitney Avenue
 Hamden, CT 06517
 (203) 562-6312
 www.connecticutbarns.org
Aren Carpenter
Pomfret Restoration
 67 Day Road
 Pomfret Center, CT 06259
 (860) 942-4497
 www.pomfretrestoration.com
Majilly
 56 Babbitt Hill Road
 Pomfret Center, CT 06259
 (888) 625-4559
 www.majilly.com

The Vanilla Bean Café
 450 Deerfield Road
 Pomfret, CT 06259
 (860) 928-1562
 www.thevanillabeancafe.com
Tyrone Farm Management, Inc.
 P.O. Box 208
 Pomfret, CT 06258
 (860) 928-3647
 www.tyronefarm.com

Go Take a Hike: Connecticut's Blue-Blazed Hiking Trails
For more information on hiking the Blue-Blazed Trails or to get a copy of the *CT Walkbook,* contact CFPA:
 www.ctwoodlands.org

Fruits of Their Labor: Cranberry Harvest

For more information on the Killingworth Land Trust:

P.O. Box 825
Killingworth, CT 06419
(860) 663-3225
http://klct.homestead.com/home.html

Whimsical Winvian: Unusual Luxury

155 Alain White Road
Morris, CT 06763
(860) 567-9600
www.winvian.com

We Love a Parade: Helium Balloon Wranglers

For more information on the parade or to volunteer as a balloon handler:

www.stamford-downtown.com

Rock Stars: Stone Walls of Connecticut

Robert Thorson has written three books on stone walls, including a field guide and a children's book. He has also founded the Stone Wall Initiative to conserve stone walls.

www.stonewall.uconn.edu

The Peabody Museum of Natural History at Yale University is located in the Science Hill section of the Yale campus, at Whitney Avenue and Sachem Street in New Haven.

www.peabody.yale.edu

Prison Tails: Second Chances

For more information on companion dogs for people with disabilities or for combat veterans:

www.neads.org

Putting the Pieces Together: The American Mural Project

www.americanmuralproject.org

Ballet of Angels: Along the Connecticut Wine Trail

For information on all these wineries and more, go to www.CTGrown.gov and look up their wine publications, or check out:

www.ctwine.com

Going Batty: Rehabbing Bats

Gerri Griswold offers bat programs from April 1 through October 1. For more information contact:

Gerri Griswold
113 Rugg Brook Road
Winsted, CT 06098
batlady@earthlink.net

History Detectives: The Legacy of Abner Mitchell

Gunn Historical Museum
5 Wykeham Road
P.O. Box 1273
Washington, CT 06793
(860) 868-7756
www.gunnlibrary.org/museum.html

Home Is Where the Art Is: Connecticut's Art Trail
For details on the museums and special package rates for overnight getaways:
www.arttrail.org
Art Trail Museums and Sites:
The Aldrich Contemporary Art Museum, Ridgefield
Bruce Museum of Arts and Science, Greenwich
Bush-Holley Historic Site, Greenwich
Florence Griswold Museum, Old Lyme
Hill-Stead Museum, Farmington
Lyman Allyn Art Museum, New London
Mattatuck Museum Arts and History Center, Waterbury
New Britain Museum of American Art, New Britain
Slater Memorial Museum, Norwich Free Academy, Norwich
Wadsworth Atheneum Museum of Art, Hartford
Weir Farm National Historic Site, Wilton/Ridgefield
William Benton Museum of Art, University of Connecticut, Storrs
Yale Center for British Art, New Haven
Yale University Art Gallery, New Haven

The Price is Right: Goodspeed Opera House
Goodspeed Opera House
6 Main Street
East Haddam, CT 06423
(860) 873-8668
www.goodspeed.org

Leading Lady: Westport Country Playhouse
Joanne Woodward still serves on the board of trustees of the Westport Country Playhouse. The artistic director of the playhouse is the renowned director Mark Lamos, who guided the Hartford Stage for seventeen years before a career that took him to Broadway, the Metropolitan Opera, Lincoln Center, and many other famous venues.
Westport Country Playhouse
25 Powers Court
Westport, CT 06880
(888) 927-7529
www.westportplayhouse.org
The Katharine Hepburn Cultural Arts Center
300 Main Street
Old Saybrook, CT 06475
Box office: (877) 503-1286
www.katharinehepburntheater.org

The Great Pumpkin: A Fascination with Giant Squash
For tips on how to grow your own giant pumpkin:
The Connecticut Giant Squash & Pumpkin Growers Association
116 Sherman Street
Fairfield, CT 06824
www.ctpumpkin.com
Yearly weigh-off in September at Penfield Beach, Fairfield
Also see the remarkable pumpkins grown by Team Pumpkin and others at the Durham Fair in September. Team Pumpkin offers seminars and free seedlings to new growers:
www.team-pumpkin.org
www.bigpumpkins.com

Hay Is for Horses—and Houses: A Straw-Bale Cottage in Old Saybrook
Tours are available by appointment:
David Brown
155 Ingham Hill Road
Old Saybrook, CT 06475
(860) 575-2387
http:// Hayhouseonline.blogspot.com

WINTER ❄

My Little Chickadee: Gordon Loery and the White Memorial Foundation

White Memorial Conservation Center
 80 Whitehall Road
 Litchfield, CT 06759
 (860) 567-0857
 www.whitememorialcc.org

Blades of Gold: Del Arbour Designs

Del Arbour Designs
 152 Old Gate Lane
 Milford, CT 06460
 (800) 417-0773
 www.delarbourstore.com

A Nice Cuppa: Bigelow Tea

 www.bigelowtea.com
Chocopologie
 12 South Main St
 Norwalk, Ct 06854
 (203) 838-3131
 www.knipschildt.com

The Iceman Cometh: Masterpieces That Melt

Ice Matters
 Waterbury, CT
 (203) 271-3736
 www.icematters.com

The Secret Life of Plants: Ecology and Evolutionary Biology Greenhouses

University of Connecticut
 75 North Eagleville Road, Unit 3043
 Storrs, CT 06269-3043
 (860) 486-4052
 http://florawww.eeb.uconn.edu

Exploring the Depths: The Institute for Exploration at Mystic Aquarium

 www.mysticaquarium.org

Welcome to the Wheel World: Senior Skaters

For information on joining the sessions or finding a coach:
Ron-A-Roll Indoor Roller Skating Center
 85 South Frontage Road

Vernon, CT 06066
(860) 872-8400
www.ronaroll.com

**Whispers of the Past: Reclaiming
the Pequot Language**
Mashantucket Pequot Museum and Research Center
110 Pequot Trail
Mashantucket, CT 06338-3180
(800) 411-9671
www.pequotmuseum.org

Connecticut's Other Huskies: Dogsledding
Meetings of the Connecticut Valley Siberian Husky
Club are held ten months out of the year, and the
sled dog training begins in late October when the
temperatures are in the 30s in the morning. Races
start with wheeled rigs in November and other events
are scheduled for December, January, and February
dates, hopefully on snow and real sleds. For more on
the club, check out:
www.cvshc.org

**Dashing through the Snow:
Allegra Farm Sleigh Rides**
Allegra Farm
P.O. Box 455
East Haddam, CT 06423
(860) 680-5149
(860) 537-8861
www.allegrafarm.com/country

Swept Away: The Norfolk Curling Club
Norfolk Curling Club
70 Golf Drive
P.O. Box 102
Norfolk, CT 06058
(860) 542-1100
www.norfolkcurlingclub.org
www.nutmegcurling.com
www.usacurl.org

Abracadabra: The Society of Young Magicians
For kids ages seven to seventeen:
The Society of Young Magicians
c/o Bill Andrews
P.O. Box 8218
Stamford, CT 06905
(203) 975-2667
www.stamfordsocietyofyoungmagicians.com

Simply PURR-fect: Feline Heaven on Earth
The Last Post
95 Belden Street
P.O. Box 259
Falls Village, CT 06031
(860) 824-0831
www.thelastpostonline.org

**Hoop Dreams: Preserving and Promoting the
History of Women's Basketball**
Megan Pattyson Culmo is now an announcer on
CPTV covering UConn Women's Basketball games.
www.allamericanredheads.com
www.womensbasketballmuseum.com
www.uconnhuskies.com

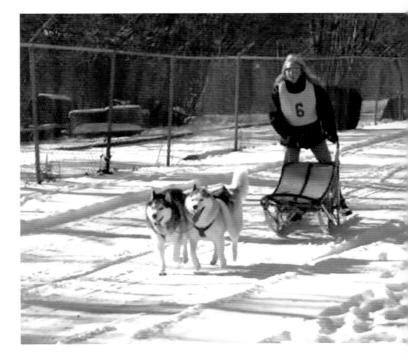

PHOTO CREDITS

Page i: upper left, lower left, lower right: Katherine Griswold; upper right: Joan Levy

Page ii: Duane Button

Page vi: upper left, upper right: Tom Woodruff; lower left, lower right: Katherine Griswold

Spring, page 1: top: Joan Levy; center: Gerri Griswold; bottom: Cindy Erickson

Pages 2 and 3: Courtesy The Knox Parks Foundation

Page 4: Ray Gruzas

Page 5: Jack Benas

Page 6: Gloria Freund

Pages 7, 8, and 9: Bree Berner/First Company Governor's Horse Guards

Pages 10: David Wilson

Page 11: top: Ed Gonsalves; bottom: Alan Camp

Page 12: top: David Wilson; bottom: Alan Camp

Pages 13 and 14: Gerri Griswold

Pages 15 and 16: John Groo/Courtesy Mark Twain House

Page 17: Tom Woodruff

Pages 18 and 19: Tom Woodruff

Pages 20, 21, 22, and 23: Robert Gregson

Pages 24 and 25: Cindy Erickson

Pages 26 and 27: Joan Levy

Pages 28 and 29: Howard Pincus

Page 30: Kindra Clineff/Essex Clipper Dinner Train

Pages 31, 32, and 33: Ian Gereg

Pages 34, 35, and 36: William Dressler

Summer, page 37: top: Dan Rennie; center and bottom: Katherine Griswold

Pages 38: Mystic Whaler Cruises

Page 39: Courtesy Norwalk Maritime Aquarium

Pages 40, 41, and 42: Tom Woodruff

Pages 43 and 44: Tom Woodruff

Pages 46, 47, and 48: Riverfront Recapture/Gregory Kriss

Pages 49: Jim Benini

Pages 50, 51, 52, and 53: Tracy M. Brown

Pages 54 and 55: Duane Button

Pages 56, 57, and 58: Tom Woodruff

Page 59: Michelle Parr Paulson

Page 60: Courtesy Charter Oak chapter of the Wally Byam Caravan Club

Page 63: Kathleen Naples

Pages 64 and 65: Beverly Lambert

Pages 66 and 67: Yankee Flyers Dog & Disc Club (http://yankeeflyers.com)

Page 69: John Spaulding

Pages 70, 71, and 72: Courtesy Southern Connecticut Cricket Association

Pages 73 and 75: Ben Kimmerle

Page 74: Stuart Feldman

Page 76: Cedrick Haboush

Pages 77 and 78: Tom Woodruff

Page 79: left: Sean Elliot; right: Courtesy Mansfield Drive-In Theatre

Page 80 and 81: Tom Woodruff

Pages 82: Avery's Beverages LLC

Pages 83 and 84: Tom Woodruff

Fall, page 85: top: Ed Gonsalves; center: Katherine Griswold; bottom: Tom Woodruff

Page 86: Martha Emilio

Pages 87 and 88: Steven Savard Photography

Pages 89, 90, 91, and 92: Bob Pagini

Page 93: Tom Woodruff

Pages 94 and 95: Courtesy Taylor Brooke Winery

Pages 96, 97, and 98: Gerri Griswold

Pages 99, 100, and 101: Courtesy Gunn Memorial Museum

Pages 102 and 103: David Gumbart

Pages 104, 105, and 106: Courtesy Winvian.com

Pages 107, 108, and 109: Tom Woodruff

About the Author

Diane Smith is an Emmy-award-winning TV jour-
nalist who has been on the air in Connecticut since
1982. Her very popular series for Connecticut Public
TV, *Positively Connecticut,* searches out the inspiring,
warm, funny, and sometimes downright strange sto-
ries that give Connecticut its character. Diane's latest
television project is a weekly magazine series for Con-
necticut Public TV called *All Things Connecticut.* For
nine years Diane was co-host of the top-rated *Morning
Show* on WTIC-AM News Talk 1080 with Ray Dun-
away. Diane was also a news anchor and reporter for
sixteen years at WTNH-TV in New Haven.